KAFFE FASSETT QUILTS
SHOTS AND STRIPES

24 New Projects Made with Shot Cottons and Striped Fabrics

KAFFE FASSETT AND LIZA PRIOR LUCY

photographs by Debbie Patterson

*For Ken Bridgewater and Stephen Sheard,
who believed in the vision.*

STC Craft | A Melanie Falick Book | Stewart, Tabori & Chang, New York

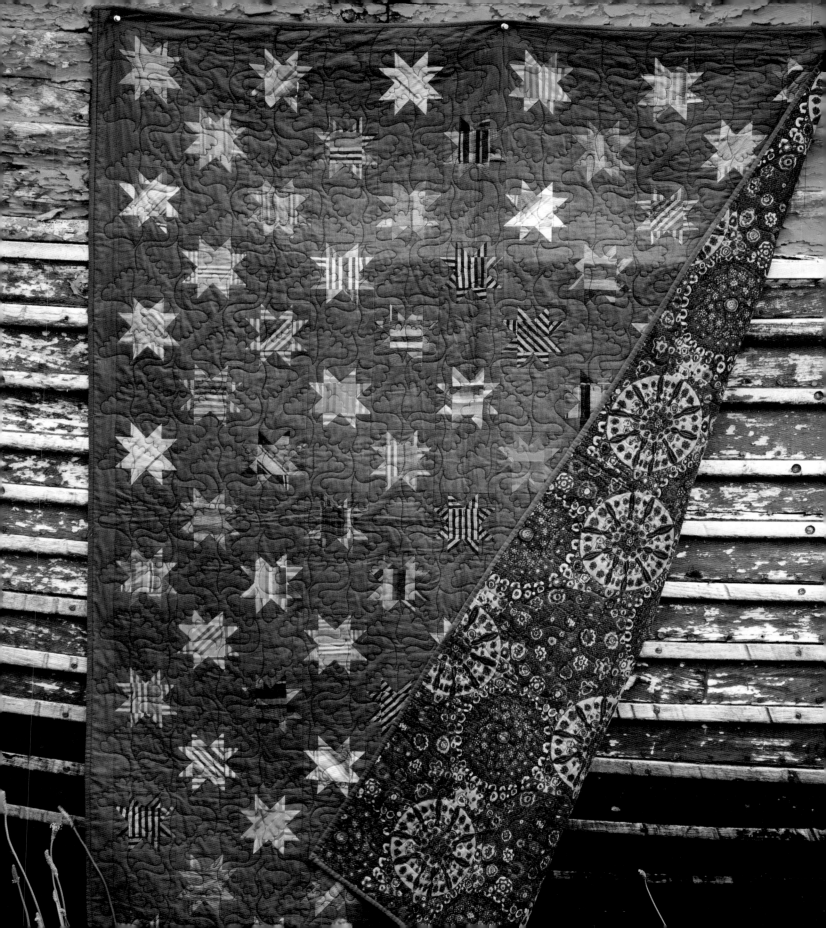

CONTENTS

INTRODUCTION

Many years ago, after my solid shot cottons became big sellers for the network of shops that stock my quilt fabrics, the idea of using only those combined with my established collection of woven stripes sparked my imagination. Of course, along my journey I have used my woven stripes and shot cottons in combination with my floral prints, but a collection of quilts made up exclusively of these shots and stripes has long remained an unfullfilled dream. My longtime quilt collaborator Liza Lucy shared my enthusiasm for a collection like this. Liza had convinced me to get into quilting in the mid-1990s when I was mostly designing knitwear for the Rowan yarn company and she was one of their reps. When Liza and I originally proposed the idea of a shots and stripes book to Westminster Fibers, who were distributing my fabrics, there was so much going on that we never got the go-ahead.

The development of my quilt fabrics began in the early 1990s. I had been designing furnishing fabrics since the 1970s, but the idea of creating fabrics for quilts really only got going when I designed my first woven stripes, an event that I stumbled into fortuitously in India. On my first trip to India in early 1992 I met the New Delhi organizers of one of Britain's biggest charities called Oxfam. They believed that I was the sort of designer who could successfully encourage village craftspeople to produce products that would be "marketable in the West." They kept me in mind and in 1994 contacted me in London. I soon found myself, with my assistant Brandon Mably, visiting a village of weavers near the sea in Andhra Pradesh.

The weavers lived in primitive stick houses where they operated hand-crafted looms from pits they dug in the dirt floor. I designed for them a series of striped fabrics. Because there was no specific market in Oxfam's guidelines, I designed colorful fabrics for shirts I'd like to wear. I knew little about weaving, so upon arrival in the village I handed the weavers a long swatch of knitted stripes in various widths and told them to make a woven piece like those.

The first design they set up on the loom was multi-hued, broad even stripes about half an inch wide in gold, blue, maroon, orange, and so on. Once the warps were ready, we had them try many different wefts. With a bright blue weft all the tones took on a cool blue mood.

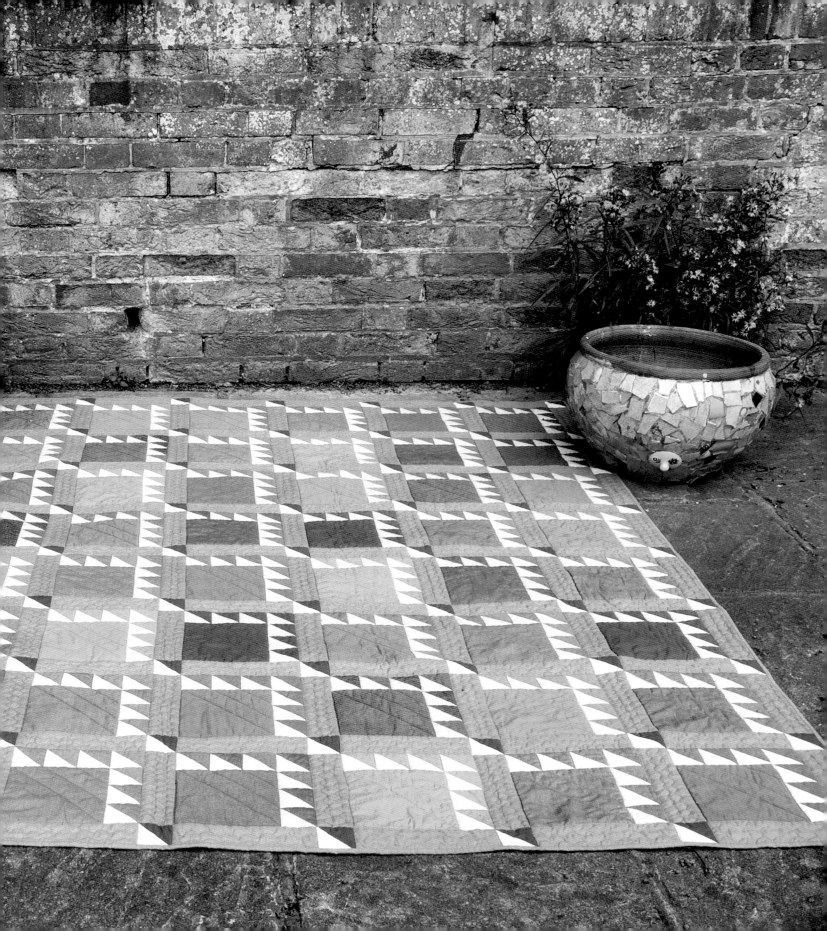

When the weft was changed to scarlet all the colors became hot reddish tones. A dark magenta weft gave a deep mysterious bias to the colored stripes, while a white weft created a faded pastel effect over the original stripe sequence. It was a thrill and an education to see how each weft transformed the warp. We were spellbound.

I then tried a finer regular stripe, each band of color about a quarter of an inch wide, which I eventually named Narrow Stripe. After that I designed an even finer regular repeating stripe called Caterpillar Stripe, and lastly came Exotic Stripe, a variegated-width stripe. When we left we hoped Oxfam would be able to put the stripe designs to good use.

My 1994 trip to India happened to coincide with the period when I was working on my very first book with Liza, *Glorious Patchwork*. Since 1987 Liza had been encouraging me to start designing quilts, a craft she knew I was fascinated by, and I was finally deeply involved in making my first ones. On one of my trips to work with Liza in Pennsylvania I brought the swatch book with my Indian woven stripes. Although I hadn't designed them to use in quilts, we could see they might work. They were the right thickness and stunning, so were worth trying.

As an initial order Liza and I decided on five yards of each of 30 different designs—the five stripe types in six different colorways. We wrote in our request. For a whole year we heard nothing, so we contacted the weavers again. It turned out that they needed money upfront to start. To get over this hurdle, we brought friends—Stephen Sheard of Rowan Yarns, Ken Bridgewater of Westminster Fibers, and Susan Druding, the owner of a yarn store in California called Straw into Gold—into the conversation; they agreed to share in the minimum order required by the Indian weavers to produce my first collection.

A lot of patchworkers are really nervous about working with stripes, feeling they must make them line up precisely when they stitch them together, which can be a difficult task. So when the fabrics hit the shops I was unsure of what the response would be. Luckily, Karen Stone, Roberta Horton, and Mary Mashuta jumped at the chance to do quilts with them right away. When I saw that they were interested, I was knocked out. It got me going on using them in my own designs.

The stripes really took off. That first collection was so rich and different from other Indian weaves that it made a big stir, not for Oxfam, which didn't know how to market it, but the quilting world, which embraced it with abandon. On the strength of those stripes, the Rowan Patchwork and Quilting Company was born. Soon after I started

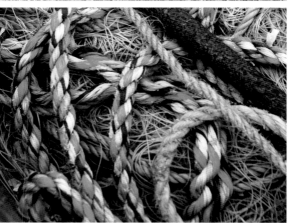

Ropes on Hastings beach have the same graphic repetition as African Stripe (page 10), which shows Liza's clever use of just two fabrics.

designing quilting prints—Gazania, Chard, and Roman Glass were the first—and my collections became the hot new kids in the quilting world.

After the second year of successful sales on the stripes, the village weavers were doing so well with the steady income from our orders that they installed concrete floors and electric lights. At the start they had been unable to work in dim light or after any rain that muddied their floors, and now they could weave in all weather and at all times of day to supply our growing demand.

With my stripes and prints on the go, I found I needed some calmer background solids to mix in with my other fabrics. In search of the right colors, I cut up the various colorways on my first broad stripes—to separate out some solids. I then selected one of these solid stripe colors for each of my color moods. This selection was sent back to the weavers for them to make my first shot cotton color range. I had grown up loving the magical shimmer of shot silks—magenta warp with a scarlet weft would have me gasping with excitement. My solid cotton fabrics, with their differently colored warp and weft, have the same sort of shimmer, just more matte so a bit more subtle. The shot cottons became one of our most popular lines.

My first collection of woven stripes went on for years, which is a very rare occurrence in the everchanging fabric world. Eventually, I designed new collections of stripes and they were introduced with moderate success. After a while people who had stocked up on the first collection ran out of fabric and longed to have the old stripes back. Liza and I put our heads together and arrived at a set of stripes very similar to the originals but in a slightly different palette. There is now a range of my regular and irregular stripes available in retail outlets around the world.

Liza and I would return to our dream book often over the years as we'd spot a good graphic idea in an exhibition or in a book on vintage quilts, so the concept of a collection of quilts made up solely of shots and stripes stayed alive for us. When Stewart, Tabori & Chang agreed to take this book idea, we were thrilled and began making quilts with great passion. For years I've relied on my large-scale lush florals to make my quilts exciting, but here was a chance to take our slant on some great traditional forms and do them in bold graphic style. Liza and I would surprise each other with new ideas in the years of designing and making that followed.

For inspiration for using both the shots and stripes, we looked at Amish quilts, African weaves, and the work of painter Sonia Delauney,

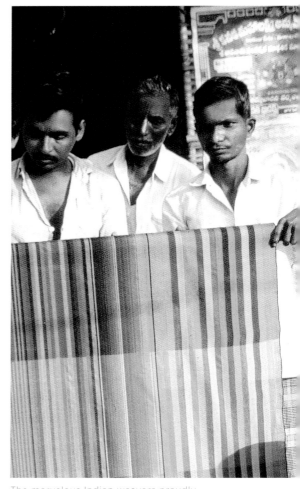

The marvelous Indian weavers proudly displaying the first sample of my woven stripes. You can clearly see how dramatically the red and blue wefts influence the stripe colors of the warps.

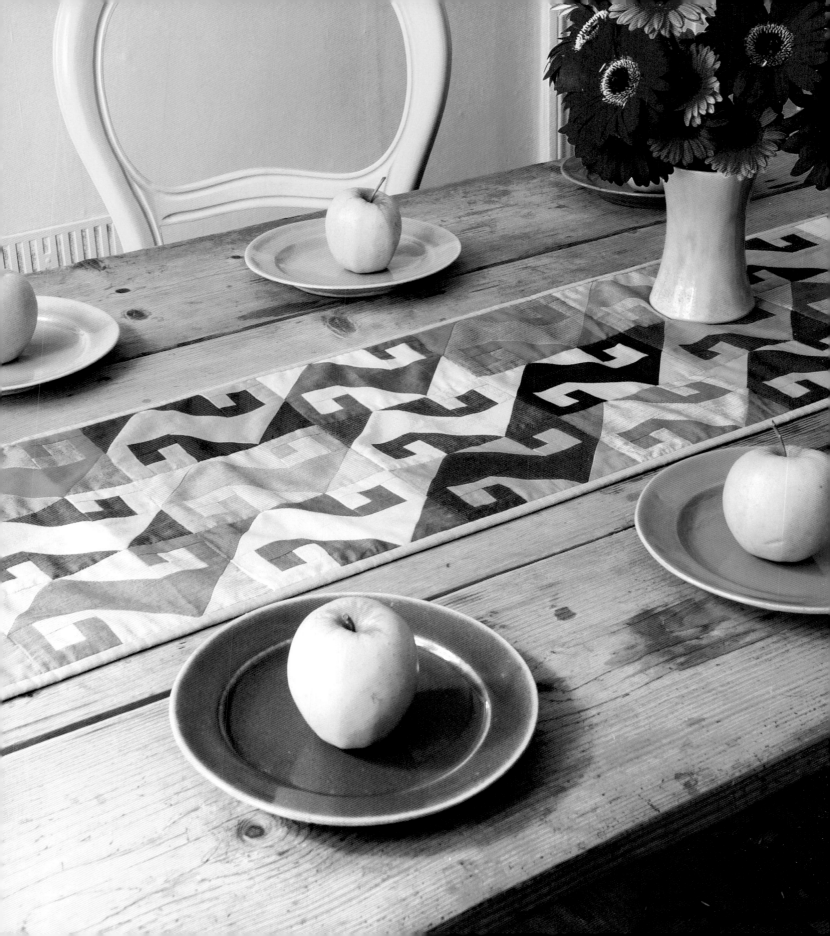

who made bold patchwork coats and hangings from contrasting colors of plain fabrics. As you can see from our collection, architecture, tiles, and ethnic textiles inspired us as well.

Liza is passionate about Amish quilts and started by digging through her books to find good examples in that world (see page 16). I am in love with Japanese work clothes that are patched so excitingly; the restraint of the indigo and cream fabrics creates such a powerful mood. So I began with my small hanging. I used the deepest of my Indian stripes and shot cottons to create a dark world. Quilting the finished patches with big stitches in thick cotton thread was rewarding as my "Japanese" textile emerged (see page 58). For other projects I found references in vintage quilt books and sent them to Liza, who would then start mocking up our own version. If I was stuck for an idea I would just get out all my stripes and stare at them until something occurred to me. The golden range of stripes, for instance, suggested Jambo (see page 124). They were so like the narrow-strip African weaves I'd seen in books on the subject.

When the shots and stripes collection was completed, we took them to the English seaside town of Hastings, where Brandon and I have a house. The combination of fishing boats on the beach and the Victorian villa we have decorated ourselves proved a good background to show the colors of Liza's and my new works. Our photographer, Debbie Patterson, lives a few miles up the coast so none of us had to travel too far to find the richly colored backgrounds we love to match up with our quilts. After designing and making them, which is always a very creative process, photographing them in the right setting is a satisfying culmination of our efforts.

KAFFE Fassett

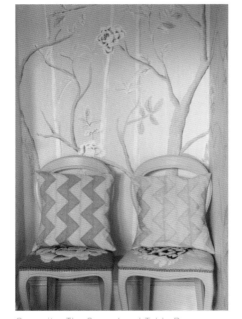

Opposite: The Samarkand Table Runner (see page 90). Above: The Zigzag Cushions (see page 96) glowing against my handpainted version of Chinese wallpaper in the house in Hastings.

AFRICAN STRIPE

Here's a patchwork steeped in influence from Africa, that continent so bursting with creative ideas. Liza had taken on the challenge of working with only two fabrics. I was completely amazed when I saw the finished quilt. I have rarely worked with such a limited palette and don't feel I would have conjured up such a rich arrangement. The subtle but powerful effect achieved from the cut-up patches of the multitoned stripe really has you perusing the composition over and over to see how it is constructed and to spot the nuances. The smoky, warm ground sets off the smoldering teals, turquoise, and cobalt of the stripe wonderfully.

African Stripe was born after many of the other quilts in this book were designed and we saw that we needed simpler, more graphic uses of the shot cottons to really highlight the woven stripes. I would be intrigued to see other combinations, such as deep reds—perhaps Alternating Stripe in red coupled with magenta shot cotton. Or a hot orange version using Exotic Stripe in earth with clementine shot cotton.

FINISHED SIZE

84" x 84" (210 cm x 210 cm)

MATERIALS

Use the specified 42–44"- (112–114-cm-) wide fine-weight Kaffe Fassett *Shot Cotton* and *Woven Stripe* for the patchwork, and use an ordinary printed quilting-weight cotton fabric for the backing.

PATCHWORK FABRICS

Solid fabric: 4 yd (3.7 m) of *Shot Cotton* in Bronze

Stripe fabric: 4 1/2 yd (4.2 m) of *Broad Stripe* in Blue

OTHER INGREDIENTS

Backing fabric: 7 yd (6.4 m) of desired printed quilting fabric

Binding fabric: 3/4 yd (70 cm) extra of *Broad Stripe* in Blue

Thin cotton batting: 91" x 91" (225 cm x 225 cm)

Quilting thread: Deep-taupe thread

TIPS

This quilt is easy and quick to stitch, which makes it a good beginner's project. Use the *Shot Cotton* and *Woven Stripe* suggested in the instructions or one of the alternative colorways above.

CUTTING PATCHES

Press and starch the patchwork fabrics before cutting. (Read page 163 for more information about preparing *Shot Cotton* and *Woven Stripes* for your patchwork project.)

The quilt is made up of two different blocks: Block A consists of six narrow rectangles, and Block B consists of four wide rectangles. Cut all the stripe-fabric rectangles lengthwise so the stripes run parallel to the long edges of the rectangle. The striped rectangles for each block are not cut to match, so they can be cut with the stripes running through the rectangles in random positions.

BLOCK-A PATCHES

84 solid rectangles: From the solid fabric, cut 84 rectangles measuring 2 1/2" by 12 1/2" (6.5 cm by 31.5 cm)—this is enough solid strips for 28 blocks.

84 striped rectangles: From the stripe fabric, cut 84 rectangles measuring 2 1/2" by 12 1/2" (6.5 cm by 31.5 cm) with the stripes running parallel to the long edges—this is enough striped strips for 28 blocks.

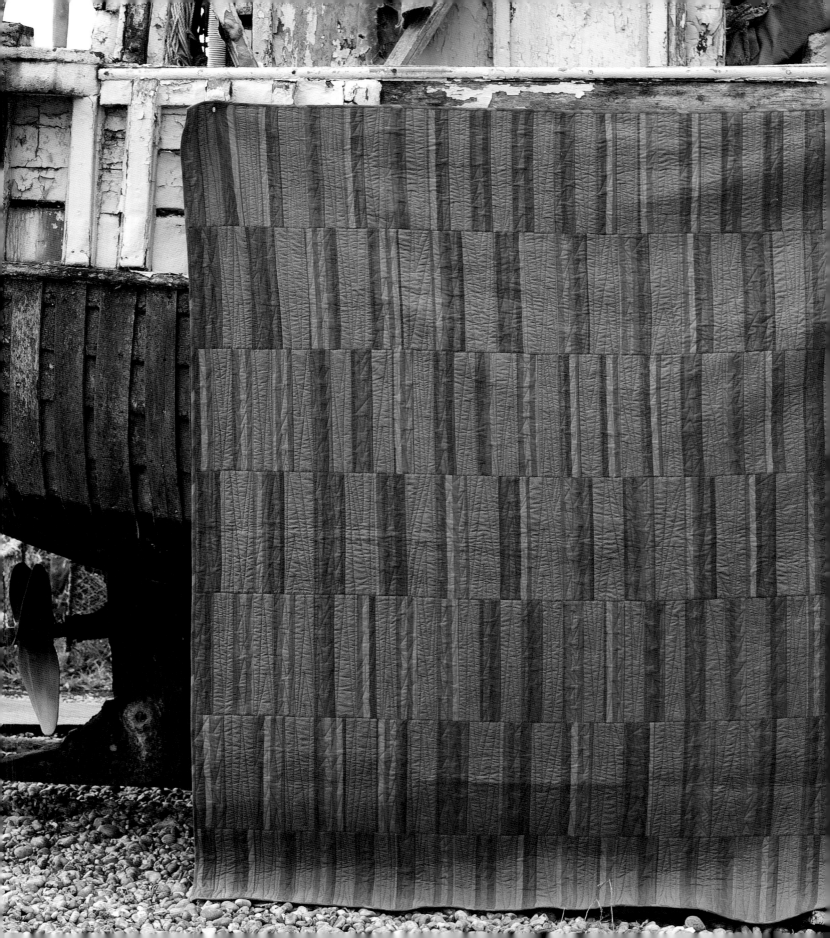

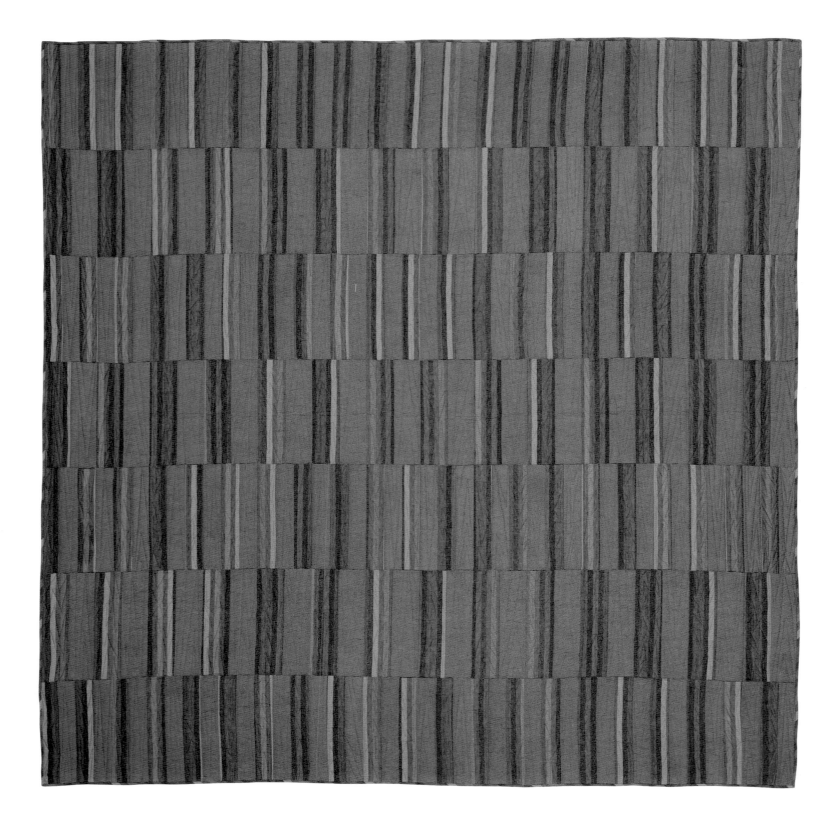

BLOCK-B PATCHES

42 solid rectangles: From the solid fabric, cut 42 rectangles measuring 3 1/2" by 12 1/2" (9 cm by 31.5 cm) —this is enough solid strips for 21 blocks.

42 striped rectangles: From the stripe fabric, cut 42 rectangles measuring 3 1/2" by 12 1/2" (9 cm by 31.5 cm) with the stripes running parallel to the long edges— this is enough striped strips for 21 blocks.

MAKING BLOCKS

Make the blocks using a 1/4" (7.5-mm) seam allowance.

When composing the blocks, position the different-looking striped patches at random in the individual blocks to achieve the lively composition shown in the photo of the finished quilt.

28 Blocks A: For each block, use three narrow solid rectangles and three narrow striped rectangles. Stitch the long sides of the rectangles together, alternating the solids and stripes as shown in the block diagram. Make a total of 28 Blocks A.

Block A

12" (30 cm) square
(finished size excluding
seam allowance)

21 Blocks B: For each block, use two wide solid rectangles and two wide striped rectangles. Stitch the long sides of the rectangles together, alternating the solids and stripes as shown in the block diagram. Make a total of 21 Blocks B.

Block B

12" (30 cm) square
(finished size excluding
seam allowance)

ASSEMBLING TOP

Each of the seven horizontal rows on the quilt consists of seven blocks of either Blocks A or Blocks B, as shown on the assembly diagram. Before stitching the blocks together, arrange them all so you can study the composition, either laying the blocks out on the floor or sticking them to a cotton-flannel design wall. There are four Block-A rows and three Block-B rows. Position the Block-A and Block-B rows alternately, starting and ending with a Block-A row.

Once you are satisfied with your arrangement, sew the blocks together in horizontal rows, using a 1/4" (7.5-mm) seam allowance throughout. Then sew the rows together.

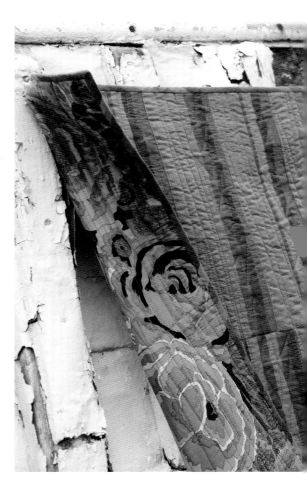

Assembly

KEY

■ solid fabric ▥ stripe fabric

FINISHING QUILT

Press the quilt top. Layer the quilt top, batting, and backing, then baste the layers together (see page 167).

Using deep taupe thread, machine quilt several horizontal rows of steeply peaked zigzags up and down across the width of each striped rectangle patch, and a single horizontal zigzag line up and down across the width of each solid rectangle patch so that the top of each zigzag touches the top of the patch and the bottom of each zigzag touches the bottom of the patch.

Trim the edges of the backing and batting so that they align with the patchwork top. Then cut the binding on the bias and sew it on around the edge of the quilt (see page 167).

Beautifully weathered paint on this English door could inspire another coloring for African Stripe.

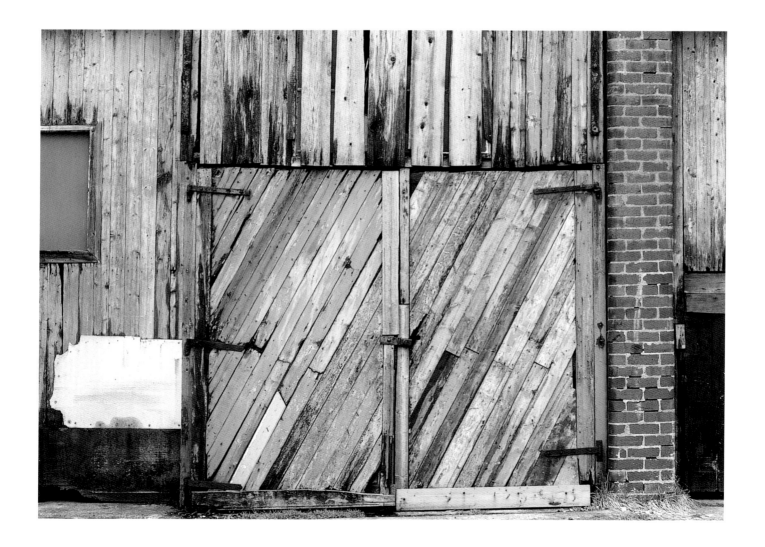

AMISH NINE-PATCH

When Liza and I conceived this book, Liza had in mind the strong graphic plainness of the Amish quilts for the shots-only concoctions. I was thinking more about the cultures of Korea, Japan, and Africa. But when I sat down with the books about antique Amish quilts that Liza collects I, too, got inspired by the strength of these quilts. The Amish often used old faded clothing for their quilts, so my shot cottons with their variations of tone worked well to approximate that mood.

For our quilt at right, the dark ground makes the red tones blast out in an exciting way. The deep magenta wall shows off the quilt to perfection. I think the Amish would approve of the palette.

FINISHED SIZE

84 3/4" x 107 1/2" (215.5 cm x 273 cm)

MATERIALS

Use the specified 42–44"- (112–114-cm-) wide fine-weight Kaffe Fassett *Shot Cottons* for the patchwork, and use an ordinary printed quilting-weight cotton fabric for the backing.

PATCHWORK FABRICS

Inner-border and Edging-triangle fabric: 2 3/4 yd (2.6 m) of *Shot Cotton* in Persimmon

Outer-border and large-squares fabric: 4 1/2 yd (4.2 m) of *Shot Cotton* in Grape

Sashing-rectangles fabric: 2 1/4 yd (2.1 m) of *Shot Cotton* in Mulberry

"Reds": Use one or all of the following— *Shot Cotton* in Persimmon, Scarlet, Bittersweet, and/or Clementine—to make up a total of 1/2 yd (50 cm)

"Golds": Use one or all of the following— *Shot Cotton* in Tobacco, Chartreuse, Sunshine, and/or Tangerine—to make up a total of 3/4 yd (70 cm)

"Blues": Use one or all of the following— *Shot Cotton* in Cobalt, Blue Jeans, and/ or Smoky—to make up a total of 3/4 yd (70 cm)

"Teals": Use one or all of the following— *Shot Cotton* in Eucalyptus, Spruce, Aegean, and/or Pool—to make up a total of 1/2 yd (50 cm)

"Greens": Use one or all of the following—*Shot Cotton* in Lichen, Moss, Viridian, and/or Pea Soup—to make up a total of 1/2 yd (50 cm)

"Browns": Use one or all of the following—*Shot Cotton* in Curry, Nut, and/or Terracotta—to make up a total of 1/2 yd (50 cm)

OTHER INGREDIENTS

Backing fabric: 8 yd (7.4 m) of desired printed quilting fabric

Binding fabric: 1 yd (1 m) extra of *Shot Cotton* in Grape

Thin cotton batting: 92" x 115" (235 cm x 290 cm)

Quilting thread: Black thread

TIPS

If you follow the instructions carefully, this quilt is less complicated to make than it looks. Many colors have been used for the small squares to enliven the composition, but they fall into just six color families—reds, golds, blues, teals, greens, and browns—and you can use as many or as few in each group as you like.

CUTTING PATCHES

Press and starch the patchwork fabrics before cutting. (Read page 163 for more information about preparing *Shot Cotton* for your patchwork project.)

Cut the pieces in the order they are listed, as the large pieces should be cut first.

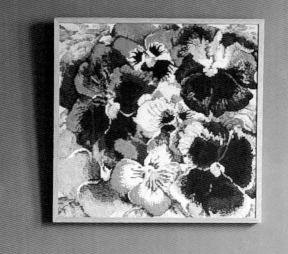

BORDERS

4 inner-border strips: From the inner-border fabric (Persimmon), cut two side borders 3 1/2" by 91" (8.9 cm by 231.1 cm) and a top and bottom border each 3 1/2" by 74 3/8" (8.9 cm by 188.9 cm).

4 outer-border strips: From the outer-border fabric (Grape), cut two side borders 6" by 97" (15.2 cm by 246.4 cm) and a top and bottom border each 6" by 85 3/8" (15.2 cm by 216.9 cm).

EDGING TRIANGLES

52 large edging triangles: From the edging-triangle fabric (Persimmon), cut 13 squares 6 7/8" by 6 7/8" (17.5 cm by 17.5 cm) and cut each of them diagonally from corner to corner in both directions to make four quarter-square triangles—for a total of 52 large triangles.

4 small edging-corner triangles: From the edging-triangle fabric (Persimmon), cut two squares 3 3/4" by 3 3/4" (9.5 cm by 9.5 cm) and cut each of them diagonally from corner to corner to make two half-square triangles—for a total of 4 small triangles.

SASHING RECTANGLES

48 sashing rectangles: From the sashing-rectangles fabric (Mulberry), cut 48 patches 4 1/2" by 12 1/2" (11.4 cm by 31.8 cm). Cut these rectangles so that the long sides run parallel to the selvage—this is the most frugal way to cut the pieces.

BLOCK SQUARES

96 large squares: From the large-squares fabric (Grape), cut 96 squares 4 1/2" by 4 1/2" (11.4 cm by 11.4 cm).

84 small "red" squares: From the "reds" fabric/s, cut 84 squares 2 1/2" by 2 1/2" (6.4 cm by 6.4 cm).

90 small "gold" squares: From the "golds" fabric/s, cut 90 squares 2 1/2" by 2 1/2" (6.4 cm by 6.4 cm).

80 small "blue" squares: From the "blues" fabric/s, cut 80 squares 2 1/2" by 2 1/2" (6.4 cm by 6.4 cm).

88 small "teal" squares: From the "teals" fabric/s, cut 88 squares 2 1/2" by 2 1/2" (6.4 cm by 6.4 cm).

66 small "brown" squares: From the "browns" fabric/s, cut 66 squares 2 1/2" by 2 1/2" (6.4 cm by 6.4 cm).

60 small "green" squares: From the "greens" fabric/s, cut 60 squares 2 1/2" by 2 1/2" (6.4 cm by 6.4 cm).

MAKING FOUR-PATCH BLOCKS

Make the blocks using a 1/4" (6-mm) seam allowance throughout. Keep the various block colorways in stacks and label each stack so they are easy to select when making the nine-patch blocks.

24 gold/blue blocks: Using two small matching "gold" squares and two small matching "blue" squares for each block, make 24 four-patch blocks as shown in the block diagram.

12 gold/teal blocks: Using two small matching "gold" squares and two small matching "teal" squares for each block, make 12 four-patch blocks as shown in the block diagram.

24 red/teal blocks: Using two small matching "red" squares and two small matching "teal" squares for each block, make 24 four-patch blocks as shown in the block diagram.

16 green/blue blocks: Using two small matching "green" squares and two small matching "blue" squares for each block, make 16 four-patch blocks as shown in the block diagram.

6 green/brown blocks: Using two small matching "green" squares and two small matching "brown" squares for each block, make six four-patch blocks as shown in the block diagram.

18 red/brown blocks: Using two small matching "red" squares and two small matching "brown" squares for each block, make 18 four-patch blocks as shown in the block diagram.

8 green/teal blocks: Using two small matching "green" squares and two small matching "teal" squares for each block, make eight four-patch blocks as shown in the block diagram.

9 gold/brown blocks: Using two small matching "gold" squares and two small matching "brown" squares for each block, make nine four-patch blocks as shown in the block diagram.

Four-Patch Blocks

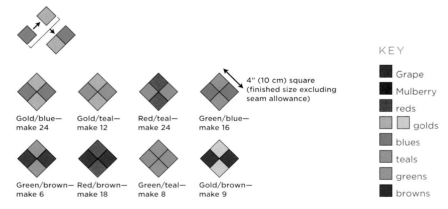

Gold/blue—
make 24

Gold/teal—
make 12

Red/teal—
make 24

Green/blue—
make 16

4" (10 cm) square
(finished size excluding
seam allowance)

Green/brown—
make 6

Red/brown—
make 18

Green/teal—
make 8

Gold/brown—
make 9

KEY

■ Grape
■ Mulberry
■ reds
■ ☐ golds
■ blues
☐ teals
☐ greens
■ browns

MAKING NINE-PATCH BLOCKS

12 Blocks A: Each block is made up of two gold/blue, two red/teal, and one gold/teal four-patch blocks, plus four large Grape squares. Sew the blocks and squares together in diagonal rows as shown, then sew the rows together. Make a total of 12 Blocks A.

6 Blocks B: Each block is made up of two green/blue, two red/brown, and one green/brown four-patch blocks, plus four large Grape squares. Sew the blocks and squares together in diagonal rows as for Block A, then sew the rows together. Make a total of six Blocks B.

Nine-Patch Blocks

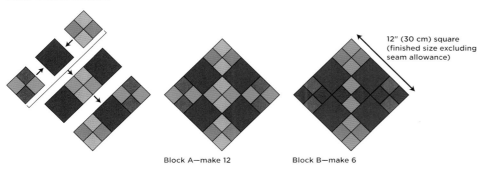

12" (30 cm) square
(finished size excluding
seam allowance)

Block A—make 12 Block B—make 6

MAKING EDGE SETTING–TRIANGLE BLOCKS

4 Triangle Blocks A: Each block is made up of one blue/green four-patch block, two large Grape squares, and three large Persimmon edging triangles. Sew the pieces together in diagonal rows as shown, then sew the rows together. Make a total of four Triangle Blocks A.

6 Triangle Blocks B: Each block is made up of one red/brown four-patch block, two large Grape squares, and three large Persimmon edging triangles. Sew the pieces together in diagonal rows as shown, then sew the rows together. Make a total of six Triangle Blocks B.

Edge Setting–Triangle Blocks

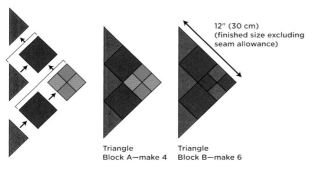

12" (30 cm)
(finished size excluding
seam allowance)

Triangle
Block A—make 4 Triangle
Block B—make 6

Assembly

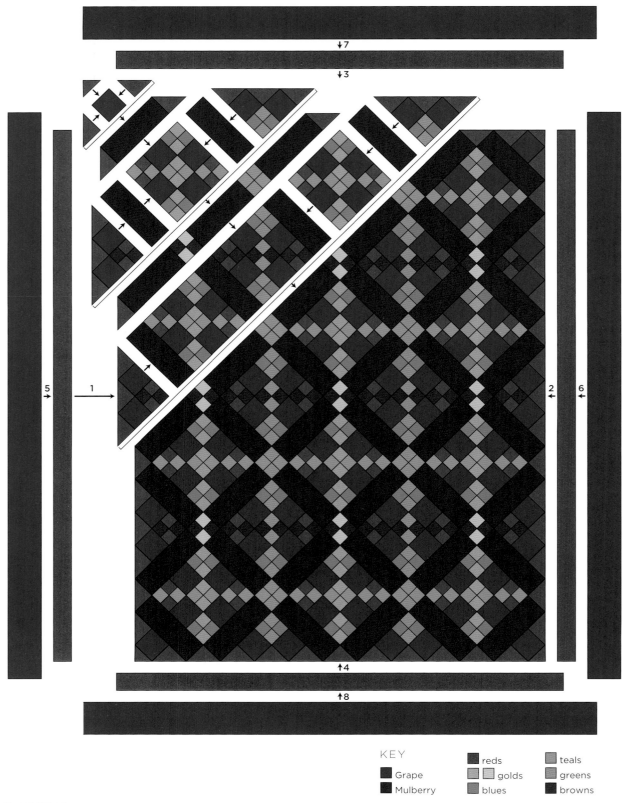

KEY

- ■ Grape
- ■ Mulberry
- ■ reds
- ■ golds
- ■ blues
- ■ teals
- ■ greens
- ■ browns

ASSEMBLING TOP

Arrange the blocks and the remaining patches, either laying them out on the floor or sticking them to a cotton-flannel design wall. Follow the assembly diagram carefully, first positioning the large nine-patch blocks "on point" in vertical rows, leaving room for the sashing in between. Make sure the colors line up correctly to create long vertical gold and green chains and long horizontal teal and brown chains as shown.

Then position the sashing rectangles between the nine-patch blocks and the remaining four-patch blocks between the ends of the sashing rectangles. Lastly, place the large edging triangles along the edges, and make up the four quilt corners with one large Grape square, two large edging triangles, and one small corner edging triangle.

Using a 1/4" (6-mm) seam allowance, sew the four pieces for each of the four corners together. Then sew the blocks and sashings together in diagonal rows as shown in the assembly diagram. Finally, sew all the pieced diagonal rows together.

Sew the two longer Persimmon inner borders to the sides of the assembled quilt center, then sew on the shorter inner borders to the top and bottom.

Sew the two longer Grape outer borders to the sides of the quilt, then sew on the shorter outer borders to the top and bottom.

FINISHING QUILT

Press the quilt top. Layer the quilt top, batting, and backing, then baste the layers together (see page 167).

Using black thread, machine quilt using traditional quilting patterns. We used Baptist Fans on the outer border, Feathers on the inner border, Feather Wreaths on the big blocks, and Pumpkin Seeds and curves on the sashings. If you have the luxury of time, you might like to hand quilt these patterns to achieve an authentic traditional surface texture.

Trim the edges of the backing and batting so that they align with the patchwork top. Then cut the binding on the bias and sew it on around the edge of the quilt (see page 167).

For the quilting, Liza used traditional patterns that read well against the relative plainness of the graphic arrangement of the patches.

ON-POINT
HANDKERCHIEF CORNERS

Liza and I made a version of this quilt for my second quilt book. I wanted to use all the stripes from my collection at the time to create multitoned borders in quarter-squares. They looked like handkerchieves to me, hence the name. Because my Indian stripes were fairly new on the market then, this became our most popular use of the stripes and shot cottons. It was so exciting as an idea that a German carpet company copied it in every detail. I must admit it made a gorgeous carpet.

Our original was square-on but Liza had the idea to put the square blocks "on point" for this version, which gives it a whole new elegant thrust. We didn't create any particular color bias, just tossed in the whole collection in as many different combos as we could think up. I advised Liza to use fairly neutral shots for the centers of the large blocks so they would enhance all the various colors in the stripes. The deep shadowy tones at the outside borders let the hot shades of the stripes really sing out.

My new collection of stripes worked well here, and I can't help wanting to see some inventive soul do this in shirt stripes garnered from thrift stores or just quite different stripes found in quilting stores.

FINISHED SIZE

84 3/4" x 84 3/4" (215.3 cm x 215.3 cm)

MATERIALS

Use the specified 42–44"- (112–114-cm-) wide fine-weight Kaffe Fassett *Shot Cottons* and *Woven Stripes* for the patchwork, and use an ordinary printed quilting-weight cotton fabric for the backing.

PATCHWORK FABRICS

Striped block fabrics: 1/2 yd (50 cm) of each of 25–30 *Woven Stripes* in any combination of colors

Solid block fabrics: 1/2 yd (50 cm) of *Shot Cotton* in each of Smoky and Galvanized (or in two other nearly matching shades of any favorite color)

Edging-triangles fabric: 1 1/4 yd (1.2 m) of *Shot Cotton* in Thunder

OTHER INGREDIENTS

Backing fabric: 8 yd (7.4 m) of desired printed quilting fabric

Binding fabric: 3/4 yd (70 cm) of *Broad Stripe* in Blue

Thin cotton batting: 92" x 92" (230 cm x 230 cm)

Quilting thread: Medium-dark neutral-colored thread

Templates: Use templates S, T, and U (see page 172)

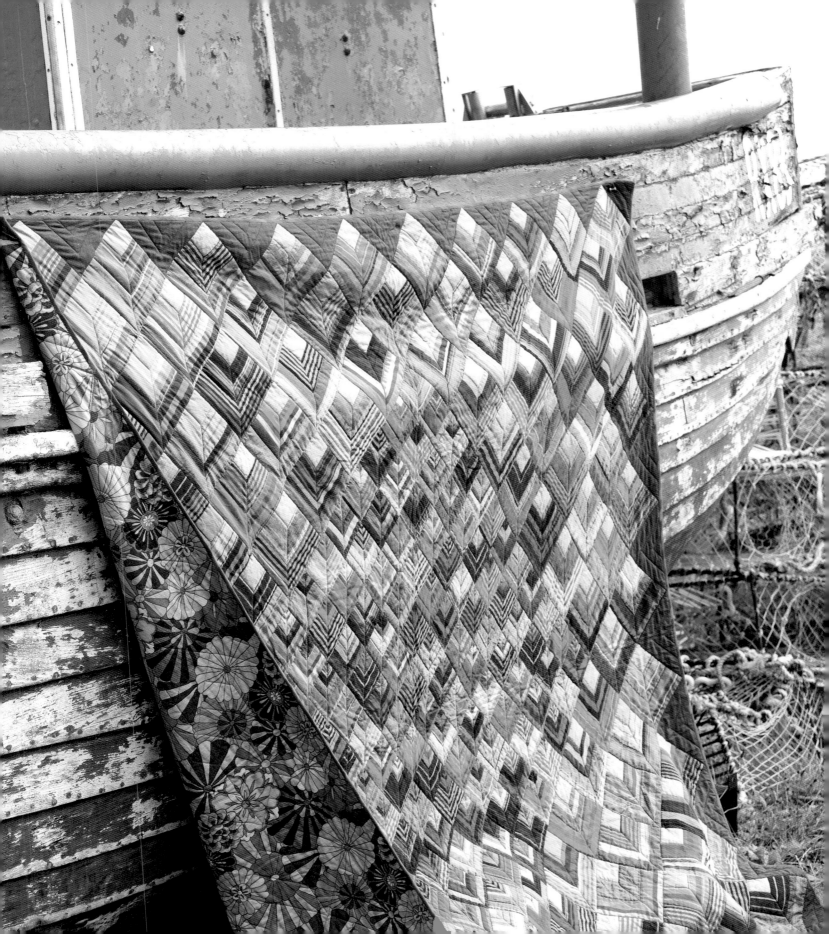

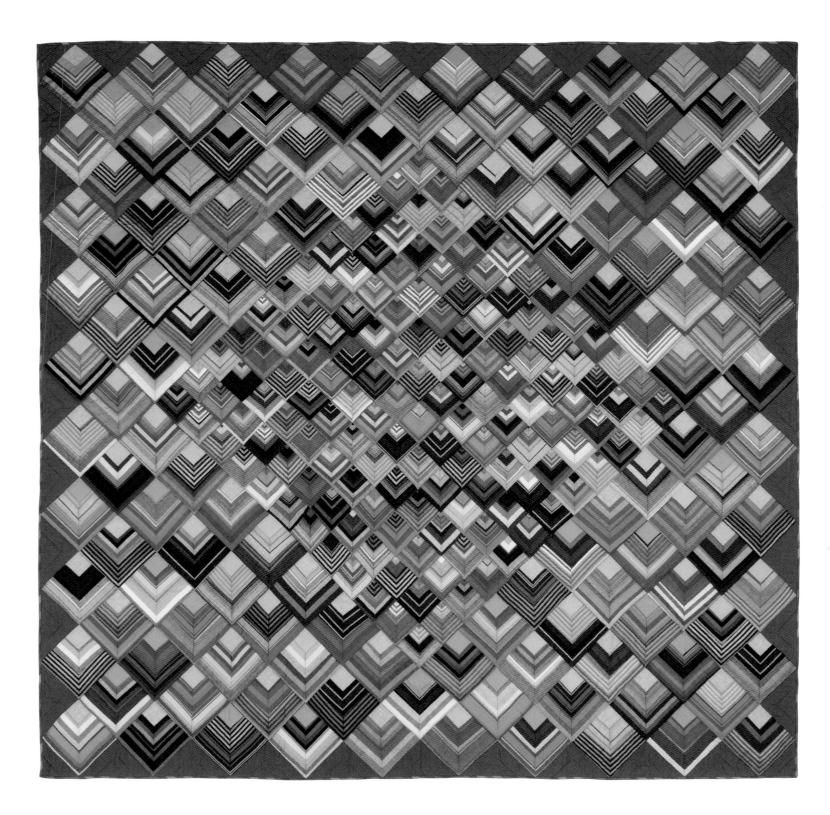

TIPS

The technique to make the blocks in this quilt is a bit tricky. Each of the larger blocks requires an inset seam (see page 166). For rich variation, the striped pieces of the blocks are cut from two different stripes that have been sewn together, "pieced," prior to cutting.

CUTTING PATCHES

Press and starch the patchwork fabrics before cutting. (Read page 163 for more information about preparing *Shot Cotton* and *Woven Stripes* for your patchwork project.)

EDGING TRIANGLES

36 large edging triangles: From the edging-triangles fabric (Thunder), cut nine squares 9 3/4" by 9 3/4" (24.8 cm by 24.8 cm) and cut each of them diagonally from corner to corner in both directions to make four quarter-square triangles—for a total of 36 large triangles.

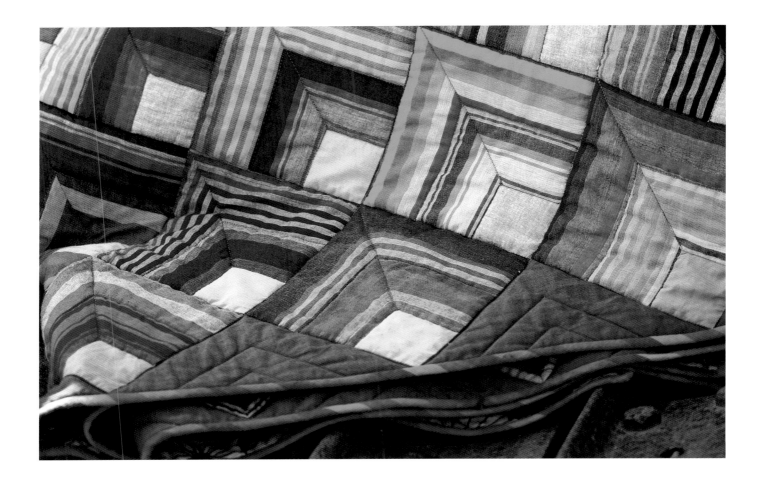

4 small edging-corner triangles: From the edging-triangles fabric (Thunder), cut two squares 5 1/8″ by 5 1/8″ (13 cm by 13 cm) and cut each of them diagonally from corner to corner to make two half-square triangles—for a total of 4 small triangles.

BLOCK PIECES

The striped trapezoids needed for the Large Blocks and the striped triangles needed for the Small Blocks are cut from pieced-together striped strips. Cut the striped strips as explained below, then piece them together and cut the striped patches as explained in the next section.

132 solid squares: From the solid block fabrics (Smoky and Galvanized), cut a total of 132 Template-S squares.

264 long striped strips: From an assortment of stripe fabrics, cut 264 long strips 2 1/2″ by 14 1/2″ (6.4 cm by 36.8 cm) with the stripes running parallel to the long edges.

12 short striped strips: From an assortment of stripe fabrics, cut 12 short strips 2 1/2″ by 9 1/2″ (6.4 cm by 24.1 cm) with the stripes running parallel to the long edges.

PREPARING STRIPED PATCHES

PIECING THE STRIPS

Pick two different *long* striped strips and sew them together along the long edges, using a 1/4″ (6-mm) seam allowance. Press the seams open. Make a total of 132 *long* pieced strips like this.

Pick two different *short* striped rectangles and sew them together along the long edges, using a 1/4″ (6-mm) seam allowance. Press the seams open. Make a total of six *short* pieced strips like this.

CUTTING THE STRIPED PATCHES

Follow the cutting diagram when cutting the Template-T trapezoids and the Template-U triangles. First, fold a long pieced strip in half widthwise with the right side of the fabric together. Then using a rotary cutter and mat (see page 165), cut off the fold about 1/8″ (3 mm) from the crease and discard. So that the two layers remain perfectly aligned, DO NOT separate or move them. Keeping the two layers of fabric together, cut the Template-T trapezoid and the Template-U triangle patches, placing the templates on the fabric in the exact positions shown on the templates. To do this, first cut the 45-degree diagonal, then trim the Template-U patches along the right edge. Since they will have to be stitched together in this position to make the blocks, keep the matching triangle patches right sides together and the matching trapezoid patches right sides together. Cut a total of 132 matching pairs of Template-T trapezoids and Template-U triangles in this way from all the long pieced strips.

Cut the remaining 12 matching pairs of Template-U triangles from the six short pieced strips. Use the same method as before, folding the strips in half, then cutting matching patches, but cut two pairs of matching Template-U triangles from each folded strip.

Cutting Patches from Joined Strips

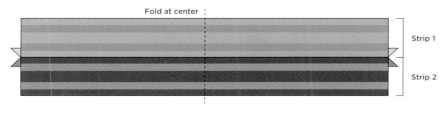

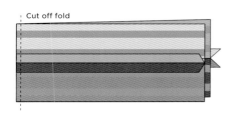

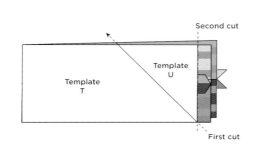

MAKING BLOCKS

Make the blocks using a 1/4" (6-mm) seam allowance.

132 Large Blocks: Each Large Block is made up of a matching pair of striped Template-T trapezoids and a solid Template-S square. Make the blocks following the diagram (see page 166 for inset seam tips). Make a total of 132 Large Blocks.

144 Small Blocks: Each Small Block is made up of a matching pair of striped Template-U triangles. Make the blocks following the diagram. Make a total of 144 Small Blocks.

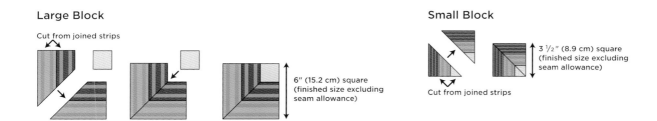

Large Block

Cut from joined strips

6" (15.2 cm) square (finished size excluding seam allowance)

Small Block

3 1/2" (8.9 cm) square (finished size excluding seam allowance)

Cut from joined strips

ASSEMBLING TOP

Arrange the Small Blocks for the quilt center first, either laying them out on the floor or sticking them to a cotton-flannel design wall. Position all 144 blocks "on-point" with the stripes forming a V-shape (as if they are pointing downward). Follow the quilt center diagram—the blocks form a large "on-point" center square with 12 diagonal rows of 12 blocks each. Aim for a pleasing random mix of colors.

Assembly

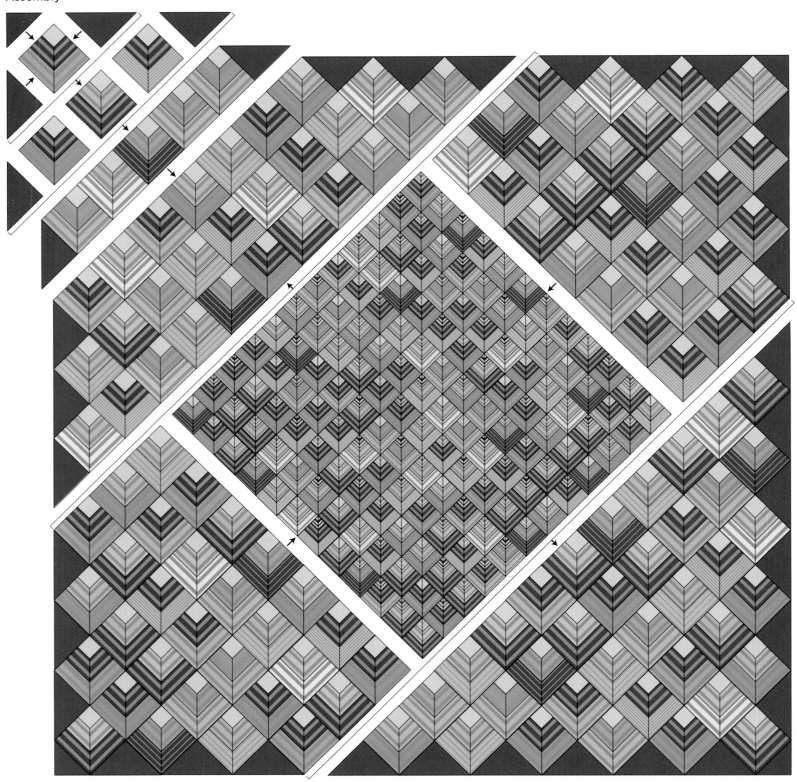

Using a 1/4" (6-mm) seam allowance, sew the blocks for the quilt center together in diagonal rows as shown on the assembly diagram. Then sew all the pieced diagonal rows together.

Place the pieced quilt center on the design wall and arrange the Large Blocks and the edging triangles around it as shown on the assembly diagram. Sew the Large Blocks together in four sections as shown on the diagram, then sew the four assembled sections to the quilt center.

Quilt Center

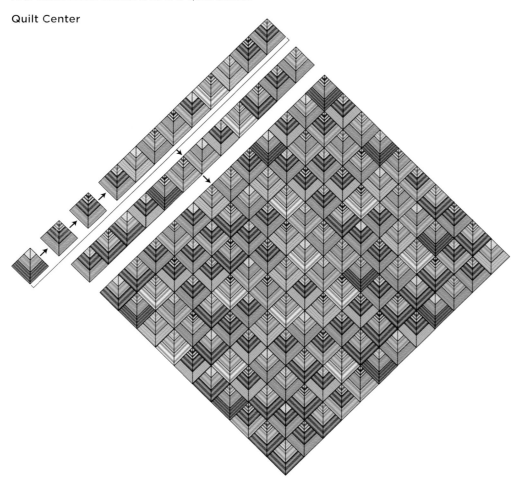

FINISHING QUILT

Press the quilt top. Layer the quilt top, batting, and backing, then baste the layers together (see page 167).

Using a medium-dark neutral-colored thread, machine quilt in-the-ditch around all the pieces. On the setting triangles around the edge of the quilt, quilt two parallel V-shapes echoing the angles of the triangle.

Trim the edges of the backing and batting so that they align with the patchwork top. Then cut the binding on the bias and sew it on around the edge of the quilt (see page 167).

CHIMNEY SWEEP

First of all, I love the name! Chimney Sweep is a traditional quilt format that was often used for Friendship Quilts or Signature Quilts, where friends contributed blocks that they signed in the center with ink or embroidered lettering. The traditional Chimney Sweeps usually have white backgrounds and the colored areas are positioned farther apart.

The vintage example that got me wanting to use this layout was done in very flat solid cottons in obvious primary colors—lemon yellow, fire engine red, cobalt blue, and Kelly green on a black background. I thought the large areas of each color could be powerful if filled with hues that really glowed together. The gray ground helps that glow, I feel, and the large motifs really show the shot cotton range to advantage.

FINISHED SIZE

66" x 82" (167.5 cm x 208 cm)

MATERIALS

Use the specified 42–44"- (112–114-cm-) wide fine-weight Kaffe Fassett *Shot Cottons* for the patchwork, and use an ordinary printed quilting-weight cotton fabric for the backing.

PATCHWORK FABRICS

"Background" fabric: 3 1/2 yd (3.2 m) of *Shot Cotton* in Galvanized

Colored patch fabrics: 1/4 yd (30 cm) each of *Shot Cotton* in the following 17 colors—Sky, Aqua, Moss, Chartreuse, Sprout, Tobacco, Sunshine, Watermelon, Clementine, Apricot, Lipstick, Magenta, Tangerine, Pudding, Jade, Lavender, and Ginger

OTHER INGREDIENTS

Backing fabric: 5 yd (4.6 m) of desired printed quilting fabric

Binding fabric: 1/2 yd (50 cm) extra of *Shot Cotton* in Galvanized

Thin cotton batting: 73" x 89" (185 cm x 225 cm)

Quilting thread: Medium-taupe thread

TIPS

Because our version of the traditional Chimney Sweep is made from only squares and triangles it is an easy quilt to piece. The individual pieces are placed without paying attention the direction of the warp and weft within the block to achieve subtle color variations.

CUTTING PATCHES

Press and starch the patchwork fabrics before cutting. (Read page 163 for more information about preparing *Shot Cottons* for your patchwork project.)

Cut the border pieces first so you can use the left-over border fabric for the "background" in the blocks at the center of the quilt.

BORDERS AND "BACKGROUND" PIECES

4 border strips: From the "background" fabric (Galvanized), cut two strips each 2 1/2" by 78 1/2" (6.4 cm by 199.4 cm) for the side borders, and two strips each 2 1/2" by 66 1/2" (6.4 cm by 169 cm) for the top and bottom borders.

174 "background" squares: From the "background" fabric, cut 174 squares 2 1/2" by 2 1/2" (6.4 cm by 6.4 cm).

480 large "background" triangles: From the "background" fabric, cut 120 squares 4 1/16" by 4 1/16" (10.3 cm by 10.3 cm) and cut each of them diagonally from corner to corner in both directions to make four quarter-square triangles—for a total of 480 large triangles. Keep these quarter-square triangles in a pile and be careful not to mix them with the half-square triangles you are going to cut next.

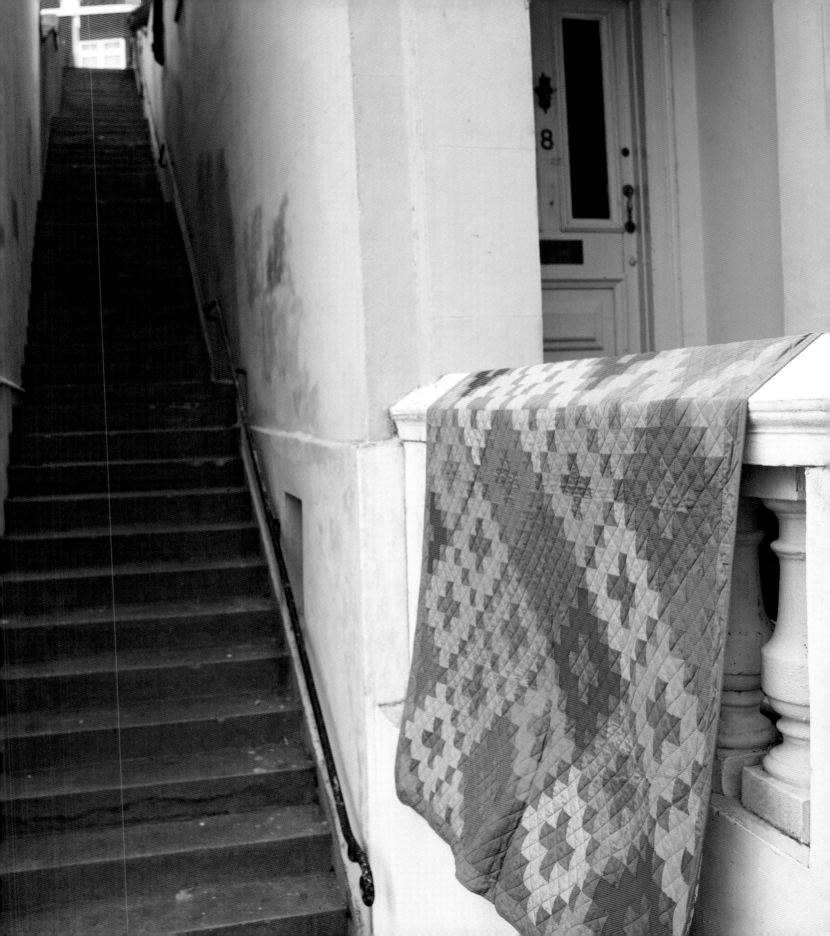

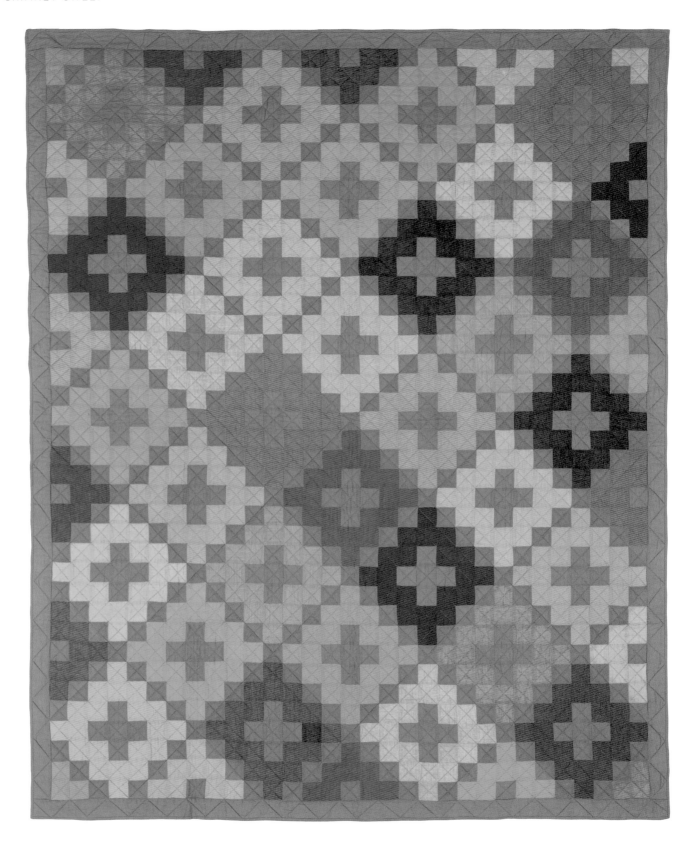

124 small corner "background" triangles: From the "background" fabric, cut 62 squares 2 1/4" by 2 1/4" (5.7 cm by 5.7 cm) and cut each of them diagonally from corner to corner to make two half-square triangles—for a total of 124 small triangles. Keep these half-square triangles in a pile and be careful not to mix them with the quarter-square triangles.

COLORED PATCHES

Note from the Block Configurations diagram below that the quilt is made up of five kinds of blocks—there are 18 full blocks; ten partial blocks with one corner triangle missing; four partial blocks with two corner triangles missing; 14 half blocks; and four corner blocks.

32 sets of 20 matching colored squares: From one of the colored fabrics, cut a set of 20 matching squares 2 1/2" by 2 1/2" (6.4 cm by 6.4 cm). Using all the colored fabrics, cut a total of 32 sets like this—these sets of 20 matching squares are for the full blocks and the blocks missing one or two corner triangles. Keep each set of squares together.

14 sets of 8 matching squares: From one of the colored fabrics, cut a set of eight matching squares 2 1/2" by 2 1/2" (6.4 cm by 6.4 cm). Using various colored fabrics, cut a total of 14 sets like this—these sets of eight matching squares are for the half blocks. Pin each set of eight matching squares together and keep these sets separate from the sets for the larger blocks.

4 sets of 3 matching squares: From one of the colored fabrics, cut a set of three matching squares 2 1/2" by 2 1/2" (6.4 cm by 6.4 cm). Using a different colored fabric for each set, cut a total of four sets like this—these sets of three matching squares are for the corner blocks. Pin each set of three matching squares together and keep these sets separate from the sets for the other blocks.

MAKING BLOCKS

Make the blocks using a 1/4" (6-mm) seam allowance.

Refer to the Block Configurations diagram below when making the blocks.

Block Configurations

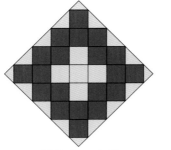

Full blocks—make 18

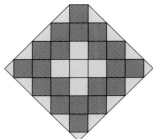

Missing one corner triangle—make 10

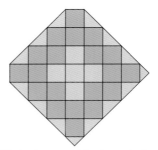

Missing two corner triangles—make 4

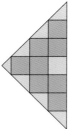

Half blocks—make 14

Corner blocks—make 4

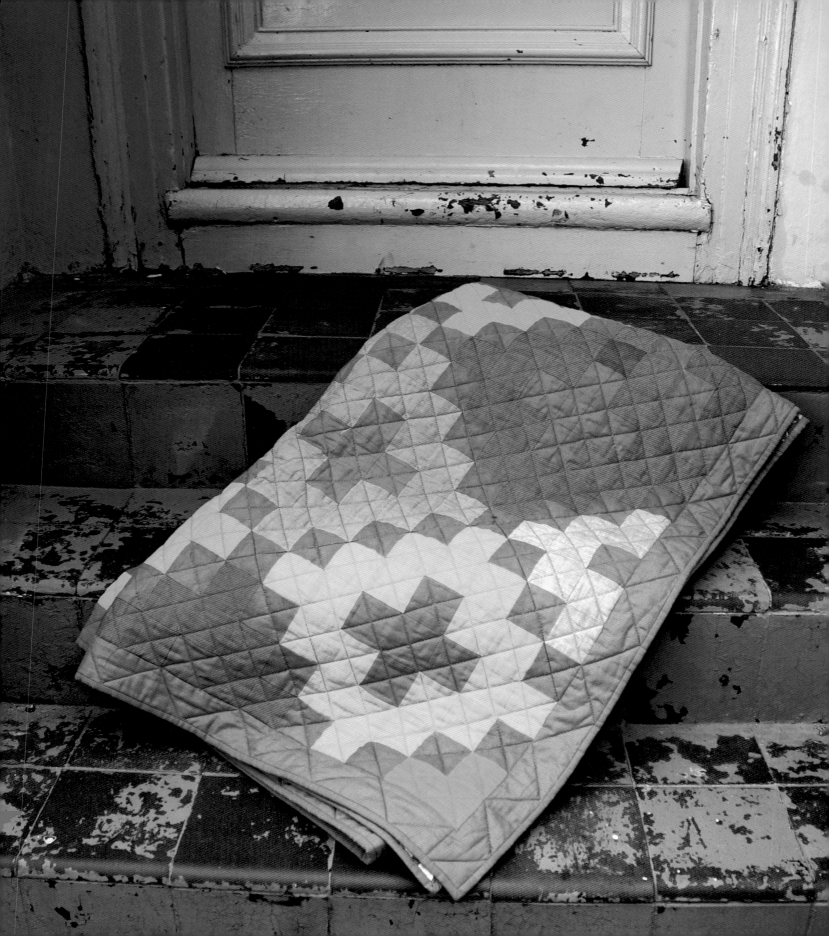

Chimney Sweep Block

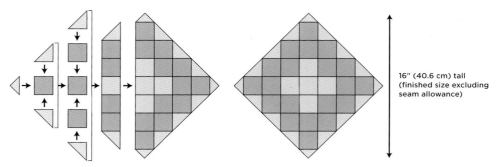

16" (40.6 cm) tall
(finished size excluding
seam allowance)

18 full blocks: For each block, select a set of 20 matching colored squares, five "background" squares, 20 large "background" quarter-square triangles, and four small "background" half-square corner triangles. As shown in the diagram above, sew the pieces together in vertical rows, then sew the vertical rows together. It is easiest to sew on the four small corner triangles last. Make a total of 18 full blocks.

10 blocks missing one small corner triangle: Select the same patches as for the full block, but omit one small "background" corner triangle. Sew the pieces together as for the full blocks.

4 blocks missing two small corner triangles: Select the same patches as for the full block, but omit two small "background" corner triangles. Sew the pieces together as for the full blocks.

14 half blocks: For each block, select a set of eight matching colored squares, one "background" square, six large "background" quarter-square triangles, and one small "background" half-square corner triangle. As shown in the diagram, sew the pieces together in vertical rows, then sew the vertical rows together, adding on the small corner triangle last.

4 corner blocks: For each block, select a set of three matching colored squares and three large "background" quarter-square triangles. As shown in the full block diagram, sew the pieces together in vertical rows, then sew the vertical rows together.

ASSEMBLING TOP

Arrange the blocks, either laying them out on the floor or sticking them to a cotton-flannel design wall. Following the assembly diagram on page 38, arrange the blocks "on point." Start by placing four big blocks across the top of the quilt, paying attention to which are full blocks and which have corner squares missing. Then place three full blocks under the first four, nestling them into the zigzag spaces created by the first row. Continue like this, positioning horizontal rows of four blocks and three blocks alternately until all the blocks are in place, ending with a four block row. Position the half blocks along the sides and top and bottom of the quilt, then place one corner block at each of the four corners of the quilt.

Assembly

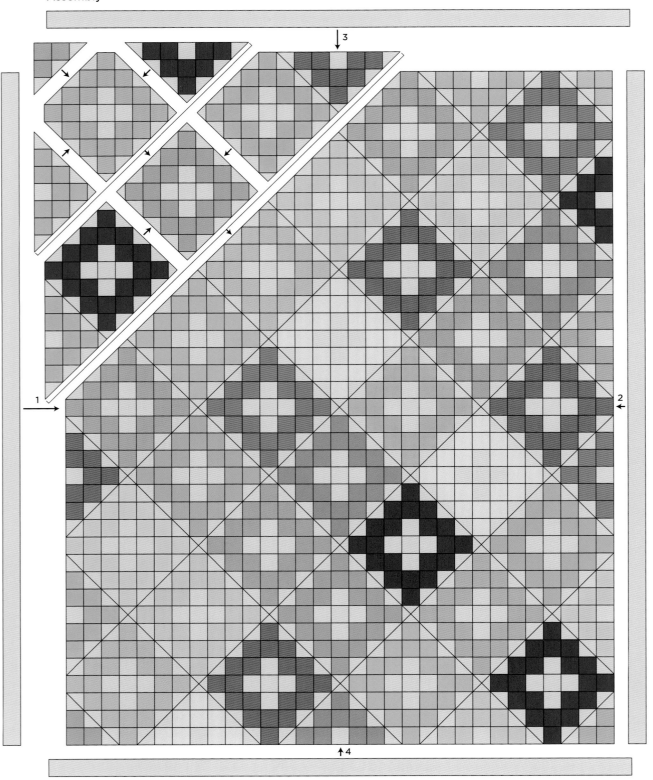

Rearrange the blocks if necessary, until you are satisfied that the colors are well mixed.

Using a 1/4" (6-mm) seam allowance, sew the blocks together in diagonal rows as shown on the assembly diagram. Then sew all the pieced diagonal rows together.

Sew the longer border strips to the sides of the quilt, then sew the shorter border strips to the top and bottom.

FINISHING QUILT

Press the quilt top. Layer the quilt top, batting, and backing, then baste the layers together (see page 167).

Using a medium-taupe thread, machine quilt diagonal lines across the quilt in both directions so that the stitching lines run through the corners of every square and extend across the border—this creates an X-shape from corner to corner across each individual square and a handsome diagonal grid over the patchwork.

Trim the edges of the backing and batting so that they align with the patchwork top. Then cut the binding on the bias and sew it on around the edge of the quilt (see page 167).

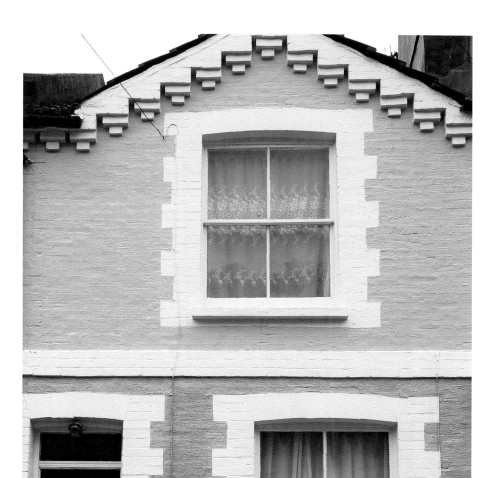

The Caribbean pink/blue combo on this house in Hastings echoes the shapes in our Chimney Sweep quilt.

TWINKLE THROW

As we progressed on this book—me in London, Liza in Pennsylvania—Liza would e-mail me ideas, some of which I'd get and enthuse about right away and others, like this, about which I had some doubt. I've learned to wait and see when I sense her excitement about an idea because it often works better than I could imagine.

Liza had been to see a collection of antique quilts in New York with friends, and they were all drawn to one made up of hundreds of tiny star blocks. When they got back to her studio they decided to re-create the quilt from scraps of our Indian stripes. The result was this throw, which could, of course, be transformed into a full-size quilt—I always hope our readers will go on to do their own version of what we have started on these pages. What a delicious way to play with my stripe collection. Make them into these little stars and float them in a solid "sky." I love the way some blast out while others sink back almost obscured. Liza's friends have created a real twinkling effect.

I'm not sure what the antique version was like, but I'm betting it was in calico—you could do so many variations on this simple theme. How different a chalky blue or pearly gray would look as a base, soft and neutral, letting all those star colors glow. Or a dusty pink. On the other hand, a burnt red would suit some passionate souls and would make the colors glow in a very different way.

The old fish crates with their battered streaks of color made a great setting for our quilt. We told the fisherman who owned them that we found them very beautiful. He fixed us with a stern eye and responded, "They'd be more beautiful if they were full of fish!"

FINISHED SIZE

47" x 63" (119.4 cm x 160 cm)

MATERIALS

Use the specified 42–44"- (112–114-cm-) wide fine-weight Kaffe Fassett *Shot Cotton* and *Woven Stripes* for the patchwork, and use an ordinary printed quilting-weight cotton fabric for the backing.

PATCHWORK FABRICS

Solid background fabric: 2 yd (1.9 m) of *Shot Cotton* in Moor

Striped star fabrics: An assortment of scraps of Kaffe Fassett *Woven Stripes* in different stripe widths and colors

OTHER INGREDIENTS

Backing fabric: 3 yd (2.8 m) of desired printed quilting fabric

Binding fabric: 1/2 yd (50 cm) extra of *Shot Cotton* in Moor

Thin cotton batting: 54" x 70" (135 cm x 175 cm)

Quilting thread: Medium-dark wine-colored thread

Templates: Use templates A, B, C, D, and E (see page 168)

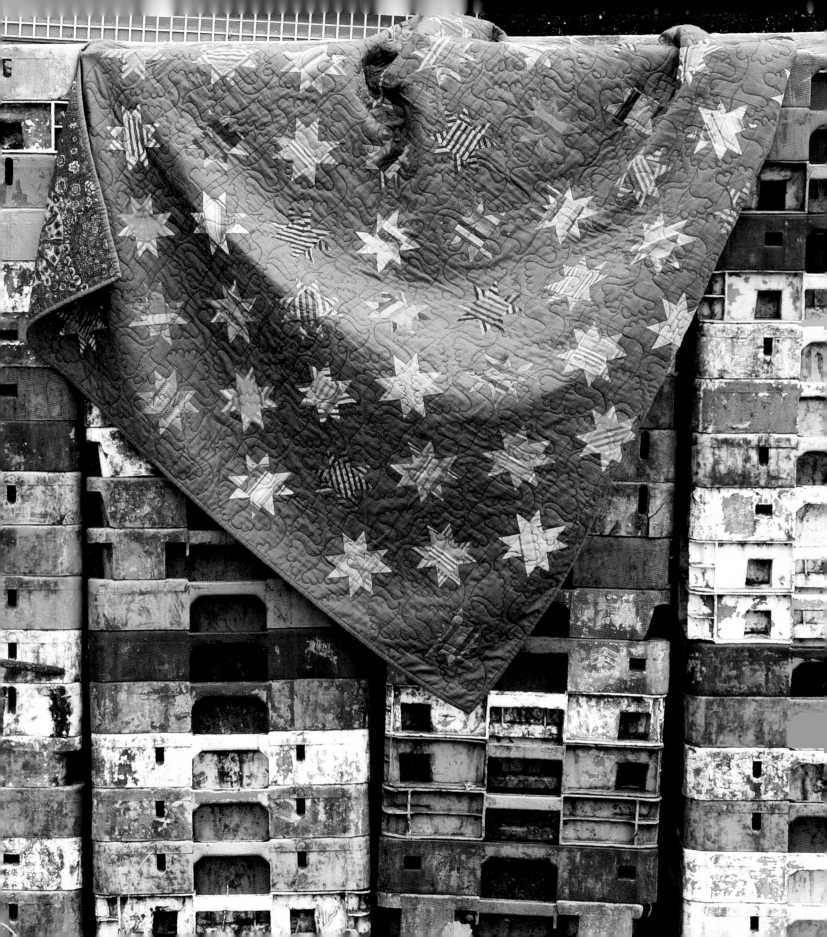

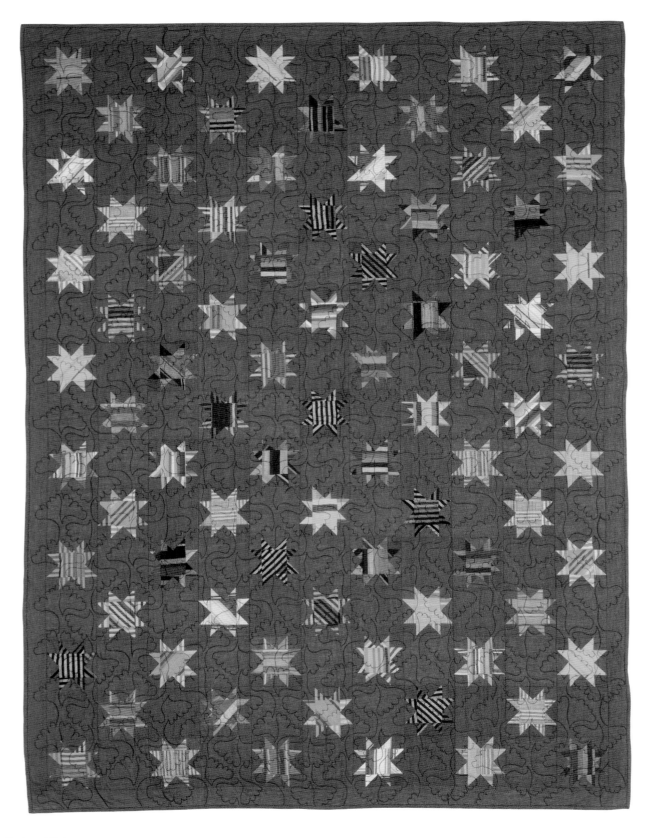

TIPS

This quilt is designed as a throw, but it can also be used as a baby quilt. To make a full-size quilt to fit your bed, simply add more blocks. If you do change the size of the quilt, recalculate the lengths of the border strips so you can cut them first.

CUTTING PATCHES

Press and starch the patchwork fabrics before cutting. (Read page 163 for more information about preparing *Shot Cotton* and *Woven Stripes* for your patchwork project.)

Cut the border pieces first so you can use the remaining solid background fabric for the background patches in the blocks at the center of the quilt.

BORDER AND BACKGROUND PIECES

4 border strips: From the solid background fabric (Moor), cut two strips each 2″ by 60 1/2″ (5.1 cm by 153.7 cm) for the side borders, and two strips each 2″ by 47 1/2″ (5.1 cm by 120.7 cm) for the top and bottom borders.

82 large background squares: From the solid background fabric, cut 82 Template-E squares.

332 background triangles: From the solid background fabric, cut 332 Template-C triangles (4 for each of the 83 Star Blocks).

332 tiny background squares: From the solid background fabric, cut 332 Template-D squares (4 for each of the 83 Star Blocks).

STAR-BLOCK PATCHES

83 large squares: From the assortment of striped star fabrics, cut 83 Template-A squares (one for each block). Be sure to reserve enough of each striped fabric to cut four matching star points for each square. For variety, cut some of the squares on the bias so these star blocks will have diagonal stripes.

83 sets of 4 matching triangles: From the striped star fabrics, cut a set of four matching Template-B triangles for each of the 83 blocks—a total of 332 triangles. Align one short side of the triangle with the stripes when cutting these triangles. Pin each set of striped star points to its matching striped star square.

MAKING BLOCKS

Make the blocks using a 1/4″ (6-mm) seam allowance (the allowance marked on the templates).

83 blocks: For each block, select a striped square with its four large matching striped Template-B triangles. For the block background, you will need four tiny background squares and four background triangles. Following the block diagram on page 45, sew together the block borders, then sew the borders to the striped center in the order indicated. Pay no attention to the direction of the stripes on the pieces. Make a total of 83 blocks.

Assembly

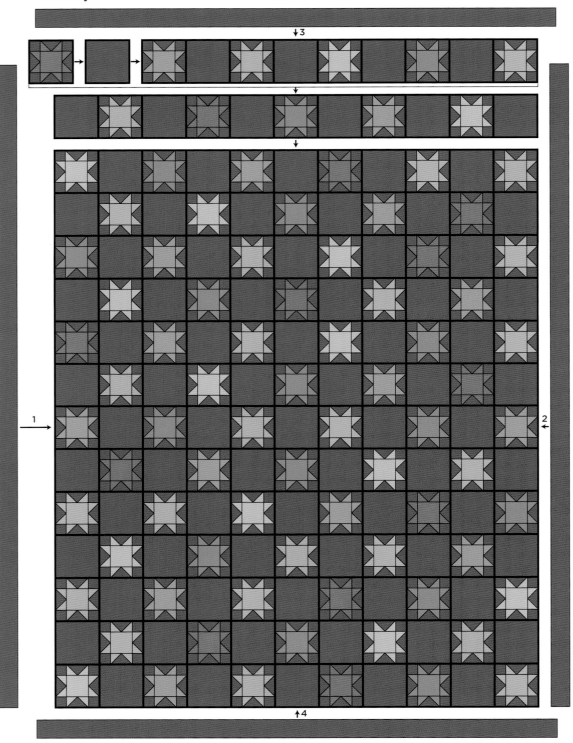

KEY

solid background fabric striped star fabrics

Star Block

4" (10.2 cm) square
(finished size excluding
seam allowance)

ASSEMBLING TOP

Arrange the blocks, either laying them out on the floor or sticking them to a cotton-flannel design wall. Following the assembly diagram, arrange the blocks and large background squares in 15 rows of 11 blocks each. Alternate the blocks and squares as shown.

Rearrange the blocks if necessary, until you are satisfied that the colors are well mixed.

Using a 1/4" (6-mm) seam allowance, sew the blocks and squares together in horizontal rows. Then sew the horizontal rows together.

Sew the longer border strips to the sides of the quilt, then sew the shorter border strips to the top and bottom.

FINISHING QUILT

Press the quilt top. Layer the quilt top, batting, and backing, then baste the layers together (see page 167).

Using a medium-dark wine-colored thread, machine quilt meandering lines across the entire quilt top.

Trim the edges of the backing and batting so that they align with the patchwork top. Then cut the binding on the bias and sew it on around the edge of the quilt (see page 167).

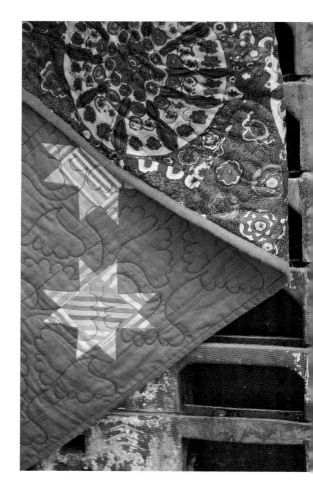

STRIPED BASKETS

I spotted the layout for this quilt in a vintage quilt book. The quilt in the book used paisleys, plaids, and stripes for the baskets, with solids or two-toned mono prints for the backgrounds. I felt my stripes would be good for the baskets, with jewel-toned shots in the backgrounds. Almost my entire stripe collection has gone into my rendition here. The diagonal placement of the stripes was purely accidental—when I cut squares from corner to corner to create my triangles I ended up with diagonals. They added a delicious vigor to the work so I kept them, being careful to place them randomly in different directions.

My stripes create a very rich palette. They make quite an extroverted quilt that would be gorgeous in a Victorian-style room with strong wallpaper and a carved mahogany bedstead. For a fresher, light feel, you could use old shirt stripes, with a base of cream or white for each one, and pearly gray and faded pastels for the backgrounds. Or keep the palette bright, with a definite color slant such as mostly red or blue tones.

FINISHED SIZE

74" x 95" (188 cm x 241 cm)

MATERIALS

Use the specified 42–44"- (112–114-cm-) wide fine-weight Kaffe Fassett *Shot Cottons* and *Woven Stripes* for the patchwork, and use an ordinary printed quilting-weight cotton fabric for the backing.

PATCHWORK FABRICS

Edging-triangle fabric: 1 1/8 yd (1.1 m) of *Shot Cotton* in Moor

Stripe fabrics: 3/4 yd (70 cm) each of the following 10 stripes—*Broad Stripe* in Earth and in Sunset; *Alternating Stripe* in Olive and in Red; *Narrow Stripe* in Dusk, Yellow, and Blue; *Exotic Stripe* in Purple and in Dark; *Caterpillar Stripe* in Tomato

Solid fabrics: 3/8 yd (40 cm) each of the following 12 solids—*Shot Cotton* in Scarlet, Sunshine, Watermelon, Mushroom, Bronze, Chartreuse, Cactus, Sprout, Lilac, Honeydew, Granite, and Aqua

OTHER INGREDIENTS

Backing fabric: 6 yd (5.5 m) of desired printed quilting fabric

Binding fabric: 3/4 yd (70 cm) of *Narrow Stripe* in Dark

TIPS

Many combinations of Kaffe's *Woven Stripes* and *Shot Cottons* would work well for this quilt—there is no need to follow the given formula exactly to get a great result. Because the stripes are woven, it doesn't matter which way they are cut as you can just flip them over for the opposite stripe direction.

CUTTING PATCHES

Press and starch the patchwork fabrics before cutting. (Read page 163 for more information about preparing *Shot Cotton* and *Woven Stripes* for your patchwork project.)

The quilt is made up of 111 blocks, and each block is made using one stripe fabric and one solid fabric. For every block, you will need: one large striped triangle (the "basket"), three small striped triangles (the "flowers") that match the "basket," and six small solid triangles (the block "background").

Thin cotton batting: 81" x 102" (205 cm x 260 cm)

Quilting thread: Medium-dark neutral-colored thread

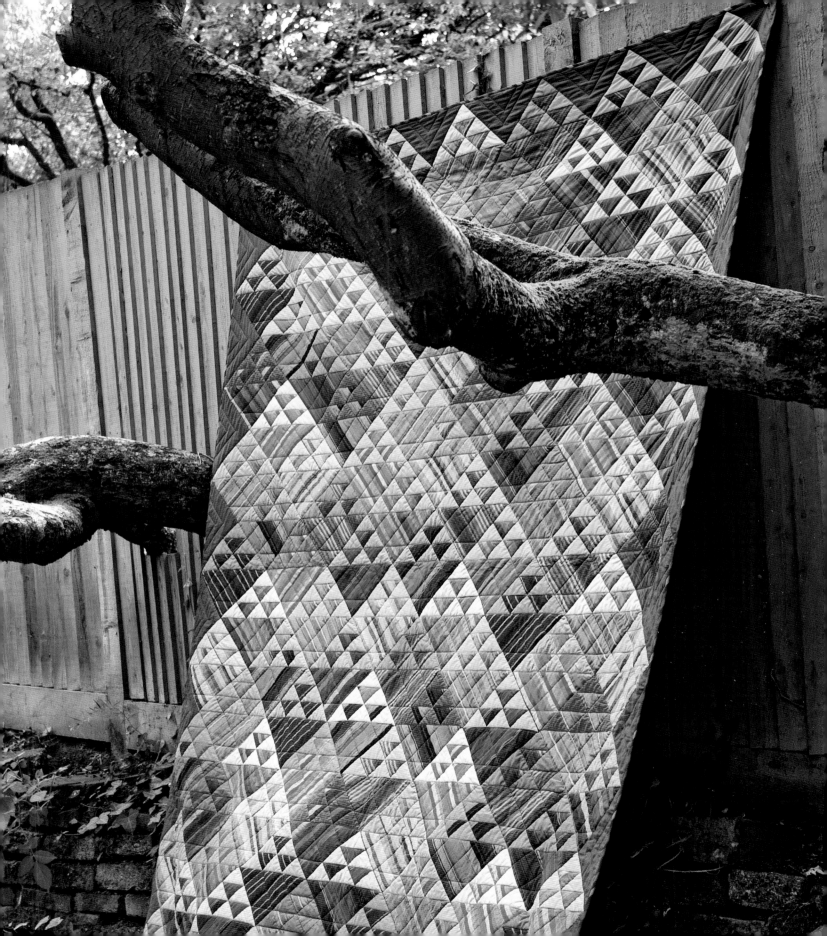

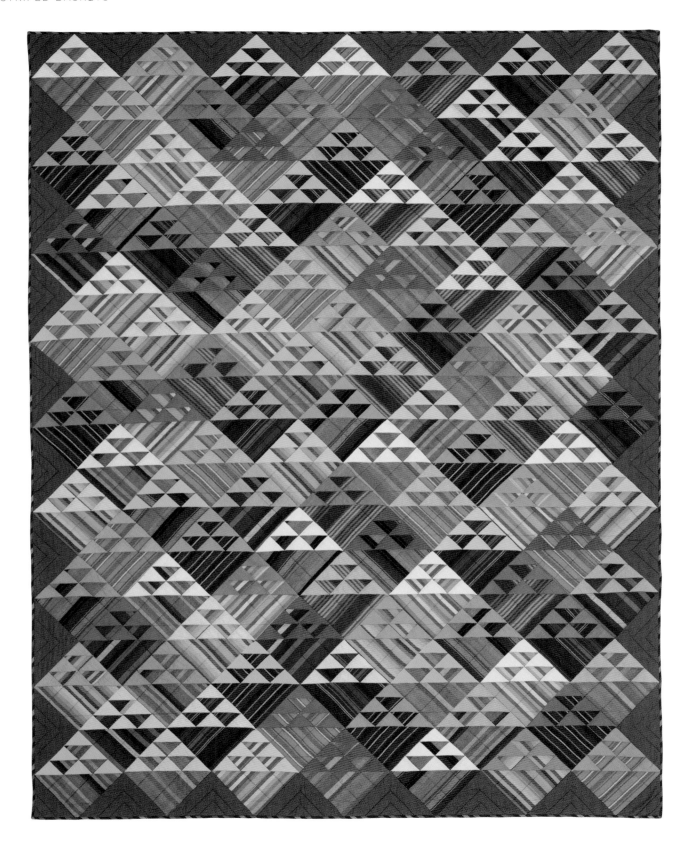

EDGING TRIANGLES

28 large edging triangles: From the edging-triangle fabric (Moor), cut seven squares 11 7/8″ by 11 7/8″ (30.2 cm by 30.2 cm) and cut each of them diagonally from corner to corner in both directions to make four quarter-square triangles—for a total of 28 large triangles.

4 small edging-corner triangles: From the edging-triangle fabric (Moor), cut two squares 6 1/8″ by 6 1/8″ (15.6 cm by 15.6 cm) and cut each of them diagonally from corner to corner to make two half-square triangles—for a total of 4 small triangles.

BLOCK PATCHES

111 large striped triangles ("baskets"): From each of the 10 striped fabrics, cut four, five, or six squares 8 3/8″ by 8 3/8″ (21.3 cm by 21.3 cm) and cut each of them diagonally from corner to corner to make two half-square triangles—you need a total of 111 large striped triangles (9–12 from each fabric). Do not rotary cut the pieces in layers; instead cut one square at a time so that you can make the stripes run as straight as possible parallel to the sides of the square.

333 small striped triangles ("flowers"): For each of the large striped triangles, cut a set of three small striped triangles from the same stripe fabric. To cut these triangles, cut squares 3 3/8″ by 3 3/8″ (8.6 cm by 8.6 cm) and cut each of them diagonally from corner to corner to make two half-square triangles. Cut 111 sets of three small striped triangles, and pin each set to its large triangle. Be sure to cut the squares as for the large striped triangles so that the stripes run as straight as possible parallel to the sides of the square.

666 small solid triangles ("background" pieces): From each of the 12 solid fabrics, cut 9–10 sets of six matching small triangles. To cut these triangles, cut squares 3 3/8″ by 3 3/8″ (8.6 cm by 8.6 cm) and cut each of them diagonally from corner to corner to make two half-square triangles. Cut a total of 111 sets of six matching solid triangles so you have a set for each block.

MAKING BLOCKS

Make the blocks using a 1/4″ (6-mm) seam allowance.

111 blocks: For each block, select a large striped triangle and its three small striped triangles, then select a set of six matching small solid triangles.

First, make three triangle squares as shown in the diagram on page 53, sewing together a small striped triangle and a small solid triangle for each triangle square. Then sew together the triangle squares and the remaining small solid triangles in diagonal rows as shown in the block diagram. Next, sew together the pieced diagonal rows, and lastly sew the pieced block top to the large striped triangle.

Make each of the 111 blocks in the same way, but making some blocks with the stripes all running up to the right in the same direction, others with the stripes all running up to the left in the other direction, a few with the "basket" stripes running in one direction and the "flower" stripes in the other, and a few with the stripes all running in random directions.

Assembly

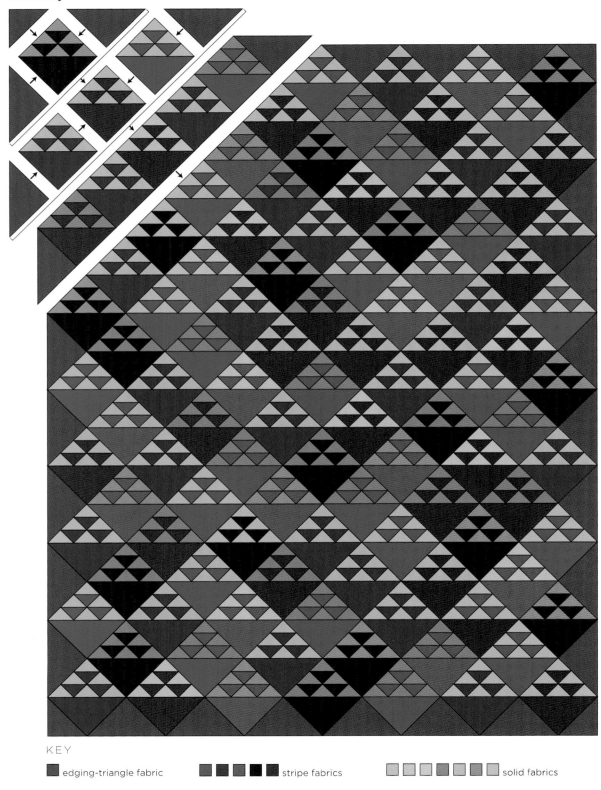

KEY

edging-triangle fabric ■■■■■ stripe fabrics ■■■■■■■ solid fabrics

Triangle Square

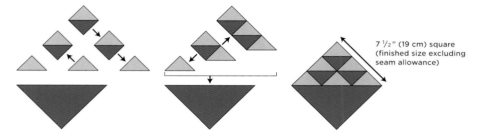

2 ¹/₂″ (6.3 cm) square
(finished size excluding
seam allowance)

Striped Baskets Block

7 ¹/₂″ (19 cm) square
(finished size excluding
seam allowance)

ASSEMBLING TOP

Arrange the blocks, either laying them out on the floor or sticking them to a cotton-flannel design wall. Following the assembly diagram, arrange the blocks "on point." Start by placing seven blocks across the top of the quilt, then place six blocks under these, nestling them into the zigzag spaces created by the first row. Continue like this, positioning horizontal rows of seven blocks and six blocks alternately until all the blocks are in place, ending with a seven block row. Position the large setting triangles along the sides and top and bottom of the quilt, then place one small corner triangle at each of the four edging corners.

Rearrange the blocks if necessary, until you are satisfied that the stripe colors are well mixed.

Using a ¹/₄″ (6-mm) seam allowance, sew the blocks together in diagonal rows as shown on the assembly diagram, beginning and ending each row with a setting triangle. Finally, sew all the pieced diagonal rows together.

FINISHING QUILT

Press the quilt top. Layer the quilt top, batting, and backing, then baste the layers together (see page 167).

Using a medium-dark neutral-colored thread, machine stitch in-the-ditch around each block, then stitch in-the-ditch along the edges of the small triangles, extending the quilting lines through the large triangles—this will create a diagonal grid covering the whole top. Inside each large edging triangle, stitch two equally spaced V-shapes with the sides of the "V" parallel to short sides of the triangle. Inside each small corner triangle, stitch two equally spaced straight lines that run parallel to the long side of the triangle.

Trim the edges of the backing and batting so that they align with the patchwork top. Then cut the binding on the bias and sew it on around the edge of the quilt (see page 167).

LONG DIAMONDS

When I produced my first knitting book, *Glorious Knits*, I included a drapey jacket with elongated diamonds to give the illusion of length. I used this layout for a quilt in my last book, *Simple Shapes Spectacular Quilts*. With that version we forgot to separate dark and light sections of the string piecing so we ended up with solid dark diamonds on a light ground.

In this interpretation we separated the dark and light half-diamonds and alternated them. The light airy sides of the diamonds are made up of just four shades of soft-toned shot cottons. These frame and isolate the striped sections, allowing the strings of stripes to dazzle us with their rich toning. By grouping together cool blue stripes, then warm rusty red-gold ones, we achieved a complex, exciting effect. Sometimes I use warm- and cool-toned stripes together for even more richness, but here I combined the stripes in color groups to create a varied effect. Against all that color I restricted myself to only the grayest, softest of shot cottons for a neutral base to set off all the vibrating tones of the stripes.

FINISHED SIZE

72" x 72" (182.9 cm x 182.9 cm)

MATERIALS

Use the specified 42–44"- (112–114-cm-) wide fine-weight Kaffe Fassett *Shot Cottons* and *Woven Stripes* for the patchwork, and use an ordinary printed quilting-weight cotton fabric for the backing.

PATCHWORK FABRICS

Border fabric: 3 yd (2.8 m) of *Caterpillar Stripe* in Dark

Solid fabrics (lights): A total of 3 yd (2.8 m) of at least four light-toned *Shot Cotton* fabrics—those on the quilt pictured are Aqua, Latte, Galvanized, and Sandstone, another good choice to add in is Artemisia

Stripe fabrics (darks): 1/3 yd (35 cm) of each of 16–20 different *Woven Stripes*

OTHER INGREDIENTS

Backing fabric: 5 yd (4.6 m) of desired printed quilting fabric

Binding fabric: Use left-over *Caterpillar Stripe* in Dark

Thin cotton batting: 79" x 79" (200 cm x 200 cm)

Quilting thread: Medium-gray thread

TIPS

This is a "string" quilt—a quilt in which long "strings" (strips) of fabric are sewn together before the patches are cut out. For this reason, fabric amounts for the solid and striped fabrics are approximate.

PREPARING STRING-PIECED FABRICS

Press and starch the patchwork fabrics before cutting. (Read page 163 for more information about preparing *Shot Cotton* and *Woven Stripes* for your patchwork project.)

All the big triangle patches for the quilt top are cut from string-pieced fabrics. Preparing the fabrics takes time, and you will get the best results if you don't rush. Note that the prepared string-pieced rectangles are bigger than necessary, so you don't need to line up the strips precisely at the ends when

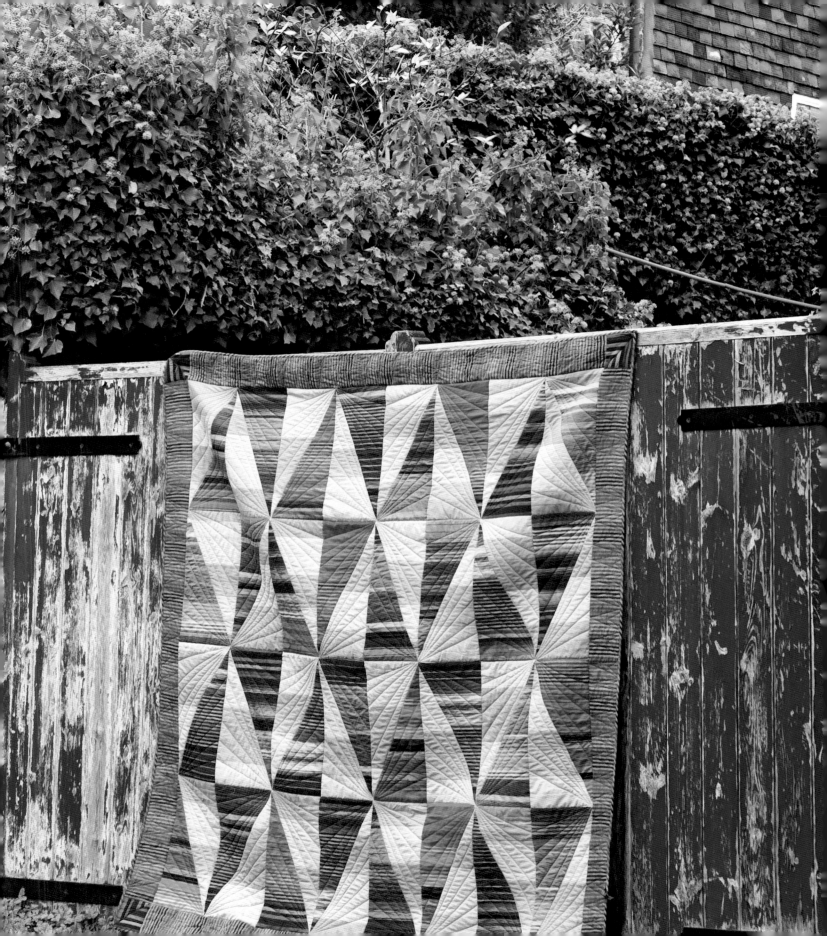

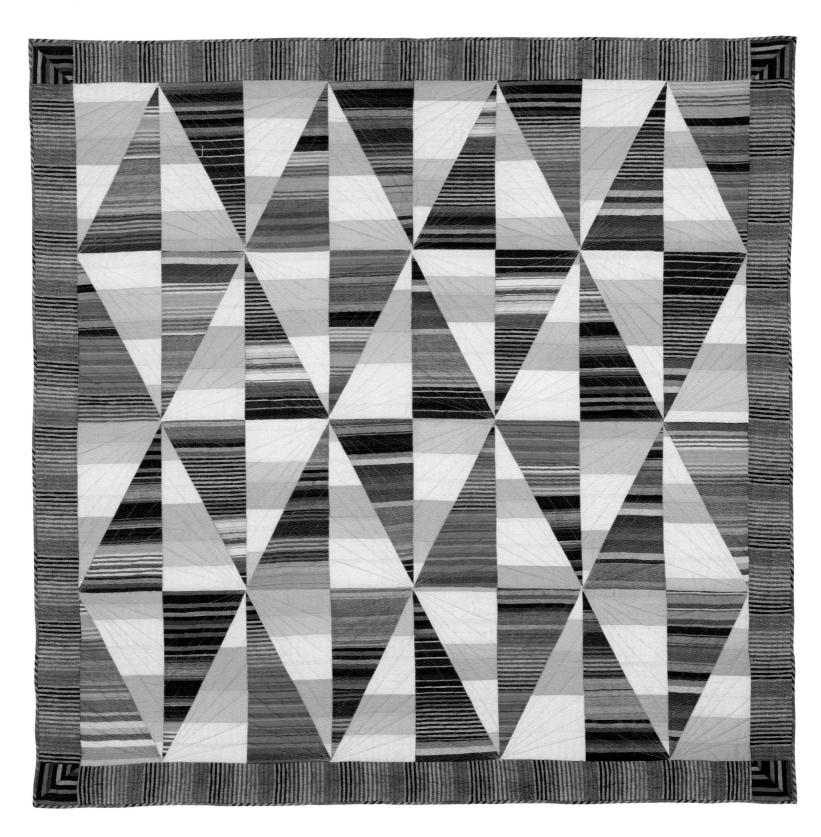

stitching them together—there is more than 2″ (5 cm) extra both widthwise and lengthwise in each string-pieced rectangle; they will be trimmed after they are completed.

CUTTING BORDER PIECES

Before starting the string-piecing, cut the border pieces first so that you can use the left-over stripes in the string-pieced fabrics.

4 border strips: From the border fabric (*Caterpillar Stripe* in Dark), cut seven strips 4 1/2″ (11.4 cm) wide from selvage to selvage. Trim off the selvages and sew these strips together end to end. Then cut four strips each 4 1/2″ by 64 1/2″ (11.4 cm by 163.8 cm) from this pieced strip.

8 corner border-triangles: From another one of the stripe fabrics, cut four squares 4 7/8″ by 4 7/8″ (12.4 cm by 12.4 cm) and cut each of them diagonally from corner to corner to make two half-square triangles—for a total of eight triangles.

CUTTING AND SORTING STRIPES AND SOLIDS

Cut all the solid and stripe fabrics into strips 11″ (28 cm) long and in random widths—from 1 1/2″ to 4 1/2″ (3.8 cm to 11.4 cm) wide. Be sure to cut the stripe fabrics so the stripes run lengthwise along the strips (parallel to the long edges) and cut random widths from each fabric.

PIECING STRIPS INTO 32 RECTANGLES

16 solid-fabric string-pieced rectangles: Using a 1/4″ (6-mm) seam allowance and stitching along the long edges of the strips, sew together random strips of the solids to make a sheet of fabric approximately 11″ (28 cm) wide (the length of the strips) by at least 20″ (51 cm) long. Make 16 large solid-fabric string-pieced rectangles like this.

16 stripe-fabric string-pieced rectangles: Before piecing the striped strips, sort them into 16 color-groups—for example, red groups, green groups, orange groups, blue groups. These are only guidelines as the fabrics are multicolored and the groups will not look totally a single color. Each group will be sewn together to make a new "fabric," so take your time in selecting the strips for each group. Some colors can be used in two groups, but keep the overall look of the four groups predominantly reds, greens, oranges, and blues. For variety, mix colors in some groups (see photo of quilt). Make a total of 16 groups—one group for each pieced rectangle.

Using a 1/4″ (6-mm) seam allowance throughout and stitching along the long edges of the strips, sew together the strips of the stripes in one group to make a sheet of fabric approximately 11″ (28 cm) wide (the length of the strips) by at least 20″ (51 cm) long. Make 16 large stripe-fabric string-pieced rectangles like this, one from each color group.

PRESSING AND STARCHING

Press all the seams open on each of the 32 pieced rectangles. Then starch the sheets with a strong starch to make the fabric as stiff as possible and press

Assembly

KEY

pieced stripe fabrics pieced solid fabrics border fabric

again. Many of the seams on this quilt are sewn along the slanting edges, so it is important to use a strong starch and to make an effort to keep the pieced rectangles and the cut pieces flat until they are all sewed together.

TRIMMING RECTANGLES

Trim all the 32 starched rectangles to measure exactly 8 5/8" (21.9 cm) wide by 17 1/4" (43.8 cm) long.

CUTTING PATCHES

32 solid-fabric triangles: Cut eight of the 8 5/8"-by-17 1/4" (21.9-cm-by-43.8-cm) solid-fabric rectangles from corner to corner diagonally as shown in the first cutting diagram; then cut the remaining eight from corner to corner diagonally in the *opposite direction* as shown in the second cutting diagram—for a total of 32 large solid-fabric string-pieced triangles.

32 stripe-fabric triangles: Cut eight of the 8 5/8"-by-17 1/4" (21.9-cm-by-43.8-cm) stripe-fabric rectangles from corner to corner diagonally as shown in the first cutting diagram; then cut the remaining eight from corner to corner diagonally in the *opposite direction* as shown in the second cutting diagram—for a total of 32 large stripe-fabric string-pieced triangles.

ASSEMBLING TOP

Arrange the quilt center as shown on the assembly diagram, either laying out the patches on the floor or sticking them to a cotton-flannel design wall. Position the pieces so that there are alternating solid-fabric and stripe-fabric triangles. Aim for a good mix of colors.

Using a 1/4" (6-mm) seam allowance throughout, sew the triangle patches together in pairs to form eight rectangles across each of the four horizontal rows, then sew together the rectangles in each horizontal row. Lastly, sew the four horizontal rows together.

Sew two of the borders to the sides of the quilt center. Sew four pairs of two border-triangles together to form four squares, then sew one square to each end of each of the two remaining borders. Sew these borders to the top and bottom of the quilt.

FINISHING QUILT

Press the quilt top. Layer the quilt top, batting, and backing, then baste the layers together (see page 167).

Using a medium-gray thread, machine quilt in-the-ditch around the triangles. Then quilt each large triangle with five diagonal lines of stitching, each starting at the same corner (the angle on the short edge of the triangle opposite the 90-degree angle) and radiating out from this corner across the longest edge of the triangle (see right). Quilt zigzags in the borders.

Trim the edges of the backing and batting so that they align with the patchwork top. Then sew a binding on around the edge of the quilt (see page 167).

Cutting String-Pieced Rectangles

17 1/4" (43.8 cm)

8 5/8" (21.9 cm)

Cut eight solid-fabric string-pieced rectangles and eight stripe-fabric string-pieced rectangles like this.

17 1/4" (43.8 cm)

8 5/8" (21.9 cm)

Cut eight solid-fabric string-pieced rectangles and eight stripe-fabric string-pieced rectangles like this.

JAPANESE RAGS

The antique patched household textiles and work clothes from Japan are a never-ending source of ideas for me. I have a few books on them and have collected some fragments of the patched pieces. They are usually all indigo-dyed fabrics or blue and white with the occasional beige tone. For this hanging, I went for my deepest cobalts, turquoises, and burgundy tones, with some multitoned dark stripes. The secret was to keep any light tones out as they jumped and distracted from the deep cold pools of the color mood here. I wanted the whole piece to feel as if it were being seen in moonlight or deep underwater. Most of the fabrics are my own, but I've included a few Oakshott tonal stripes with dusty deep hues for a rich complexity.

FINISHED SIZE

33 1/2" x 52" (85 cm x 132 cm)

MATERIALS

Use the specified 42–44"- (112–114-cm-) wide fine-weight Kaffe Fassett *Shot Cottons* and *Woven Stripes* and Oakshott Fabrics *Longshott Stripes* for the patchwork.

PATCHWORK FABRICS

The stripes run lenthwise on the hanging so you will need lengths up to 3/4 yd (70 cm) long of a few of the stripe fabrics—the ones that you want to dominate the composition.

Solid fabrics: Scraps or 1/4 yd (30 cm) of *Shot Cotton* in each of the following five colors—Cobalt, Thunder, Bronze, Aegean, and Eucalyptus

Kaffe Fassett Stripe fabrics: Scraps or up to 3/4 yd (70 cm) of each of the following six stripes—*Exotic Stripe* in Dark; *Broad Stripe* in Blue and in Dark; *Caterpillar Stripe* in Blue and in Dark; and *Narrow Stripe* in Dark

Oakshott stripe fabrics: Scraps or up to 3/4 yd (70 cm) of *Longshott Stripe* in each of the following five colors—Chives, Purple Haze, Sage, Rosea, and Holly

OTHER INGREDIENTS

Lightweight fusible adhesive web (optional): Enough paper-backed fusible adhesive web to cover the backs of all the patches, large and small

Foundation fabric: 1 5/8 yd (1.5 cm) of Kaffe Fassett *Shirt Stripes* in Cobalt

Quilting thread: Medium-taupe thread—use a 30-weight cotton thread, a size-12 pearl cotton, or embroidery floss

TIPS

The technique used for this hanging creates a surface texture that imitates Japanese antique patched textiles. All the patches are laid directly onto a foundation fabric that serves as the backing—there is no batting between the layers. The quilting holds the overlapping raw-edged patches in place.

CUTTING AND ARRANGING PATCHES

Wash and press the patchwork fabrics before cutting. Do not starch, so the fabric remains flexible and easy to hand quilt with thick thread.

The instructions that follow are guidelines for how to approach the technique, rather than how to exactly duplicate the original. The size on the diagram on page 61 is the size of the finished hanging in the photograph, but you can adjust the size as desired. The patches on the diagram are there to give you an idea of how they should vary in size and overlap at random.

Start by cutting the selvages off the foundation fabric. Lightly draw an outline 33 1/2" by 52" (85 cm by 132 cm)—or the desired finished size—on the wrong side of the fabric. The foundation fabric should be at least 2" (5 cm) larger all around than the desired finished hanging size.

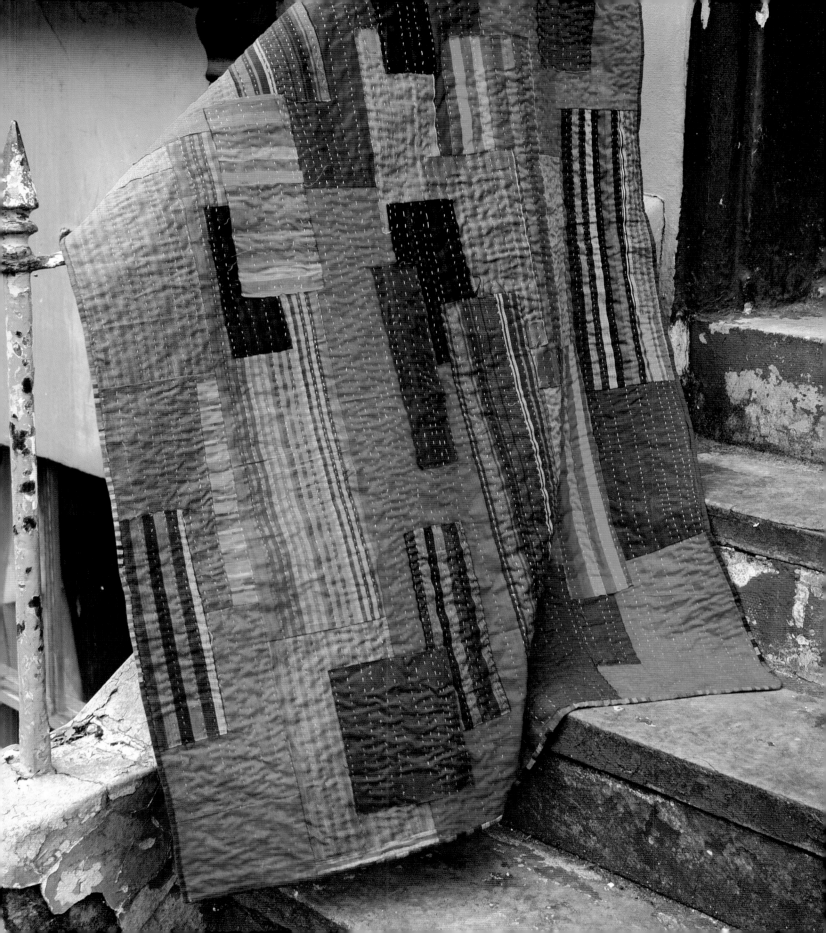

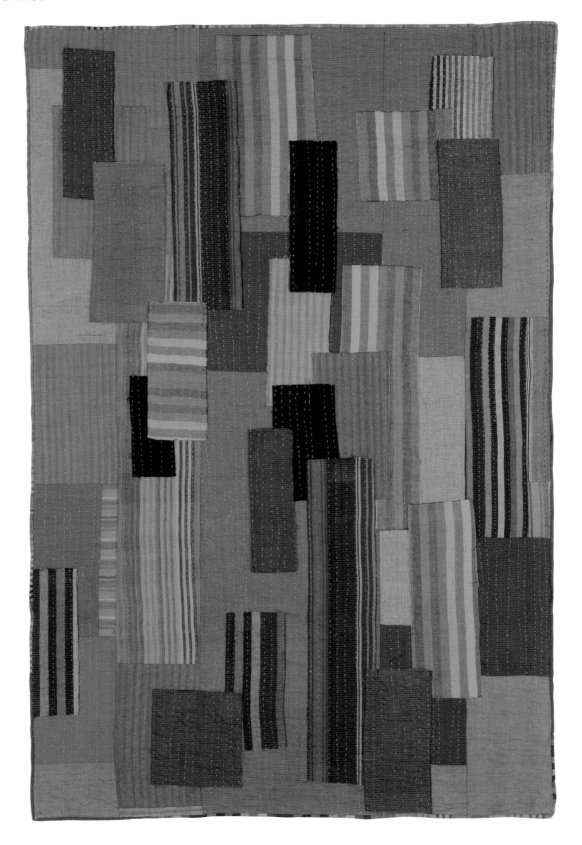

Next cut random-size patches—you can see from the diagram that some of the patches laid down first are very large and are overlapped by smaller patches. If desired, you can back each patch with fusible adhesive web, then remove the paper backing. (The fusible adhesive is optional—it can be used to hold the pieces temporarily in place as you baste your final arrangement.)

As you cut the patches, lay them face up on the wrong side of the foundation fabric, arranging them so that they overlap one another; they should also overlap the outline by at least 1 1/2" (4 cm). The edges will be trimmed later, so the pieces do not have to be positioned perfectly around the edges.

When you have achieved the final arrangement, "pin baste" the layers, or if you have backed the patches with adhesive web, press the arrangement lightly to fuse the patches in place temporarily.

Next, baste the raw-edged patches firmly in place with basting thread (see page 167) or using safety pins to "pin baste" every 2" to 4" (5 cm to 10 cm).

FINISHING HANGING

Using a thick thread as suggested in the Materials, hand quilt the layers together. First, sew a vertical line of stitching from top to bottom down the center of the quilt, taking long and even stitches. Working from the center outward, sew parallel vertical lines of stitching about 1/2" (12 mm) apart to cover the entire hanging.

Remove the basting threads when the quilting is complete.

Trim the edges of the backing and patchwork top to create straight edges and so that the hanging measures the desired finished size. Piece together left-over scraps of the patchwork fabrics to make the binding fabric and cut the binding on the bias. Sew the binding on around the edge of the hanging (see page 167).

Patch Arrangement

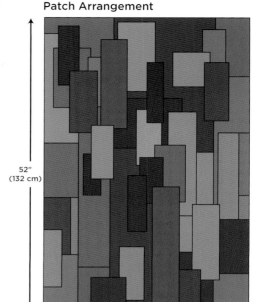

52"
(132 cm)

33 1/2"
(85 cm)

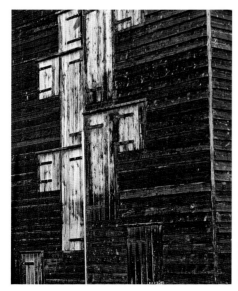

Left to right: Doors on the net-drying sheds in Hastings. A Japanese antique patched worker's coat. A detail of my hanging.

LADY OF THE LAKE

Such a quaint name for this traditional quilt pattern. I've long wanted to use it and was delighted when Liza started on this very chalky toned version. Before finishing it we both decided it was too blah to go in our book and, uncharacteristically, we gave up and dumped the blocks in a drawer. Later I took them out and said to myself, There must be some way these handsome colors can work. My idea: instead of trying to wring colorfulness out of them, why not play to their subdued quality and add more gray? Success! The sashing with the two-toned cornerstones made those chalky colors sing.

FINISHED SIZE

82" x 82" (208.3 cm x 208.3 cm)

MATERIALS

Use the specified 42–44"- (112–114-cm-) wide fine-weight Kaffe Fassett *Shot Cottons* for the patchwork, and use an ordinary printed quilting-weight cotton fabric for the backing.

PATCHWORK FABRICS

Sashing fabric: 2 1/2 yd (2.3 m) of *Shot Cotton* in Galvanized

Dark sashing-triangle fabric: 1/2 yd (50 cm) of *Shot Cotton* in Steel

Light triangle fabric: 1 3/4 yd (1.6 m) of *Shot Cotton* in Ecru

Colored block fabrics: 3/4 yd (70 cm) of *Shot Cotton* in each of the following nine colors—Eucalyptus, Spruce, Blueberry, Curry, Moss, Pea Soup, Granite, Tobacco, and Bronze

OTHER INGREDIENTS

Backing fabric: 7 1/2 yd (6.9 m) of desired printed quilting fabric

Binding fabric: 3/4 yd (70 cm) extra of *Shot Cotton* in Galvanized

Thin cotton batting: 89" x 89" (225 cm x 225 cm)

Quilting thread: Medium-gray thread

TIPS

A contemporary take on the traditional Lady of the Lake pattern, this quilt is good practice for making crisp "triangle squares"—little blocks made up of two contrasting triangles. Once you get in the swing, you will be able to speedily chain stitch these little blocks (see page 166).

CUTTING PATCHES

Press and starch the patchwork fabrics before cutting. (Read page 163 for more information about preparing *Shot Cotton* for your patchwork project.)

After cutting the sashing patches, keep them in a pile, separate from the block patches. Pin each set of block patches together as you cut them.

SASHING PATCHES

144 sashing rectangles: From the sashing fabric (Galvanized), cut 144 rectangles 2 1/2" by 8 1/2" (6.4 cm by 21.6 cm). When cutting the rectangles, cut them so that the long side runs parallel to the selvage—this is the most frugal way to cut the rectangles.

81 dark sashing triangles: From the dark sashing-triangle fabric (Steel), cut 41 squares 2 7/8" by 2 7/8" (7.3 cm by 7.3 cm) and cut each of them diagonally from corner to corner to make two half-square triangles—for a total of 82. You need only 81 dark triangles, so discard one.

81 light triangles: From the light triangle fabric (Ecru), cut 41 squares 2 7/8" by 2 7/8" (7.3 cm by 7.3 cm) and cut each of them diagonally from corner to corner to make two half-square triangles—for a total of 82. You need only 81 light triangles, so discard one.

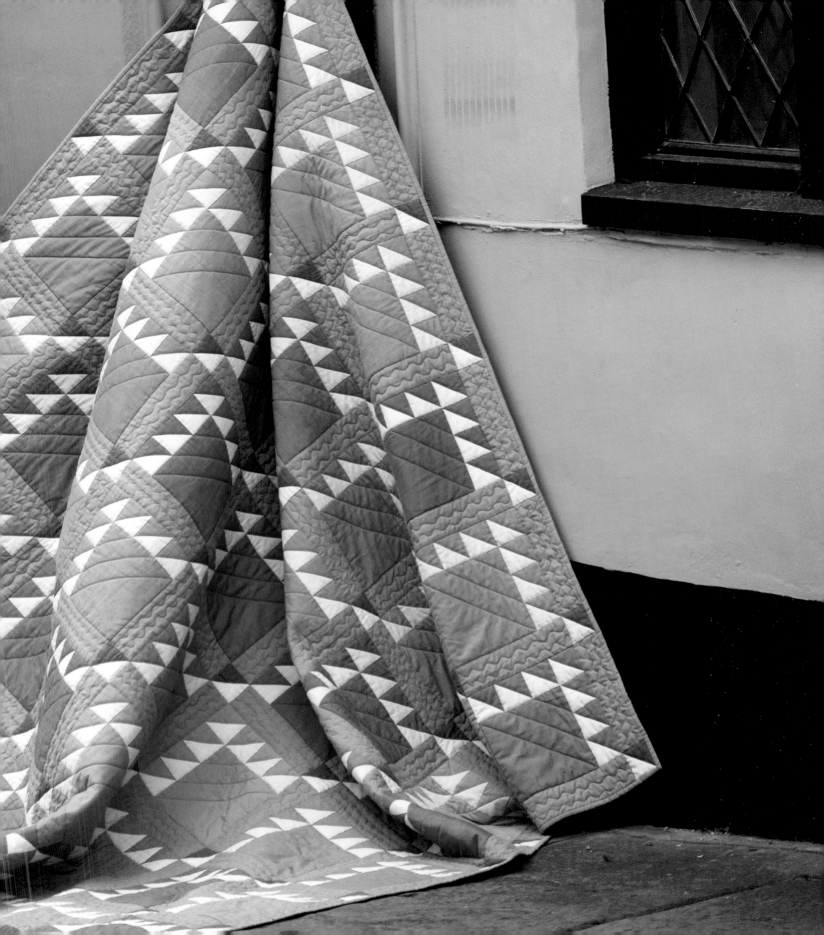

BLOCK PATCHES

Each block is made up of one large colored square, and seven triangle squares each consisting of one light and one colored triangle.

64 large colored squares: From the colored block fabrics, cut a total of 64 squares 6 1/2″ by 6 1/2″ (16.5 cm by 16.5 cm)—seven from Eucalyptus, eight from Spruce, eight from Blueberry, seven from Curry, seven from Moss, six from Pea Soup, seven from Granite, seven from Tobacco, and seven from Bronze.

64 sets of 7 matching colored triangles: For each of the 64 blocks, cut a set of seven triangles from the same colored block fabric. To cut the triangles, cut squares 2 7/8″ by 2 7/8″ (7.3 cm by 7.3 cm) and cut each of these diagonally from corner to corner to make two half-square triangles. Four squares makes eight triangles, so cut four squares for each block square and reserve the left-over triangle for another block of the same color. Pin seven matching triangles to each large square as you cut them.

448 light triangles: From the light triangle fabric (Ecru), cut 224 squares 2 7/8″ by 2 7/8″ (7.3 cm by 7.3 cm) and cut each of them diagonally from corner to corner to make two half-square triangles—for a total of 448 light triangles. Pin seven light triangles to each of the large squares.

MAKING BLOCKS

Make the blocks using a 1/4″ (6-mm) seam allowance.

64 blocks: For each block, you will need the large colored square, the seven matching triangles, and seven light triangles.

First make seven triangle squares as shown in the diagram, sewing together one colored triangle and one light (Ecru) triangle for each triangle square.

Triangle Square

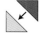

2″ (5.1 cm) square (finished size excluding seam allowance)

Then sew together three pieced triangle squares to fit across the top of the large square, and four pieced triangle squares to fit down the side of the large square, as shown in the block diagram. Make sure the light triangles all point in the direction shown in the diagram—they sit upright like little sails.

Next, sew the short row of triangle squares to the top of the large square and then the longer row to the side. Make each of the 64 blocks in the same way.

Lady of the Lake Block

8″ (20.4 cm) square (finished size excluding seam allowance)

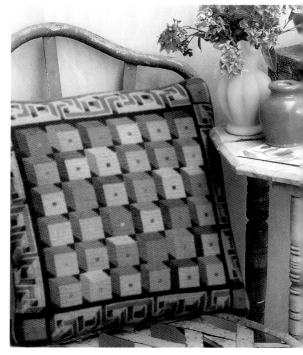

This needlepoint cushion was inspired by a Roman mosaic but contains a similar color story as Lady of the Lake.

Assembly

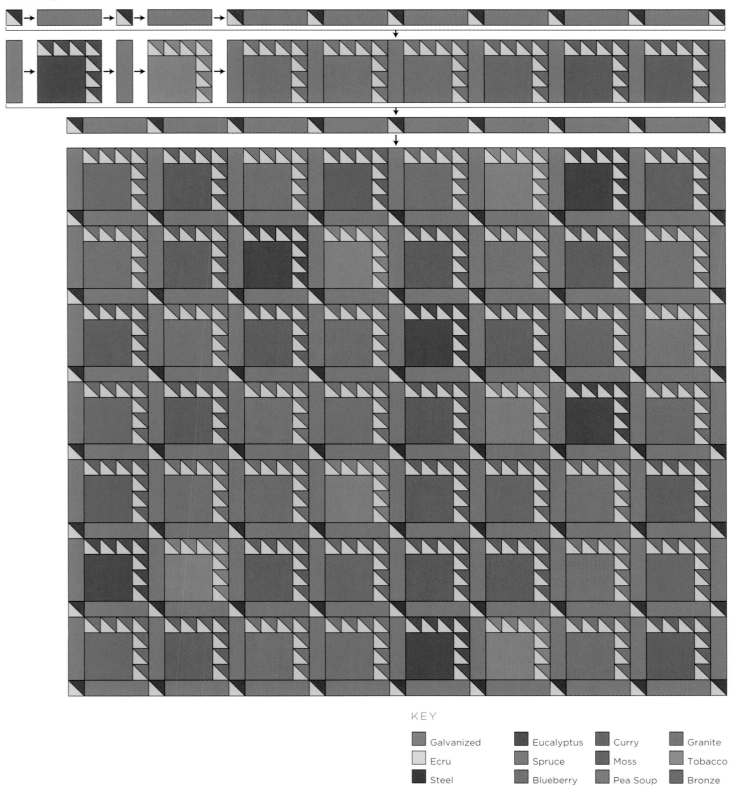

KEY

Galvanized Eucalyptus Curry Granite

Ecru Spruce Moss Tobacco

Steel Blueberry Pea Soup Bronze

MAKING HORIZONTAL SASHING

Make the long sashing strips using a 1/4" (6-mm) seam allowance.

9 horizontal sashing strips: First, make 81 triangle squares, sewing together one light (Ecru) triangle and one dark (Steel) triangle for each triangle square. (Make these as you made the triangle squares for the blocks.)

Then sew together nine triangle squares (cornerstones) and eight sashing rectangles for each horizontal sashing strip, alternating the squares and rectangles and starting and ending with a triangle square (see assembly diagram). Make a total of nine horizontal sashing strips.

ASSEMBLING TOP

Arrange the blocks, either laying them out on the floor or sticking them to a cotton-flannel design wall. Following the assembly diagram, arrange the blocks in eight horizontal rows of eight blocks each, leaving room for the sashing. Arrange the blocks at random or follow the placements in the assembly diagram.

Then place the vertical sashing rectangles between the blocks along the horizontal rows and one at each end of the rows. Next, arrange the horizontal sashing strips, placing them between the horizontal rows of blocks and positioning one across the top and one across the bottom of the quilt.

Using a 1/4" (6-mm) seam allowance, sew the blocks and vertical sashing rectangles together in horizontal rows as shown on the assembly diagram. Then sew together the horizontal block rows and the horizontal sashing strips.

FINISHING QUILT

Press the quilt top. Layer the quilt top, batting, and backing, then baste the layers together (see page 167).

Using a medium-gray thread, machine quilt in-the-ditch between all the small triangles and stitch diagonal lines through the large squares. Machine quilt two parallel wavy lines along the length of each sashing rectangle.

Trim the edges of the backing and batting so that they align with the patchwork top. Then cut the binding on the bias and sew it on around the edge of the quilt (see page 167).

The multi-tones of Hastings row houses that so attracted me to the town—a veritable patchwork like our Lady of the Lake.

AFRICAN COLLAGE

When I was visiting South Africa some years ago, I was struck by the many brilliant and amusing uses of recycled material in the arts and crafts there. Whole townships looked like three-dimensional patchwork quilts, with abodes made up of all sorts of unconventional materials. One collaged door in an art center in Durban particularly summed up the creative verve in the country. It was made of old magazine pages and was the direct influence for my African Collage hanging (see page 71).

FINISHED SIZE

46 1/4" x 58" (117 cm x 147 cm)

MATERIALS

Use the specified 42–44"- (112–114-cm-) wide Kaffe Fassett *Shot Cottons* and Oakshott fabrics for the patchwork, and use an ordinary printed quilting-weight cotton fabric for the backing.

PATCHWORK FABRICS

1/4 yd (30 cm) of each of an assortment of mostly pale fabrics and a few stronger colors, and 1/2 yd (50 cm) of each of the colors you want to use most. Use Oakshott plain quilting-weight fabrics and their *Longshott Stripes* for most of the fabrics, and add in Kaffe Fassett *Shot Cotton* in Sunshine, Tangerine, Lavender, Scarlet, Latte, Dill, Violet, Squash, Pumpkin, Quartz, Shell, Aqua, and Artemisia.

OTHER INGREDIENTS

Backing fabric: 3 1/2 yd (3.2 m) of desired printed quilting fabric

Binding fabric: Piece together left-over fabrics for binding

Thin cotton batting: 54" x 65" (135 cm x 165 cm)

Quilting thread: Medium-toned neutral-colored thread

TIPS

To make this hanging, you will need to have had some experience making blocks with the paper-foundation piecing technique. As this is a rather tricky quilt, it is not a good patchwork for a beginner paper-piecer.

MAKING THE PAPER FOUNDATION

Press and starch the patchwork fabrics before cutting. (Read page 163 for more information about preparing *Shot Cottons* for your patchwork project, and prepare the Oakshott fabrics in the same way.)

The instructions for this hanging are guidelines for how to approach the technique used, rather than specifics for how to exactly duplicate the original. The size marked on the full template on page 72 is the size of the finished center of the hanging in the photograph, but you can adjust the size as desired. You can either blow up the full template provided or draw a life-size template of your own—to the size of the finished hanging. (Note that the quilt will be a mirror image of the original drawing.)

If you are using the template provided on page 72, blow it up 150 percent on a photocopier—the resulting size is the size we started out with. Have the store copy the image to as big as they can, then cut this into four pieces and enlarge these to the maximum size. Continue enlarging until the taped together pieces achieve a finished size of approximately 40 1/4" by 52" (102 cm by 132 cm).

Alternatively, you can just draw the patch shapes on a huge piece of paper, making them look similar to the template provided. The goal is to have various shapes with most intersections having no more than four pieces meeting. Straight lines going through intersections are easiest to piece. Odd angles require a bit more finesse.

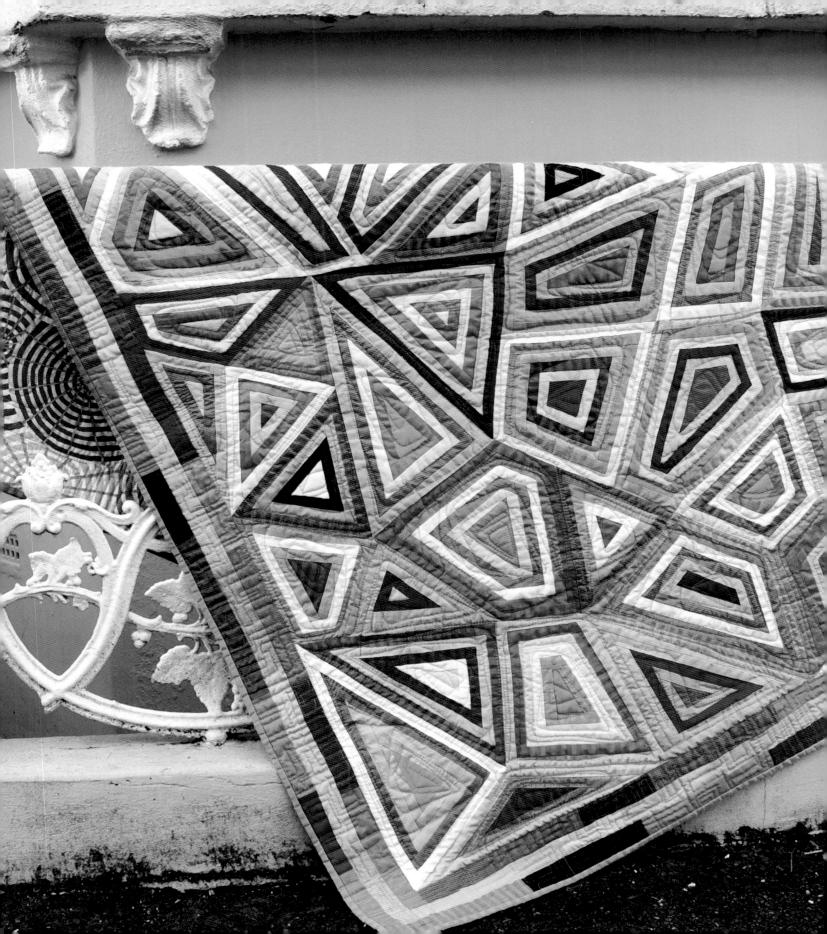

Once you have the full-size pattern, be sure that each block is numbered and draw an arrow pointing toward the top of the pattern next to the number. (Be sure to take a photo of the numbered drawing if you made your own pattern.) Then cut the blocks apart.

PREPARING FOUNDATION PAPERS

We wanted the "logs" (strips) on our quilt to be more or less even. If you prefer a more free-form look, skip this step.

As a stitching guideline, mark the boundaries of each strip on each of the block papers you cut from the life-size drawing of the hanging. With the block number and arrow markings face up and using a long quilter's rotary ruler, start at one outside edge of the block paper and draw a line 1/2" (12 mm) from this edge and parallel to it. Turn the paper clockwise and draw another line 1/2" (12 mm) from the next edge and parallel to it, but do not draw across the first line, stop here. Turn the paper clockwise again, and draw another line in the same way. Continue around the edge of the block in this way. Make sure the last line (the third line on a triangular block) crosses neither of the previously drawn lines. Continue in this manner, drawing concentric lines inside the block, all 1/2" (12 mm) apart. You want to end up near the center with the same number of lines on each side of the block. (This gets trickier when you have large four- or five-sided blocks, which often start out as lop-sided rectangles and as the concentric lines are drawn become triangles.)

When you have the same number of lines on each side of the block and a center remaining that is anywhere from 3/4" (2 cm) to 2 1/2" (6.4 mm) in size, pencil in a number in each individual strip. Start the numbering with "1" in the center and "2" in the last log drawn, "3" is the second to last log drawn, and so on clockwise around the block, until the last space (the first one you drew) is numbered.

Mark the logs and number them on each block. Some will have only three logs on each side, some as many as six.

The collaged door in a South African art center that inspired the African Collage hanging.

Preparing Foundation Papers

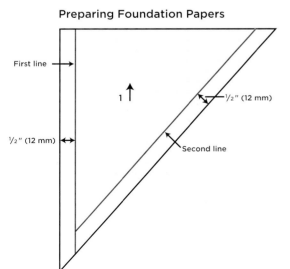

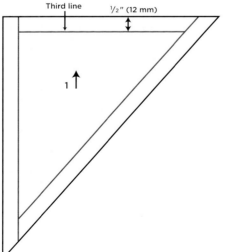

Full Template for Hanging

52"
(132 cm)

40 1/4"
(102 cm)

MAKING BLOCKS

Start each block with one center color, then add one round of logs around it in another color, using the paper-foundation-piecing technique. Continue adding logs, changing color after each round of logs. The colors should contrast quite a lot on each successive round, so, for example, start with a light peach, surround this with a medium blue, then surround these with a round of off-white logs, then a medium gold. The colors should not merge together; each round should be distinct. When using the *Longshott Stripes* for your logs, cut them so the stripe runs perpendicular to the long edge.

As you make each block, consider what color is on the outside of the blocks that touch it; you do not want these to match.

Sew the fabrics to the blocks in sequence as you would any paper-pieced block. Do not remove the paper. Trim the outside edge of each block to 1/4" (6 mm) beyond the paper (this is the seam allowance for sewing the blocks together).

ASSEMBLING TOP

When all the blocks are completed, sew them to one another, noting that the quilt is a mirror image of the original drawing. When you have a difficult join to make, it may be easiest to tear back the paper where the blocks will intersect. When a block is completely surrounded by other blocks sewn to it, you can remove its paper.

ADDING BORDERS

Cut long strips of many of the remaining fabrics, 1 1/2" (3.8 cm) wide by various lengths. Sew the strips together end to end, making one pale border and two darker borders, each 215" (5.5 m) long.

Measure the side of the quilt center and cut two strips from one of the dark border strips to the same length. Sew these to the sides of the quilt center. Then measure the top of the quilt and cut two dark border strips to the same length and sew these to the top and bottom of the quilt center.

Add a light border in the same way, then another dark border.

FINISHING HANGING

Press the quilt top. Layer the quilt top, batting, and backing, then baste the layers together (see page 167).

Using a medium-toned neutral-colored thread, machine quilt spirals in each block that mimic the shape of the block. Stitch meandering lines in the borders.

Trim the edges of the backing and batting so that they align with the patchwork top. Then cut the binding on the bias and sew it on around the edge of the quilt (see page 167).

STRIPED RICE BOWLS

Inspired by a painting of empty bowls, I made a quilt like this for my book *Passionate Patchwork*. In the original I used flowery patterns in the bowls and plain fabrics for the box settings. Since then Liza and I have done workshops on this quilt, which is perfect for quilters new to appliqué, around the world. Often students do the bowls in a collection of themed fabrics, such as oriental prints, polka dots, or Hawaiian shirt fabrics. The version that astounded me most was one in which every part of the design was done in tiny flower prints so the whole effect was like a pointillist painting—delightful!

For this book Liza had the idea to use my stripes for the bowls, which, interestingly, create quite a round effect. I love the way Liza has used cool duck egg for the bowls' interiors, and hot amber tones on the tabletops. The pink and lime in the background help to unify these cool and hot colors.

FINISHED SIZE

55" x 56 1/2" (139.7 cm x 143.5 cm)

MATERIALS

Use the specified 42–44"- (112–114-cm-) wide fine-weight Kaffe Fassett *Shot Cottons* and *Woven Stripes* for the patchwork and appliqué, and use an ordinary printed quilting-weight cotton fabric for the backing.

PATCHWORK FABRICS

Border (and corner dots) fabric: 1 5/8 yd (1.5 m) of *Shot Cotton* in Blue Jeans

Border dots (and corner squares and "walls") fabric: 3/4 yd (70 cm) of *Shot Cotton* in Granite

Light "wall" fabrics: 1/4 yd (30 cm) of *Shot Cotton* in each of the following three colors—Pink, Apricot, and Pudding

Dark "wall" fabrics: 1/4 yd (30 cm) of *Shot Cotton* in each of the following three colors—Sprout, Raspberry, and Mushroom

Striped "table-top" fabrics: 1/2 yd (50 cm) in each of the following seven stripes—*Alternating Stripe* in Olive and in Orange; *Exotic Stripe* in Dusk, Earth, and Midnight; *Narrow Stripe* in Yellow; and *Broad Stripe* in Sunset

Striped bowls fabrics: 1/4 yd (30 cm) in each of the following eight stripes— *Alternating Stripe* in Blue; *Narrow Stripe* in Blue, Dusk, and Dark; *Broad Stripe* in Blue; and *Caterpillar Stripe* in Blue, Dusk, and Dark

Inside-bowl fabric: 3/4 yd (70 cm) of *Shot Cotton* in Aqua

Inside-bowl shadow fabric: 1/2 yd (50 cm) of *Shot Cotton* in Spruce

Table-top shadow fabric: 1/2 yd (50 cm) of *Shot Cotton* in Moor

OTHER INGREDIENTS

Backing fabric: 3 1/2 yd (3.2 m) of desired printed quilting fabric

Binding fabric: 1/2 yd (50 cm) extra of *Broad Stripe* in Blue

Thin cotton batting: 62" x 64" (155 cm x 160 cm)

Quilting thread: Thread in matching colors for the different areas of the quilt

Templates: Use templates for the appliqué bowl pieces and the large border dots (see page 169)

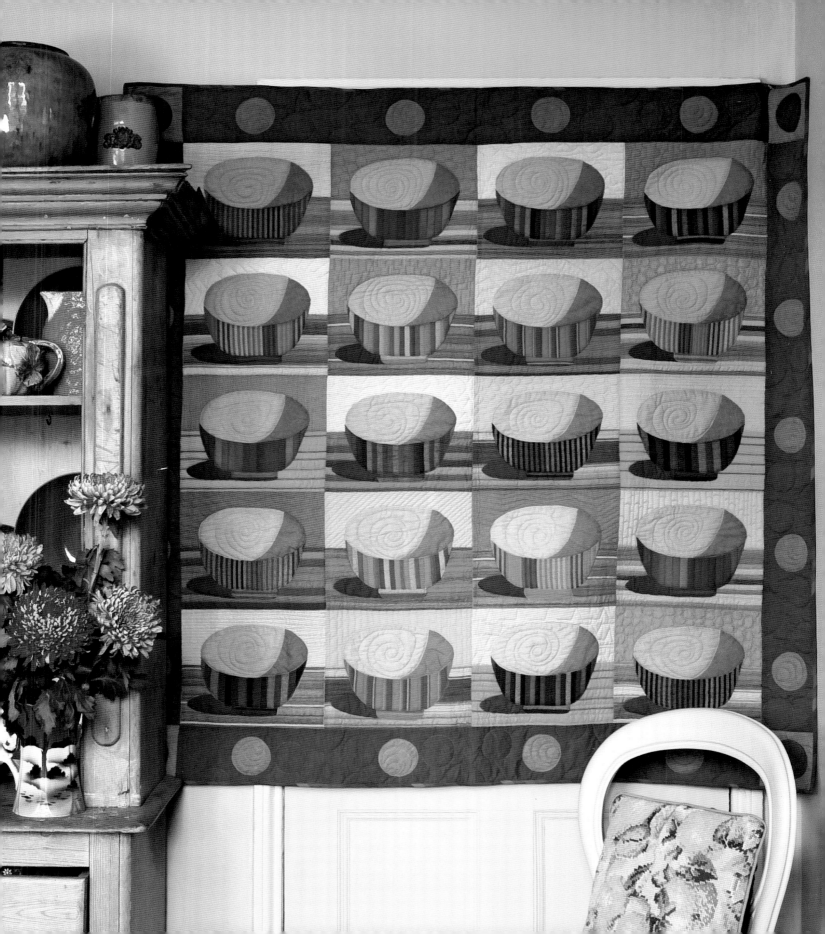

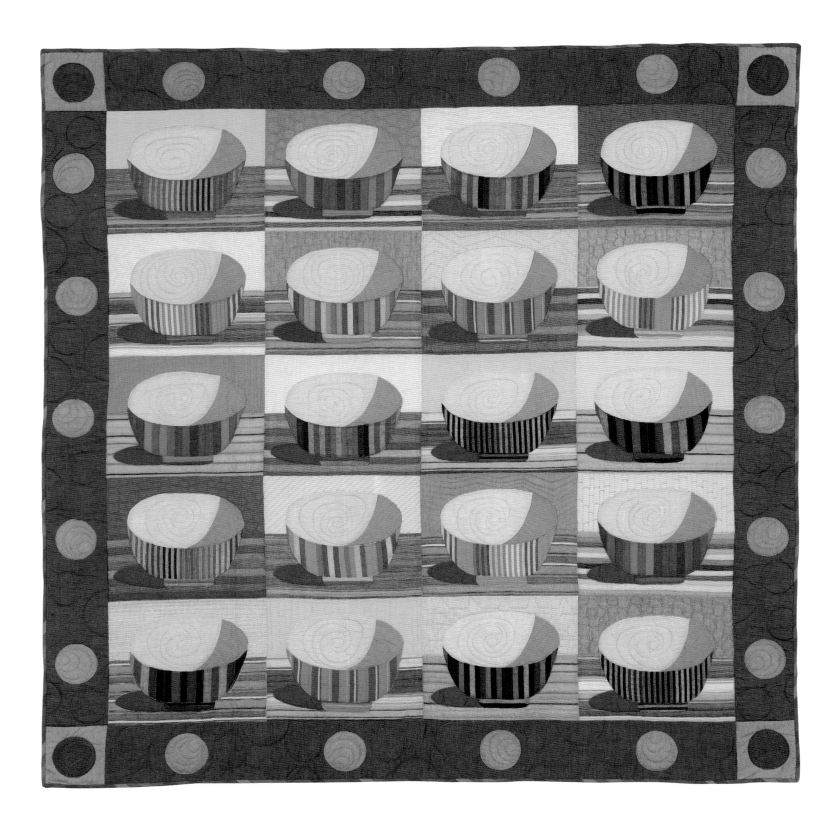

TIPS

Hand appliqué takes time but is well worth the effort. The appliqué on this quilt was done using the needle-turn method, but any preferred method can be used. As the appliqué shapes are large and the curves are gentle, the sewing is quite easy.

MAKING APPLIQUÉ TEMPLATES

Trace each of the six appliqué shapes—the striped outside-bowl, the inside-bowl, the inside-bowl shadow, the table-top shadow, the bowl base, and the circle—separately onto a piece of paper. Then glue the shapes onto a piece of thin cardboard or template plastic and cut out. Trace around these shapes onto the front side of the fabric when preparing the appliqué pieces. The fabric appliqué pieces will be cut out about 1/4" (6 mm) beyond the drawn lines.

CUTTING PATCHES AND APPLIQUÉ

Press and starch the patchwork fabrics before cutting. (Read page 163 for more information about preparing *Shot Cotton* and *Woven Stripes* for your patchwork project.)

Have your cardboard templates ready for tracing the shapes onto the front side of the fabric. Cut out the appliqué shapes about 1/4" (6 mm) beyond the drawn lines.

BORDER STRIPS, SQUARES, AND DOTS

4 border strips: From the border fabric (Blue Jeans), cut two strips each 5" by 48" (12.7 cm by 121.9 cm) for the side borders, and cut two strips each 5" by 46 1/2" (12.7 cm by 118.1 cm) for the top and bottom borders.

4 border corner squares: From the dots fabric (Granite), cut four squares 5" by 5" (12.7 cm by 12.7 cm).

18 light dots: From the dots fabric (Granite), cut 18 appliqué dots. Reserve the remainder of the Granite for dark "walls."

4 dark dots: From the border fabric (Blue Jeans), cut 4 appliqué dots, using the prepared circle template.

BLOCK PIECES

Each block is made up of a "wall" rectangle and a "table-top" rectangle. These two pieces are stitched together, and the bowl appliqué is stitched in place on top of the block.

10 light "walls": From the three light "wall" fabrics, cut a total of ten solid rectangles 5" by 12" (12.7 cm by 30.5 cm). (If desired, cut one of the light "walls" from Sprout, which is in the dark fabric group; we used this as a light in the upper left-hand corner of our hanging.)

10 dark "walls": From the four dark "wall" fabrics (which includes Granite), cut a total of ten solid rectangles 5" by 12" (12.7 cm by 30.5 cm).

20 striped "table-tops": From the striped "table-top" fabrics, cut a total of 20 striped rectangles 5 1/2" by 12" (14 cm by 30.5 cm) with the stripes running parallel to the long edges.

20 striped bowl appliqués: For each block, cut a bowl shape and a bowl-base shape from one of the striped bowl fabrics. The stripes should run vertically on the bowl and horizontally on the bowl base. Cut a total of 20 striped bowls with matching bases. Pin each base piece to its bowl to keep track of it.

20 inside-bowl appliqués: From the inside-bowl fabric (Aqua), cut 20 inside-bowl pieces.

20 inside-bowl shadow appliqués: From the inside-bowl shadow fabric (Spruce), cut 20 inside-bowl shadows.

20 table-top shadow appliqué: From the table-top shadow fabric (Moor), cut 20 table-top shadows.

PREPARING BOWL APPLIQUÉ

Use the needle-turn appliqué method or your preferred method for the appliqué.

The entire bowl-and-shadow is sewn together and then appliquéd to the background as a single piece. For this method, use a very fine thread and a "straw" needle. First, appliqué the bowl base to the shadow, then the bowl to the base. Next, appliqué the inside of the bowl to the inside of the bowl shadow, and lastly, appliqué the bowl to the inside bowl.

Press the pieced appliqué. Prepare all 20 bowl appliqués in the same way.

MAKING BLOCKS

Before stitching the block pieces together and sewing on the prepared bowl appliqués, arrange them, either laying them out on the floor or sticking them to a cotton-flannel design wall. Each block is made up of a solid-colored "wall" piece and a striped "table-top" piece. Arrange the blocks in five horizontal rows of four blocks each, as shown in the assembly diagram. Alternate the light and dark "wall" pieces and make sure there is enough contrast between the "table-top" pieces where they touch one another. Then select a bowl appliqué for each block and position all the appliqués in your arrangement. Rearrange until you have a pleasing mix of colors and stripes.

Make the blocks using a 1/4" (6-mm) seam allowance.

20 blocks: Set aside the bowl appliqué but make a note of which block it goes with, then sew each of the blocks together as shown on the block diagram on page 81. (Do not sew the blocks to one another until each block has its appliqué.)

Assembly

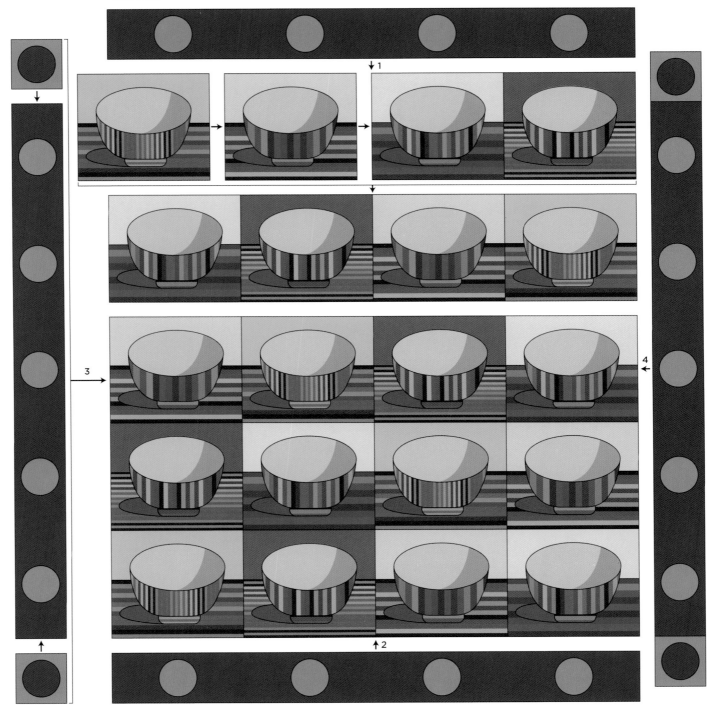

Large block

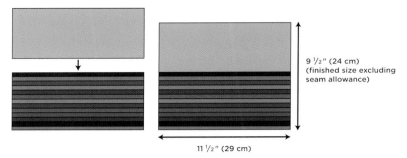

9 ½" (24 cm)
(finished size excluding
seam allowance)

11 ½" (29 cm)

SEWING BOWL APPLIQUÉS TO BLOCKS

Pin a prepared bowl appliqué to each of the 20 blocks, positioning it as
indicated on the bowl template on page 169. Stitch the bowl around its outer
edge to the block. Then carefully cut away the background fabric behind the
appliqué to within about 1/4" (6 mm) of the sewn edge.

ASSEMBLING TOP

Using a 1/4" (6-mm) seam allowance throughout, sew the blocks together in five
horizontal rows of four blocks each as shown on the assembly diagram. Then
sew the rows together.

Check that the border strips fit the sides of the quilt and trim if necessary—the
appliqué might have slightly pulled in the blocks. Sew the short border strips to
the top and bottom of the quilt. Sew one border corner to each end of each of
the two side borders and sew these borders to the quilt.

Pin one dark dot to each corner square and appliqué the dot to the square.
Pin four light dots to the top border, four to the bottom border, and five to
each side, lining them all up with the centers of the blocks, and appliqué the
dots in place.

FINISHING QUILT

Press the patchwork top. Layer the patchwork top, batting, and backing, then
baste the layers together (see page 167).

Using a color of thread to match each area of the quilt, machine quilt swirls in
the inside-bowl. Echo quilt the stripes on the bowls and the table-tops. Quilt
meandering lines in each wall area, using different shapes, such as bubbles,
zigzags, diagonal lines. Quilt each border appliqué dot with concentric circles
and quilt random circles of various sizes in the border.

Trim the edges of the backing and batting so that they align with the patchwork
top. Then cut the binding on the bias and sew it on around the edge of the quilt
(see page 167).

KOREAN LOG CABIN

This quilt, a dream of cool pastels, was inspired by Korean wrapping cloths, which are almost always a freeform log cabin or a crazy quilt layout of mostly solid fabrics. The wrapping cloths are particularly sensitive when made in light, delicate palettes.

FINISHED SIZE

70" x 70" (177.8 cm x 177.8 cm)

MATERIALS

Use the specified 42–44"- (112–114-cm-) wide fine-weight Kaffe Fassett *Shot Cottons* and Oakshott fabrics for the patchwork, and use an ordinary printed quilting-weight cotton fabric for the backing.

PATCHWORK FABRICS

1/4–1/2 yd (30–50 cm) of each of an assortment of at least 10 very pale solids and at least 10 light-toned to light-medium-toned solids. From the Kaffe Fassett *Shot Cottons* include any of these colors: Ice, Pink, Apricot, Lemon, Sunshine, Sprout, Pudding, Honeydew, Butter, Shell, Latte, Quartz, and Aqua. From the Oakshott fabrics, include any of these: *Colourshott* in Fleur, Candy, Biscuit, Papaya, Apricot, Sunshine, White Sand, Lilac, Mango, and Melon; and *Longshott Stripes* in Snowy White, Papyrus, Mint Ice, Pale Gold, and Sweet.

OTHER INGREDIENTS

Backing fabric: 4 1/2 yd (4.2 m) of desired printed quilting fabric

Binding fabric: 3/4 yd (70 cm) extra of a *Shot Cotton* in desired color

Thin cotton batting: 77" x 77" (195 cm x 195 cm)

Quilting thread: White thread

TIPS

The instructions here are for accurate machine piecing, but if you desire a more organic effect—and want to have a portable project—just use the measurements as guidelines and hand piece the strips like I did. You can then trim your finished blocks to the right size when they are all completed.

CUTTING BLOCK PATCHES

Press and starch the patchwork fabrics before cutting. (Read page 163 for more information about preparing *Shot Cotton* for your patchwork project, and prepare the Oakshott fabrics in the same way.)

SORTING THE FABRICS

Sort your fabrics into two group—the "lights" and the "darks." The lights should be the palest colors and the darks the fabrics that are light-toned to light-medium-toned. The differences in the tones are subtle, but are necessary to create the effects. The alternating lighter and darker colors in the small blocks make the concentric rings stand out from one another rather than merging together in tone—the contrast can be sharp but is mostly subtle. In the center block the tones are mixed in each ring, which creates a very different effect—in places the rings appear to merge together in tone.

CENTER BLOCK

The large center block is made up of a center square and seven rounds of strips. Cut the strips in the center block (after Round 1) from pieced strips that have been made by joining together shorter strips of different colors.

Follow the Cutting Chart on page 86 for which colors to use as the predominant hues in each round, then add in short lengths of other colors. Mix fabrics from both groups—the lights and the darks—into every round. Cut *Longshott Stripes* with the stripes running perpendicular to the length of the strips.

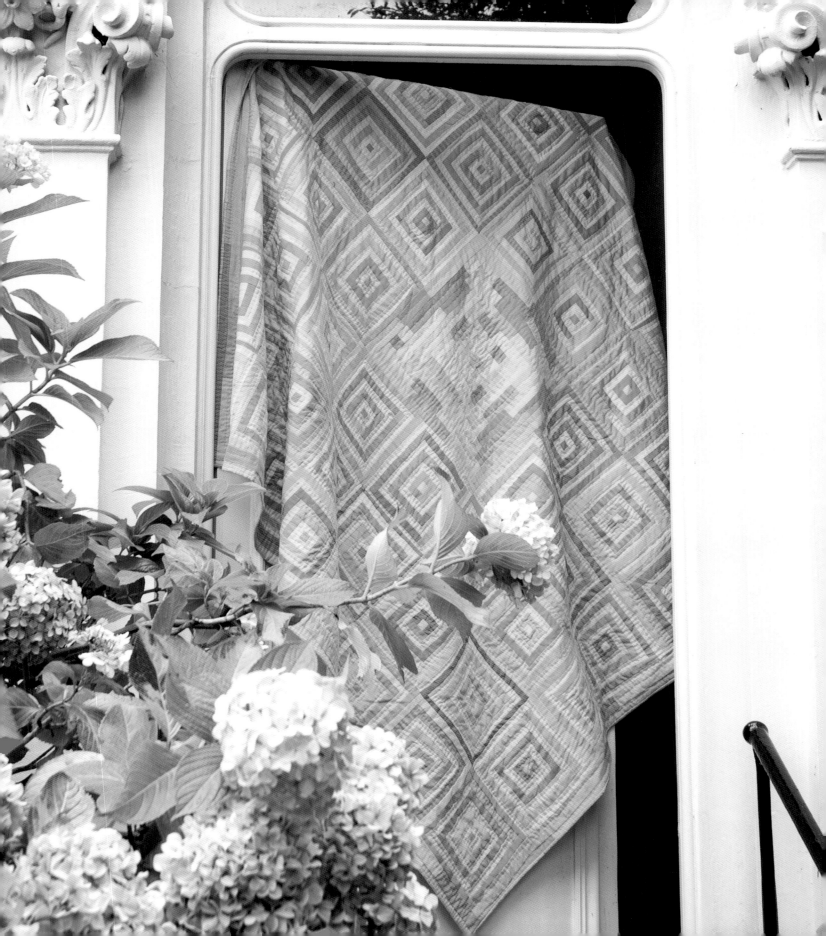

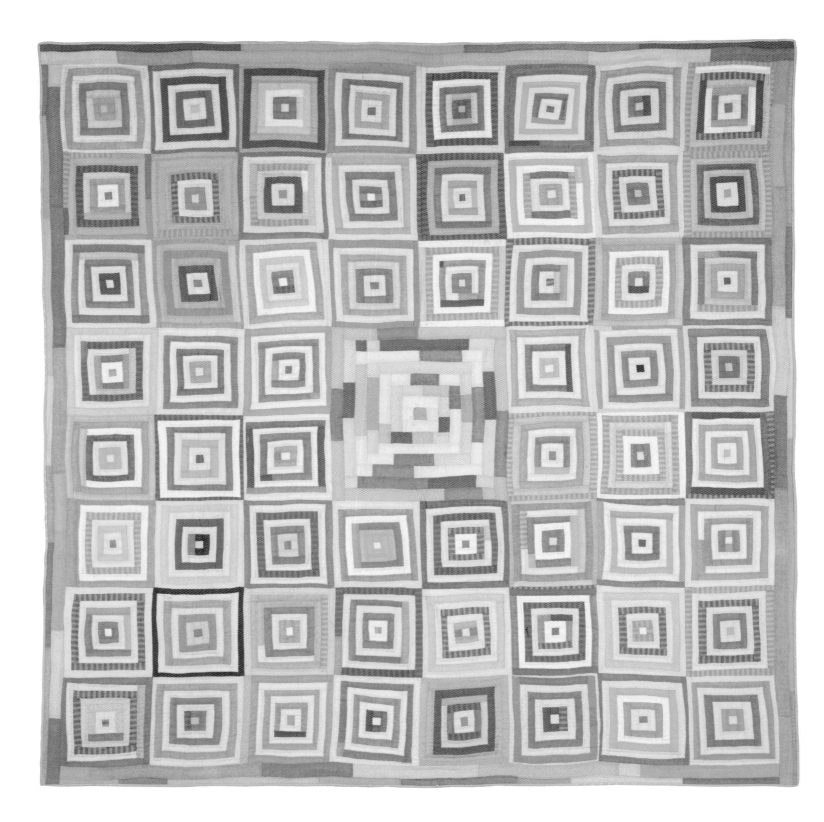

Center Block Strip Sequence

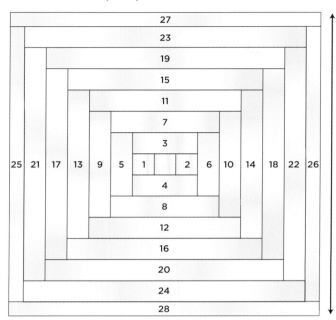

16 ¼" (41.2 cm) square
(finished size excluding
seam allowance)

SMALL BLOCKS

The small blocks are each made up of a center square and six rounds of strips. Follow the Cutting Chart on page 86 for cutting the center square and the strips for each of the rounds. The strips in each round are mostly cut from a single fabric, but for variety on some of the blocks add in another color in a ring, either cutting a whole strip from the other color or using a pieced strip.

Cut strips for a total of 60 small blocks—30 for Blocks A and 30 for Blocks B. The rings in the blocks alternate light and dark. Block A starts with a light center and Block B starts with a dark center. When adding in an extra color in a round, take it from the same fabric group as the predominant ring color. Cut any *Longshott Stripes* strips so the stripes run perpendicular to the length.

Small Block Strip Sequence

8 ⅛" (20.6 cm) square
(finished size excluding
seam allowance)

Some of the colorful row houses of Hastings that inspired my pastel approach to Korean Log Cabin.

Cutting Chart for Large Center Block

CENTER SQUARE

From a green, cut one square 1 5/8" x 1 5/8" (4.1 cm x 4.1 cm)

ROUND 1

Cut strips from a blue.

Strips 1 and 2: Cut two strips 1 5/8" x 1 5/8" (4.1 cm x 4.1 cm)

Strips 3 and 4: Cut two strips 1 5/8" x 3 7/8" (4.1 cm x 9.8 cm)

ROUND 2

Cut strips from pieced lengths, made up mostly of pinks.

Strips 5 and 6: Cut two strips 1 5/8" x 3 7/8" (4.1 cm x 9.8 cm)

Strips 7 and 8: Cut two strips 1 5/8" x 6 1/8" (4.1 cm x 15.6 cm)

ROUND 3

Cut strips from pieced lengths, made up mostly of blues.

Strips 9 and 10: Cut two strips 1 5/8" x 6 1/8" (4.1 cm x 15.6 cm)

Strips 11 and 12: Cut two strips 1 5/8" x 8 3/8" (4.1 cm x 21.3 cm)

ROUND 4

Cut strips from pieced lengths, made up mostly of pinks.

Strips 13 and 14: Cut two strips 1 5/8" x 8 3/8" (4.1 cm x 21.3 cm)

Strips 15 and 16: Cut two strips 1 5/8" x 10 5/8" (4.1 cm x 27 cm)

ROUND 5

Cut strips from pieced lengths, made up mostly of blues and oranges.

Strips 17 and 18: Cut two strips 1 5/8" x 10 5/8" (4.1 cm x 27 cm)

Strips 19 and 20: Cut two strips 1 5/8" x 12 7/8" (4.1 cm x 32.7 cm)

ROUND 6

Cut strips from pieced lengths, made up mostly of pinks.

Strips 21 and 22: Cut two strips 1 5/8" x 12 7/8" (4.1 cm x 32.7 cm)

Strips 23 and 24: Cut two strips 1 5/8" x 15 1/8" (4.1 cm x 38.4 cm)

ROUND 7

Note: The strips are narrower in the final round.

Cut strips from pieced lengths, made up mostly of yellows.

Strips 25 and 26: Cut two strips 1 5/16" x 15 1/8" (3.3 cm x 38.4 cm)

Strips 27 and 28: Cut two strips 1 5/16" x 16 3/4" (3.3 cm x 42.5 cm)

Cutting Chart for Small Blocks

CENTER SQUARE

Cut one square 1 1/8" x 1 1/8" (2.9 cm x 2.9 cm)

ROUND 1

Strips 1 and 2: Cut two strips 1 1/8" x 1 1/8" (2.9 cm x 2.9 cm)

Strips 3 and 4: Cut two strips 1 1/8" x 2 3/8" (2.9 cm x 6 cm)

ROUND 2

Strips 5 and 6: Cut two strips 1 1/8" x 2 3/8" (2.9 cm x 6 cm)

Strips 7 and 8: Cut two strips 1 1/8" x 3 5/8" (2.9 cm x 9.2 cm)

ROUND 3

Strips 9 and 10: Cut two strips 1 1/8" x 3 5/8" (2.9 cm x 9.2 cm)

Strips 11 and 12: Cut two strips 1 1/8" x 4 7/8" (2.9 cm x 12.4 cm)

ROUND 4

Strips 13 and 14: Cut two strips 1 1/8" x 4 7/8" (2.9 cm x 12.4 cm)

Strips 15 and 16: Cut two strips 1 1/8" x 6 1/8" (2.9 cm x 15.6 cm)

ROUND 5

Strips 17 and 18: Cut two strips 1 1/8" x 6 1/8" (2.9 cm x 15.6 cm)

Strips 19 and 20: Cut two strips 1 1/8" x 7 3/8" (2.9 cm x 18.7 cm)

ROUND 6

Strips 21 and 22: Cut two strips 1 1/8" x 7 3/8" (2.9 cm x 18.7 cm)

Strips 23 and 24: Cut two strips 1 1/8" x 8 5/8" (2.9 cm x 21.9 cm)

CUTTING BORDER STRIPS

Press and starch the patchwork fabrics before cutting as for the block patches.

4 inner-border strips: Using the remaining fabric in a mixture of lights and darks, cut strips 2″ (5.1 cm) wide and piece them together end to end as you did for the center block. Keep adding on colors until you have a pieced strip 2″ (5.1 cm) wide by at least 270″ (6.9 m) long. From the pieced strip, cut two side borders 65 1/2″ (166.7 cm) long and a top and bottom border each 68 1/2″ (174 cm) long.

4 outer-border strips: Using the remaining fabric in a mixture of lights and darks, cut strips 1 1/2″ (3.8 cm) wide and piece them together end to end as you did for the inner border. Keep adding on colors until you have a pieced strip 1 1/2″ (3.8 cm) wide by at least 280″ (7.2 m) long. From the pieced strip, cut two side borders 68 1/2″ (174 cm) long and a top and bottom border each 70 1/2″ (179.1 cm) long.

MAKING BLOCKS

Make the blocks using a 1/4″ (6-mm) seam allowance.

Center block: Make one large center block using the strips you have cut for the center square and for the strips in each round. First add strips 1 and 2 to the center square, then add strips 3 and 4. Continue in this way, adding on the strips in the order shown on the strip sequence diagram on page 85.

30 Blocks A: Using the strips you have cut for each Block A, first add dark strips 1 and 2 to the light center square, then add dark strips 3 and 4 to complete the first round. Continue in this way, adding on the strips in the order shown on the strip sequence diagram on page 85 and alternating dark rings and light rings as shown in the diagram for Small Block A. Make a total of 30 Blocks A.

30 Blocks B: Using the strips you have cut for each Block B, first add light strips 1 and 2 to the dark center square, then add light strips 3 and 4 to complete the first round. Continue in this way, adding on the strips in the order shown on the strip sequence diagram and alternating dark rings and light rings as shown in the diagram for Small Block B. Make a total of 30 Blocks B.

Small Block A

Small Block B

Assembly

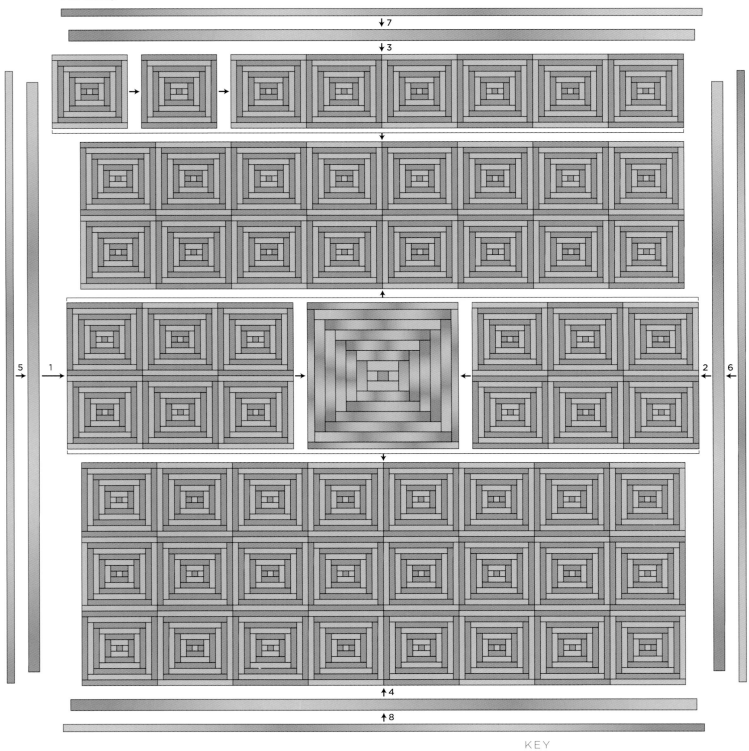

KEY

⬜ "light" fabrics ⬛ "dark" fabrics

ASSEMBLING TOP

Arrange the blocks, either laying them out on the floor or sticking them to a cotton-flannel design wall. As shown on the assembly diagram, position the large block at the center, then arrange the small blocks around it. For the top horizontal row of the small blocks, position a Block A and Block B alternately until you have eight small blocks across the top. Arrange two more horizontal rows of eight small blocks, always alternating the block types. Next, position the large center block under the two center small blocks and add two horizontal rows of three small blocks each at each side of the large center block. Under this section add three more horizontal rows of eight small blocks each. Aim for a pleasing random mix of colors.

Once you are satisfied with your arrangement, sew the small blocks together, using a 1/4" (6-mm) seam allowance throughout. Sew together the eight blocks in each of the top three horizontal rows, then sew the rows together. Sew together the eight blocks in each of the bottom three horizontal rows, then sew the rows together.

Sew together the three blocks in each of the two horizontal rows at the left of the center block, then sew the rows together. Sew together the three blocks in each of the two horizontal rows at the right of the center block, then sew the rows together. Sew one of these six-block sections to each side of the center block. Lastly, sew on the top and bottom sections.

Sew the shorter inner-border strips to the sides of the quilt and sew the longer inner-border strips to the top and bottom.

Sew the shorter outer-border strips to the sides of the quilt and sew the longer outer-border strips to the top and bottom.

FINISHING QUILT

Press the quilt top. Layer the quilt top, batting, and backing, then baste the layers together (see page 167).

Using white thread, hand quilt lines of long stitches along the center of every light ring of strips on each small block (not in the dark rings). Quilt lines of long stitches along the center of every ring of strips in the large center block and along the center of the borders.

Trim the edges of the backing and batting so that they align with the patchwork top. Then cut the binding on the bias and sew it on around the edge of the quilt (see page 167).

SAMARKAND TABLE RUNNER

The embroideries of Near Eastern countries like Uzbekistan and Kazakhstan delight me with their jewel palettes and bold graceful shapes. When I leaf through books on this part of the world, I'm always stopped in my tracks by these sharp designs. They are usually embroidered but sometimes appliquéd or felted. The pattern of interlocking shapes on this runner is particularly intriguing to me. I've knitted it to good effect and love how it turned out in pieced fabrics. It makes my shots look so jolly and bright. I used the same bright contrasting colors I'd seen in the embroideries. They remind me of Matisse paper collages. Liza used her ingenuity to figure out how to piece the intricate shapes from simple rectangles, squares, and triangles.

I for one would love to sit at a dinner table with this table runner as the centerpiece. Watermelon slices to start, a gorgeous salad of avocado and pink grapefruit segments piled high in a lime-colored bowl, with blood orange juice in tall clear glasses.

FINISHED SIZE

12" x 60" (30.5 cm x 152.4 cm)

MATERIALS

Use the specified 42–44"- (112–114-cm-) wide fine-weight Kaffe Fassett *Shot Cottons* for the patchwork, and use an ordinary printed quilting-weight cotton fabric for the backing.

PATCHWORK FABRICS

Light fabrics: 1/4 yd (30 cm) of *Shot Cotton* in each of the following eight colors—Sunshine, Jade, Sprout, Apricot, Honeydew, Watermelon, Apple, and Cactus

Dark fabrics: 1/4 yd (30 cm) of *Shot Cotton* in each of the following eight colors—Lavender, Persimmon, Grape, Spruce, Lipstick, Pool, Blueberry, and Magenta

OTHER INGREDIENTS

Backing fabric: 1 3/4 yd (1.6 m) of desired printed quilting fabric

Binding fabric: 1/2 yd (50 cm) extra of *Shot Cotton* in Sprout

Thin cotton batting: 19" x 67" (50 cm x 170 cm)

Quilting thread: Medium-gray thread

Templates: Use templates AA, BB, CC, DD, EE, and FF (see page 171)

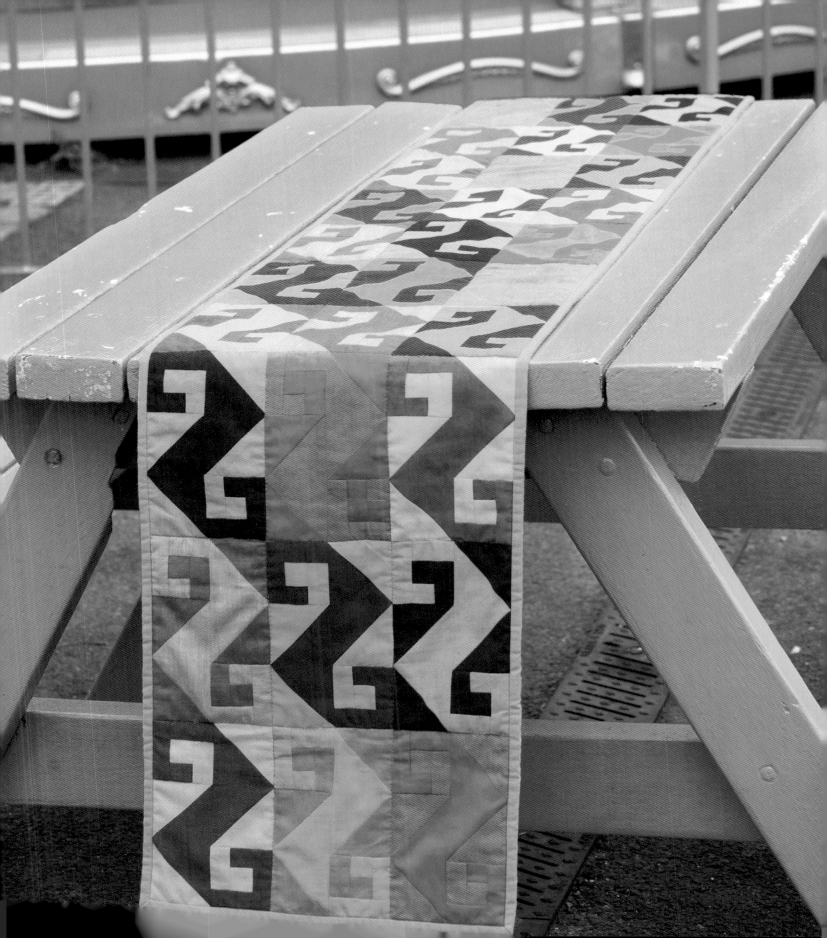

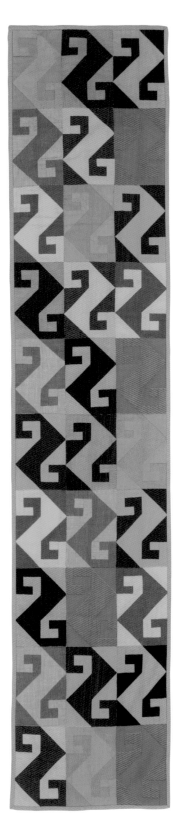

TIPS

The fabric amounts for this runner are generous, so there is sufficient fabric to make it longer or wider if desired.

CUTTING PATCHES

Press and starch the patchwork fabrics before cutting. (Read page 163 for more information about preparing *Shot Cotton* for your patchwork project.)

Since many of pieces are tiny and very close in size, be sure to keep the various patches organized by size. It is helpful to label the pieces.

CHOOSING FABRICS FOR BLOCKS

For each block, choose one light and one dark fabric. The Colorway Table tells which colors to put together and how many blocks to make in each of the colorway combinations. In half the blocks the dark color is used for the reverse-S pattern and the light is used for the background; and in the other half the reverse-S is light and the background dark.

CUTTING PATCHES FOR BLOCKS

Reverse-S patches: From the reverse-S color, cut two Template-BB rectangles, two Template-CC rectangles, two Template-DD rectangles, and two Template-EE triangles *for each block.*

Background patches: From the background color, cut two Template-AA squares, two Template-CC rectangles, and four Template-FF triangles *for each block.*

Cut patches for all 30 S-Blocks listed on the Colorway Table. Keep the patches for each block together.

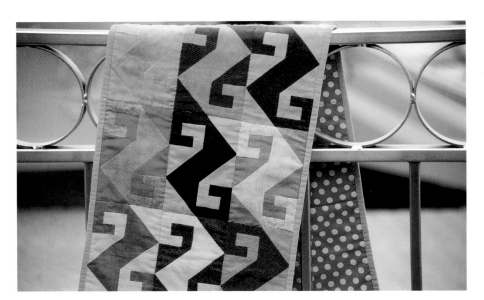

Colorway Table

COLORWAY	REVERSE-S COLOR	BACKGROUND COLOR	NUMBER OF S-BLOCKS
A	Sunshine	Lavender	make 2
B	Lavender	Sunshine	make 2
C	Persimmon	Jade	make 2
D	Jade	Persimmon	make 1
E	Sprout	Grape	make 2
F	Grape	Sprout	make 2
G	Spruce	Apricot	make 2
H	Apricot	Spruce	make 2
J	Honeydew	Lipstick	make 2
K	Lipstick	Honeydew	make 1
L	Pool	Watermelon	make 2
M	Watermelon	Pool	make 2
N	Apple	Blueberry	make 2
O	Blueberry	Apple	make 2
P	Cactus	Magenta	make 2
Q	Magenta	Cactus	make 2

Colorway Placement

A	C	E
G	J	L
N	B	P
C	J	O
H	F	M
Q	D	B
N	G	P
F	M	O
H	Q	E
K	A	L

MAKING BLOCKS

Make the blocks using a ¼" (6-mm) seam allowance (the allowance marked on the templates).

30 S-Blocks: For each large S-block, start by making the two Log Cabin Blocks following the diagram. Each Log Cabin Block is made up of one background AA-square (the center square), one reverse-S-fabric BB-rectangle, one background-fabric CC-rectangle, one reverse-S-fabric CC-rectangle, and one reverse-S-fabric DD-rectangle. Arrange the rectangles around the center square, then sew the rectangles to the center square, starting with the BB-rectangle and adding on the rectangles in a counterclockwise direction (as shown by the numbers).

Log Cabin Block

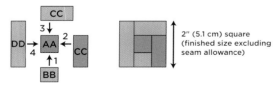

2" (5.1 cm) square
(finished size excluding
seam allowance)

Assembly

Next, make two Triangle Blocks. Each Triangle Block is made up of two background-fabric FF-triangles and one reverse-S-fabric EE-triangle. Sew the patches together as shown in the diagram.

Triangle Block

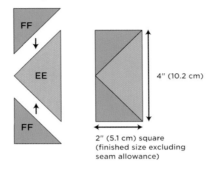

4" (10.2 cm)

2" (5.1 cm) square
(finished size excluding
seam allowance)

Once you have made the two Log Cabin Blocks and the two Triangle Blocks, sew them together as shown in the S-Block diagram.

S-Block

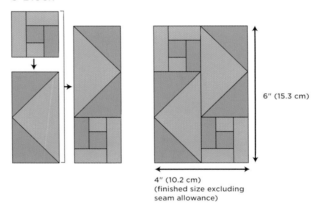

6" (15.3 cm)

4" (10.2 cm)
(finished size excluding
seam allowance)

Make a total of 30 large S-Blocks in this way.

KEY

- Sunshine
- Jade
- Sprout
- Apricot
- Honeydew
- Watermelon
- Apple
- Cactus
- Lavender
- Persimmon
- Grape
- Spruce
- Lipstick
- Pool
- Blueberry
- Magenta

ASSEMBLING RUNNER TOP

Arrange the blocks, either laying them out on the floor or sticking them to a cotton-flannel design wall. As shown on the assembly diagram, arrange ten horizontal rows of three blocks each. Arrange the colorways as shown on the Colorway Placement diagram on page 93, referring to the Colorway Table for the colors in each block. If you like, you can make another arrangement of the blocks, but remember to alternate the dark-background blocks and the light-background blocks.

Once you are satisfied with your arrangement, sew the blocks together in horizontal rows, using a 1/4" (6-mm) seam allowance throughout. Then sew the rows together as shown on the assembly diagram.

FINISHING RUNNER

Press the patchwork table-runner top. Layer the patchwork top, batting, and backing, then baste the layers together (see page 167).

Using a medium-gray thread, machine quilt in-the-ditch around each block.

Trim the edges of the backing and batting so that they align with the patchwork top. Then cut the binding on the bias and sew it on around the edge of the quilt (see page 167).

A permanent funfair in Hastings affords the community a brilliant garden of color on the sea front—as well as a bold setting for our table runner.

ZIGZAG CUSHIONS

When we were close to finishing the quilts for this book, I realized that we needed more simple, bold uses of color, so I designed these cushions. They make me think of two-color road signs, or jockey's silk jackets at a horse race.

At first I chose sharply conrasting colors like black and yellow and maroon and orange, but, after reflecting upon the soft seaside tones where we would be shooting, I settled on these dusty pastels. I like to put cool tones with warm ones to give a bit of edge even in this quiet mood.

You could play with many different palettes for these simple cushions. How about taking the colors of Two-Toned Boxes on page 106? If you wanted to use stripes you could try the palette of Long Diamonds or X-Effect (see pages 52 and 112). Of course, black and white would be the most contrasting of all.

FINISHED SIZE

Each cushion measures 19 1/4" x 19 1/4" (48.9 cm x 48.9 cm)

MATERIALS

Use the specified 42–44"- (112–114-cm-) wide fine-weight Kaffe Fassett *Shot Cottons* for the patchwork, and use an ordinary printed quilting-weight cotton fabric for the cushion back pieces.

PATCHWORK FABRICS

Colorway 1: 1/3 yd (35 cm) of *Shot Cotton* in each of the following two colors—Watermelon and Honeydew

Colorway 2: 1/3 yd (35 cm) of *Shot Cotton* in each of the following two colors—Ice and Butter

Colorway 3: 1/3 yd (35 cm) of *Shot Cotton* in each of the following two colors—Pudding and Sprout

Colorway 4: 1/3 yd (35 cm) of *Shot Cotton* in each of the following two colors—Apple and Pink

Colorway 5: 1/3 yd (35 cm) of *Shot Cotton* in each of the following two colors—Ecru and Lilac

OTHER INGREDIENTS

Patchwork Backing fabric: 1/2 yd (40 cm) of a plain quilting-weight fabric for each cushion (backing will not be seen so you can piece together scraps for this piece)

Cushion-back fabric: 1/2 yd (40 cm) of desired printed or plain quilting fabric for each cushion

TIPS

Here's a good patchwork practice project for a beginner. You can practice cutting triangles using templates and sewing them together to make perfect triangle points. Use one or all five of the color combinations suggested here.

CUTTING PATCHES

Press and starch the patchwork fabrics before cutting. (Read page 163 for more information about preparing *Shot Cotton* for your patchwork project.)

For each cushion cut the following large and small triangles.

42 large triangles: From each of the two colors for the chosen colorway, cut 21 Template-X triangles—for a total of 42 large triangles.

Thin cotton batting: 25" x 25" (65 cm x 65 cm) for each cushion

Quilting thread: Thread to match each fabric color used

Templates: Use templates X and Y (see page 171)

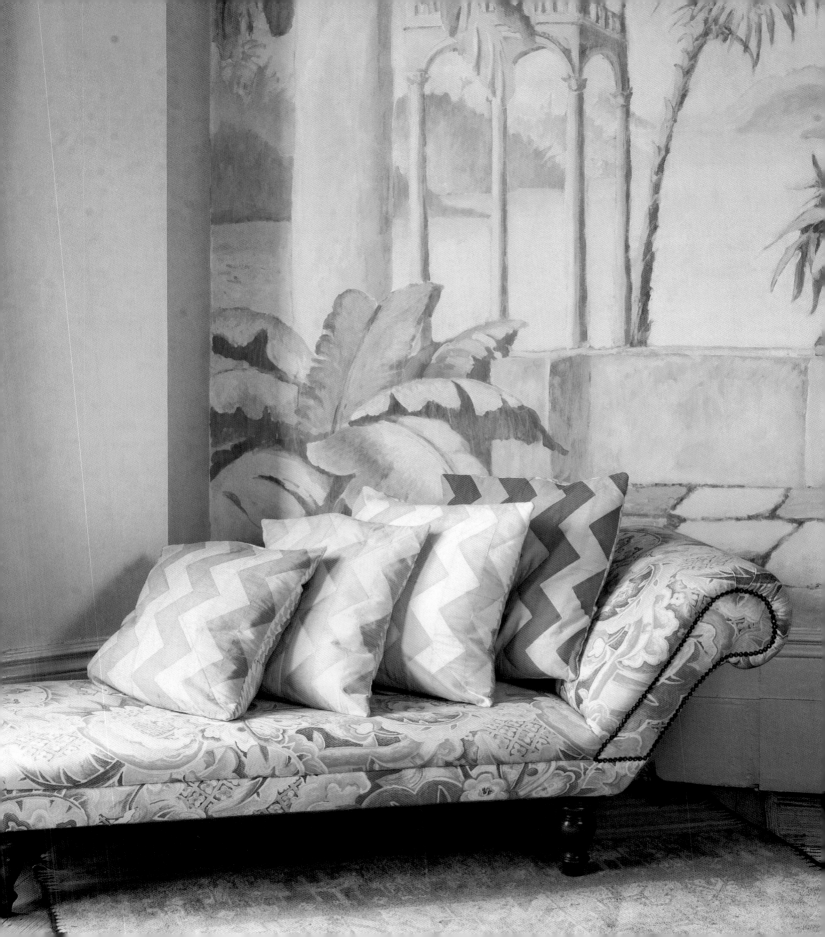

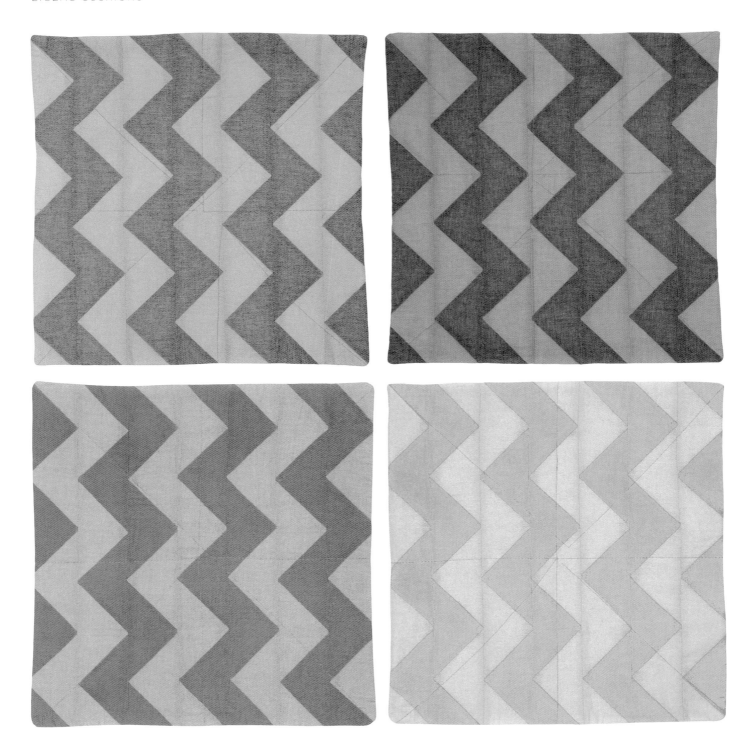

14 small triangles: From each of the two colors for the chosen colorway, cut seven Template-Y triangles—for a total of 14 small triangles.

ASSEMBLING CUSHION

Arrange the 42 large triangles (21 in each color) and the 14 small triangles (seven in each color), either laying them out on the floor or sticking them to a cotton-flannel design wall. Position the triangles to form vertical zigzags as shown on the assembly diagram.

Using a 1/4" (6-mm) seam allowance (the allowance marked on the templates), sew the triangles together in seven vertical rows, then sew the rows together.

FINISHING CUSHION

Press the patchwork cushion top. Piece the patchwork backing fabric together to make a piece measuring 25" (65 cm) square. Layer the patchwork top, batting, and backing, then baste the layers together (see page 167).

Using matching thread, machine quilt in-the-ditch along the sides of the zigzags. Using a matching thread for each area of color, stitch across the center of the patchwork, and diagonally from corner to corner across the cushion in both directions.

Trim the edges of the backing and batting so that they align with the patchwork top.

For the cushion back, cut two pieces of fabric each 19 3/4" by 13 1/2" (50.2 cm by 34.3 cm). Along one long edge of each piece, fold under 1/4" (6 mm) to the wrong side and press; then fold under another 1/2" (12 mm) and press. Stitch this double-hem in place. Pin the two back pieces to the prepared patchwork, with the right sides together and the raw edges aligned so that the back pieces overlap. Using a 1/4" (6-mm) seam allowance, stitch the back pieces to the patchwork around the outer edge of the cushion cover. Turn right side out through the opening in the back.

Assembly

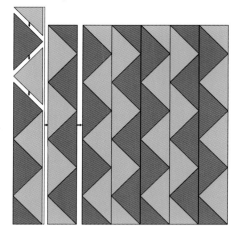

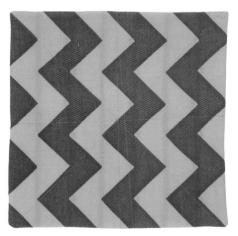

SWATCHES PLACEMATS AND TABLE RUNNER

When Liza and I sat down to plan this book, we thought first about bed-size quilts and wall hangings. Then, knowing people like smaller projects too, our minds turned to cushions and bags. Then I thought about dinner parties I've been to where the host or hostess made a color statement and created a mood using crockery, flowers, and placemats. We loved the idea of someone using our palette as the basis for setting a table and so plans for these placemats and table runner began.

This project utilizes all the cool blues in my stripe collection. They play together to create such a luminous turquoise and cobalt glow, with notes of burgundy for added richness. The jewel depth of tone is set off well by the dark sashings that look like stained-glass frames. Plums and dark bowls extend that smoldering glow in our dining room shot.

For a warmer look you could use all the reds and the more earthy tones of stripes; for an autumnal table setting you could choose all the hot ambers and oranges of Jambo on page 124. Whatever colors you go for, try to include what a friend of mine calls "kick colors"—like the light turquoise with the dark cobalt and plum tones on our table runner or a bright pink or emerald with reds.

FINISHED SIZE

Table runner: 9 1/4" x 56" (23.5 cm x 142.2 cm)

Placemats: 18" x 13" (45.7 cm x 33 cm)

MATERIALS

Use the specified 42–44"- (112–114-cm-) wide fine-weight Kaffe Fassett *Shot Cottons* and *Woven Stripes* for the patchwork, and use an ordinary printed quilting-weight cotton fabric for the backing.

PATCHWORK FABRICS

The amounts of fabric are enough for one table runner and four placemats.

Sashing fabric: 2 yd (1.9 m) of *Shot Cotton* in Thunder

Stripe fabrics: 1/4 yd (30 cm) of each of the following nine stripes—*Broad Stripe* in Blue and in Dark; *Alternating Stripe* in Blue; *Exotic Stripe* in Dark; *Caterpillar Stripe* in Blue, Dusk, and Dark; and *Narrow Stripe* in Blue and in Dark

OTHER INGREDIENTS

Backing fabric: 1 3/4 yd (1.6 m) of desired printed quilting fabric

Binding fabric: Binding is *Shot Cotton* in Thunder and is included in the sashing-fabric amount

Thin cotton batting: 15" x 62" (40 cm x 155 cm) for table runner, and 24" x 19" (60 cm x 50 cm) for each placemat

Quilting thread: Navy blue thread

TIPS

This is a great quick project for a beginner. The cut pieces are simple strips and squares and the items are small, so the set can be made in a jiffy.

CUTTING PATCHES

Press and starch the patchwork fabrics before cutting. (Read page 163 for more information about preparing *Shot Cotton* and *Woven Stripes* for your patchwork project.)

The pieces listed are for one table runner and four placemats. Cut all the sashing strips for one table runner and four placemats in the order that follows.

SASHING STRIPS

For runner, 3 long strips: From the sashing fabric, cut three strips 1 1/4" by 56 1/2" (3.2 cm by 143.5 cm).

For placemats, 32 long strips: From the sashing fabric, cut 32 strips 1" by 13 1/2" (2.5 cm by 34.3 cm).

For runner, 28 short strips: From the sashing fabric, cut 28 strips 1 1/4" by 4" (3.2 cm by 10.2 cm).

For placemats, 168 short strips: From the sashing fabric, cut 168 strips 1" by 2 1/2" (2.5 cm by 6.4 cm).

STRIPED SQUARES

DO NOT cut the striped pieces in layers; cut them individually so you can make the stripes run as straight as possible.

For runner, 26 squares: From the assortment of stripe fabrics, cut a total of 26 squares 4" by 4" (10.2 cm by 10.2 cm).

For placemats, 140 squares: From the assortment of stripe fabrics, cut a total of 140 squares 2 1/2" by 2 1/2" (6.4 cm by 6.4 cm).

ASSEMBLING RUNNER TOP

Arrange the 26 squares for the runner, either laying them out on the floor or sticking them to a cotton-flannel design wall. As shown on the assembly diagram on page 104, arrange two vertical rows of 13 squares each, leaving gaps for the sashing. All the stripes should run horizontally. Position the sashing strips between the squares so you can see how your arrangement will look with them in place. Rearrange until you are satisfied with the composition.

Using a 1/4" (6-mm) seam allowance throughout, sew one short sashing strip to the top of each square. Then sew together the 13 blocks in each of the two vertical rows. Sew a short sashing strip to the bottom of each of these vertical panels. Sew a long sashing strip to the left side of each panel. Sew the panels together. Sew the last long sashing strip to the right side of the runner.

Placemat Assembly

Table Runner Assembly

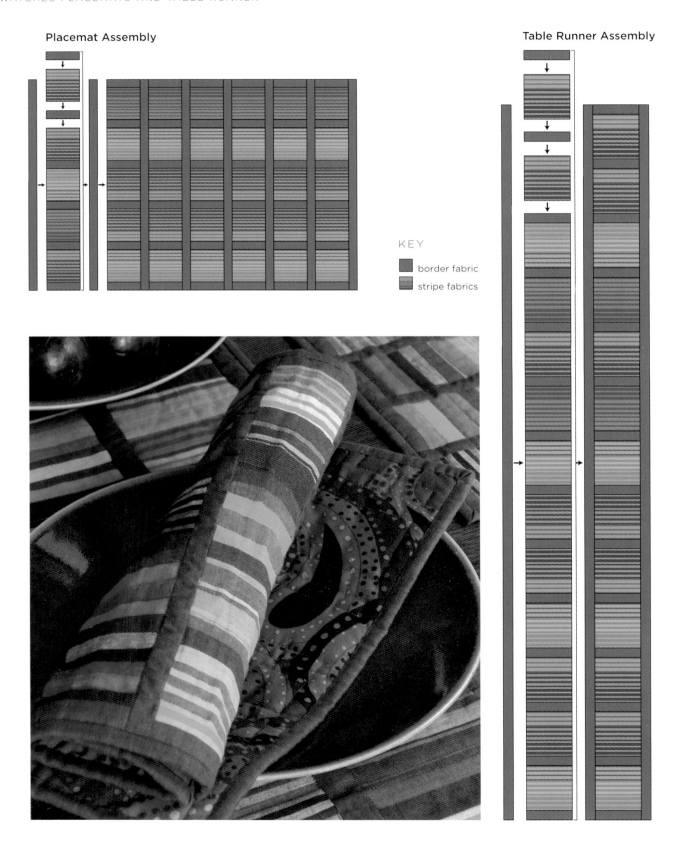

KEY

border fabric

stripe fabrics

ASSEMBLING PLACEMAT TOPS

Select 35 squares for each placemat and arrange them, either laying them out on the floor or sticking them to a cotton-flannel design wall. As shown on assembly diagram, arrange seven vertical rows of five squares each, leaving gaps between them for sashing. All the stripes should run horizontally. Position sashing strips between squares so you can see how your arrangement will look with them in place. Rearrange until you are satisfied with each placemat's composition.

Using a 1/4" (6-mm) seam allowance throughout, sew one short sashing strip to the top of each square. Then sew together the five blocks in each of the seven vertical rows. Sew a short sashing strip to the bottom of each of these vertical panels. Sew a long sashing strip to the left side of each panel. Sew the panels together. Sew the last long sashing strip to the right side of the placemat.

FINISHING RUNNER AND PLACEMATS

Press the patchwork table runner and placemat tops. For each item, layer the patchwork top, batting, and backing, then baste the layers together (see page 167). Using a navy blue thread, machine quilt in-the-ditch around each square. Then stitch parallel lines about 3/4" (2 cm) apart inside each square, but positioned so that each stitching line runs along the edge of a stripe (not through a stripe).

Trim the edges of the backing and batting so that they align with the patchwork top. Then cut the binding (Thunder) on the bias and sew it on around the edge of the quilt (see page 167).

I employed the deep rich Islamic blue and green palette of the Swatches table runner and placemats in this painting.

TWO-TONED BOXES

This bold simple layout was the first idea that occurred to me when Liza and I began contemplating a book featuring shot cottons. It reminds me of little row houses on the outskirts of San Francisco that were painted pastel colors in the 1950s. Somehow that dark neutral tone that creates the border and the square holes in each box becomes like a dynamic shadow.

I started planning with the deepest tones in my collection, but by the time we got around to sewing it I had settled on the seaside town of Hastings as our photography location. I knew that there were mostly light cream- and pastel-colored buildings, so reconsidered my palette and introduced a lot of sweeter, paler colors to it. We minimized the iridescence of the shot cottons to obtain a bright opaque quality by cutting warps and wefts in the same direction.

FINISHED SIZE

90" x 90" (228.6 cm x 228.6 cm)

MATERIALS

Use the specified 42–44"- (112–114-cm-) wide fine-weight Kaffe Fassett *Shot Cottons* for the patchwork, and use an ordinary printed quilting-weight cotton fabric for the backing.

PATCHWORK FABRICS

Dark fabric: 2 yd (1.9 m) of *Shot Cotton* in Pewter

Medium fabrics: 3/4 yd (70 cm) of *Shot Cotton* in each of the following nine colors—Chartreuse, Watermelon, Cactus, Granite, Pea Soup, Curry, Blueberry, Spruce, and Lipstick

Light fabrics: 3/4 yd (70 cm) of *Shot Cotton* in each of the following nine colors—Sunshine, Aqua, Sprout, Lilac, Honeydew, Mushroom, Pink, Lavender, and Apricot

OTHER INGREDIENTS

Backing fabric: 8 1/2 yd (7.8 m) of desired printed quilting fabric

Binding fabric: 3/4 yd (70 cm) extra of *Shot Cotton* in Pewter

Thin cotton batting: 97" x 97" (245 cm x 245 cm)

Quilting thread: Neutral taupe thread

Templates: Use templates F, G, H, and J (see pages 170–171)

TIPS

As it isn't practical to make the Two-Toned Boxes using two L-shapes mitered around a solid square, each L-shape is made up of two trapezoids and the center square is made up of two triangles. To create the seam-less look, the pieces are all cut with the warps and wefts running in the same direction.

CUTTING PATCHES

Press and starch the patchwork fabrics before cutting. (Read page 163 for more information about preparing *Shot Cotton* for your patchwork project.) It is a good idea to keep the selvage on the fabric until you have finished the cutting. This will help you to keep track of the direction of the warp and weft.

Remember that each Two-Toned Box on this quilt should look as though it is made from three solid, uncut pieces. Because the warp color and the weft color in the *Shot Cottons* is usually different, to achieve the seam-less look, you need to cut the matching pieces with their warps and wefts running in the same directions. Follow the cutting instructions carefully.

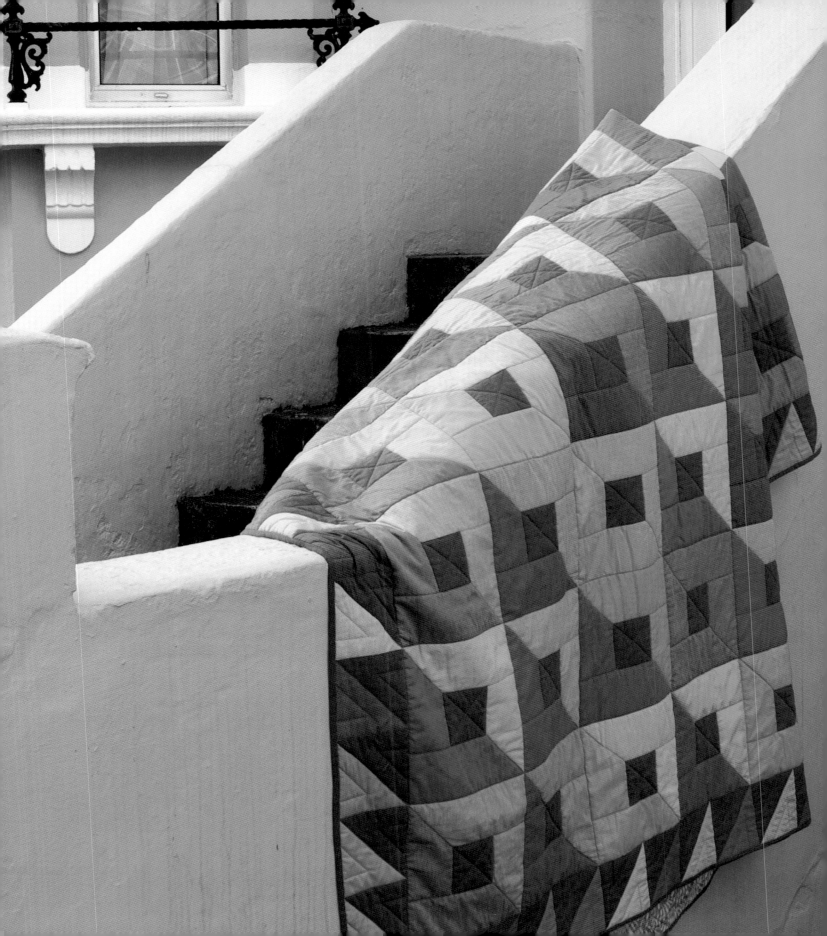

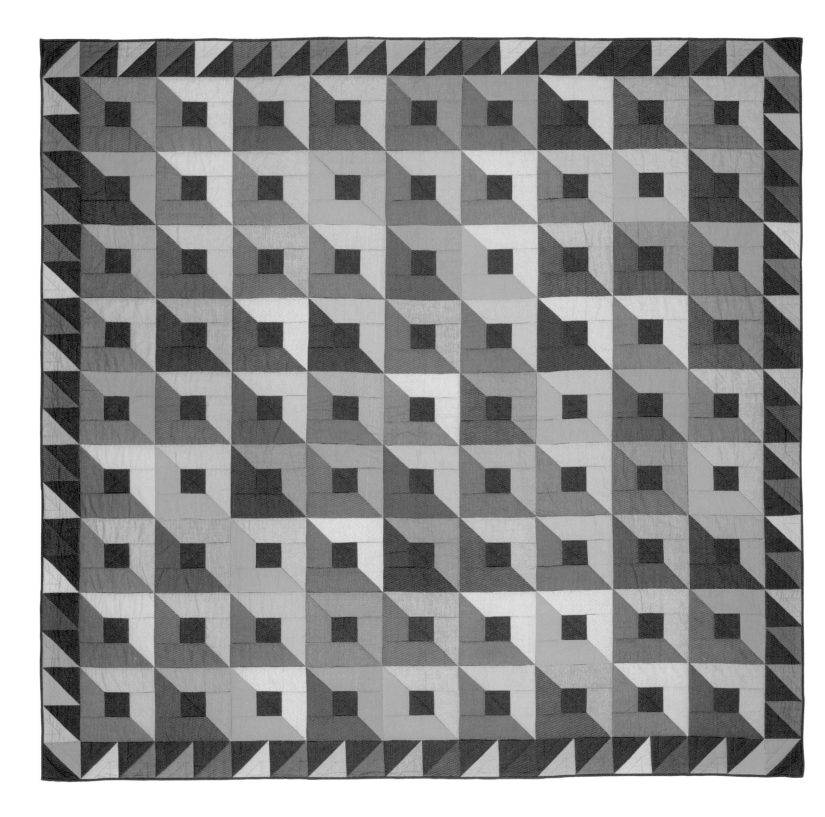

TWO-TONED BOXES PIECES

162 small dark triangles: From the dark fabric (Pewter), cut 81 Template-F squares. As indicated on the template, cut each of these squares diagonally from corner to corner to make two half-square triangles—for a total of 162 triangles. KEEP EACH OF THESE SQUARES EXACTLY AS IT IS BEFORE CUTTING. The two triangles will eventually be sewn together to form the center square in each Two-Toned Boxes Block.

81 pairs of light-fabric trapezoids: From the light fabrics, cut two trapezoids from the same color—one short (Template G) and one long (Template H)—for each of the 81 Two-Toned Boxes Blocks. Cut each light fabric to make 6–10 blocks from each. Position the templates carefully on the fabric when cutting the trapezoid patches, following the Cutting Layout. The short trapezoids are cut with the long edge running perpendicular to the selvage, and the long trapezoids with the long edge parallel to the selvage.

81 pairs of medium-fabric trapezoids: From the medium fabrics, cut two trapezoids from the same color—one short (Template G) and one long (Template H)—for each of the 81 Two-Toned Boxes Blocks. Cut each medium fabric to make 6–10 blocks from each. When cutting the pieces, position the templates as for the light-fabric trapezoids.

Cutting Layout

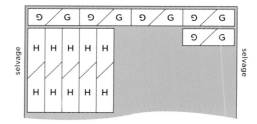

BORDER-BLOCK TRIANGLES

76 large dark triangles: From the dark fabric (Pewter), cut 38 Template-J squares. As indicated on the template, cut each of these squares diagonally from corner to corner to make two half-square triangles—for a total of 76 triangles. Stack these carefully so the warp and weft are going in the SAME direction in all the triangles.

76 large light and medium triangles: From the left-over light and medium fabrics, cut 38 Template-J squares. As indicated on the template, cut each of these squares diagonally from corner to corner to make two half-square triangles—for a total of 76 triangles.

MAKING BLOCKS

Make the blocks using a 1/4" (6-mm) seam allowance (the allowance marked on the templates).

81 Two-Toned Boxes Blocks: Each block is made up of two small dark triangles, a pair of light-fabric trapezoids, and a pair of medium-fabric trapezoids. Make the blocks following the diagram. Make a total of 81 blocks.

Two-Toned Boxes Block

9" (22.8 cm) square (finished size excluding seam allowance)

Assembly

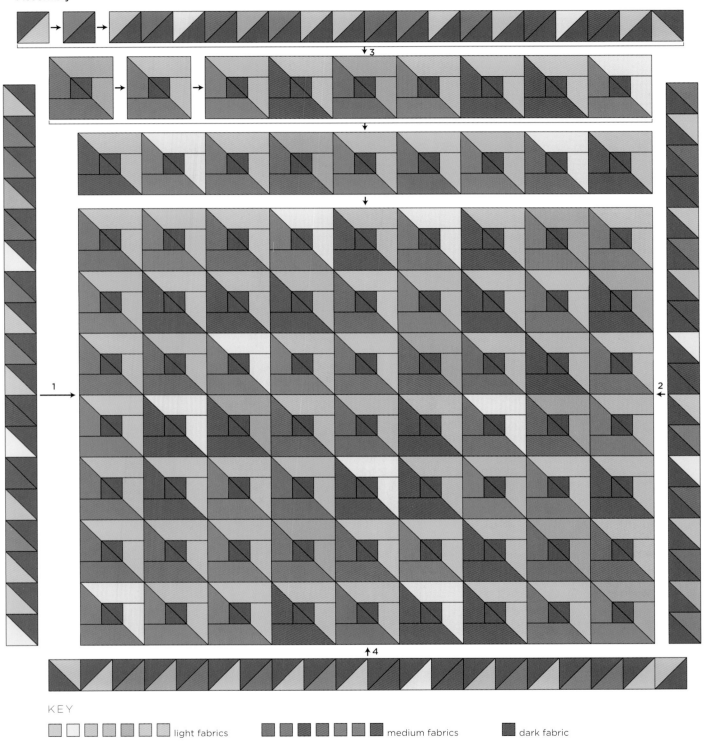

KEY

light fabrics medium fabrics dark fabric

76 Border Blocks: Make the blocks following the diagram, using one large dark triangle and one large light-fabric or one large medium-fabric triangle for each block. Make a total of 76 blocks.

Border Block

4 1/2" (11.4 cm) square
(finished size excluding
seam allowance)

ASSEMBLING TOP

Arrange the Two-Toned Boxes Blocks, either laying them out on the floor or sticking them to a cotton-flannel design wall. As shown on the assembly diagram, arrange nine horizontal rows of nine blocks each, paying attention to the direction of the blocks—the medium-fabric angle should be on the left bottom of each block. Aim for a pleasing random mix of colors.

Once you are satisfied with your arrangement, sew the blocks together in horizontal rows, using a 1/4" (6-mm) seam allowance throughout. Then sew the rows together.

Make four border strips, sewing 18 Border Blocks together for each border. Refer to the assembly diagram for the direction the dark triangles face in the borders. Sew the corner blocks onto the ends of the top and bottom borders as shown. Sew the side border to the quilt center, then sew on the top and bottom borders.

FINISHING QUILT

Press the quilt top. Layer the quilt top, batting, and backing, then baste the layers together (see page 167).

Using a neutral taupe thread, machine quilt in-the-ditch around all the patches. Then quilt a cross in the center of each block center "square." Stitch an echo triangle inside every border triangle.

Trim the edges of the backing and batting so that they align with the patchwork top. Then cut the binding on the bias and sew it on around the edge of the quilt (see page 167).

X-EFFECT

A vintage string-pieced quilt gave me this idea. The original was a lot more contrasting—prints in reds, whites, and blues. We used stripes instead of string piecing (sewing thin strips of fabric together). Keeping the lightest tone for our shot cotton sashing gives a bright, light surface to the grid, while the deeper huskier stripe colors drop back creating a "shadow." I started with the pale fleshy shot cottons and grouped them with the same sort of lightness of tone so that the sashing would stay in the foreground. That odd man out, the pistachio green shot cotton, really sings out to me. But what I love most is how different the husky stripe colors look on this quilt; they hardly feel like our woven stripes. The border has that light mulberry band, then the rich depth of the multitoned stripe radiating outward.

 This is a palette that could warm up a cold gray room or harmonize well with wood tones. How transformed this idea would be in a cool blue palette—sky, aqua, jade, and lavender shot cottons as the sashing, with all my rich jade green and cobalt blue stripes.

FINISHED SIZE

56 1/2" x 66" (143.5 cm x 167.6 cm)

MATERIALS

Use the specified 42–44"- (112–114-cm-) wide fine-weight Kaffe Fassett *Shot Cottons* and *Woven Stripes* for the patchwork, and use an ordinary printed quilting-weight cotton fabric for the backing.

PATCHWORK FABRICS

Solid fabrics: *Shot Cotton* in each of the following seven colors—1 3/4 yd (1.6 m) of Lilac; 3/8 yd (40 cm) of each of Lavender and Pink; and 1/4 yd (30 cm) of each of Apricot, Honeydew, Pudding, and Watermelon

Stripe fabrics: Stripes in each of the following nine fabrics—1 yd (1 m) of *Exotic Stripe* in Purple; and 1/2 yd (50 cm) of each of *Exotic Stripe* in Dusk, Dark, Warm, Midnight, and Earth, *Narrow Stripe* in Earth, and *Broad Stripe* in Sunset and in Red

OTHER INGREDIENTS

Backing fabric: 4 yd (3.7 m) of desired printed quilting fabric

Binding fabric: 1/2 yd (50 cm) of *Narrow Stripe* in Dark

Thin cotton batting: 64" x 73" (160 cm x 185 cm)

Quilting thread: Medium-dark taupe thread and lilac thread

Templates: Use templates Q and R (see page 172)

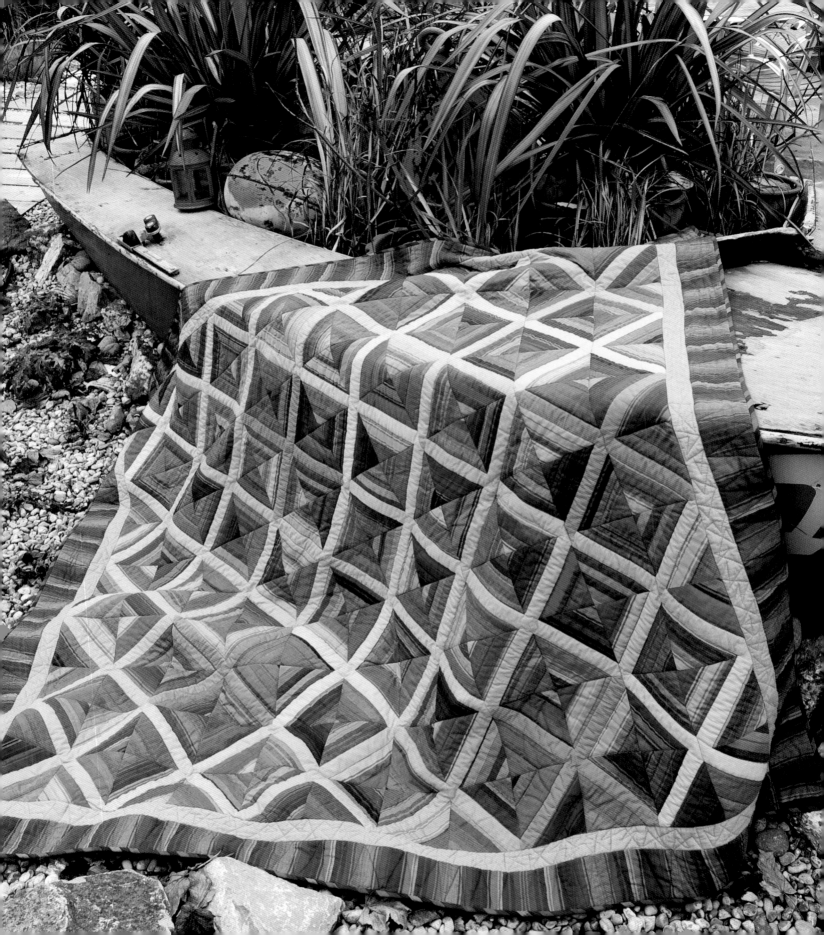

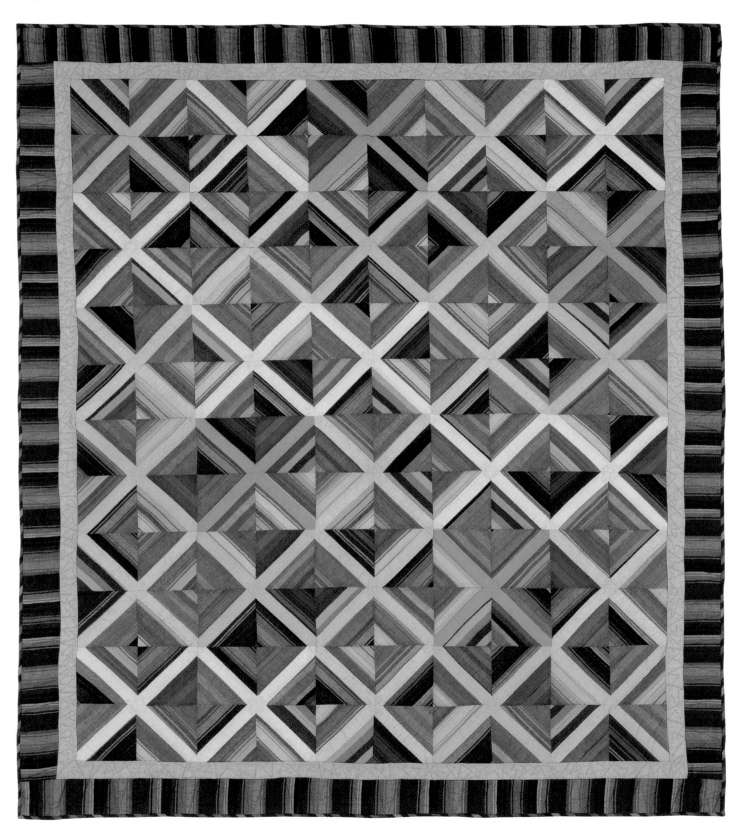

TIPS

Each block on this quilt is made up of only two template shapes so it looks quite simple to make, but it is actually a little tricky. The blocks all have bias edges, so a heavy dose of starch on the fabrics prior to cutting and lots of pinning are necessary to keep those bias edges from puckering. This is not a quilt for beginners!

CUTTING PATCHES

Press and starch the patchwork fabrics before cutting. Be extra-generous with the starch on the stripes. (Read page 163 for more information about preparing *Shot Cotton* and *Woven Stripes* for your patchwork project.)

Cut the borders first so you can use the left-over fabric for the blocks.

BORDERS

4 solid inner-border strips: From *Shot Cotton* in Lilac, cut two side borders 2" by 57 1/2" (5.1 cm by 146.1 cm) and a top and bottom border each 2" by 51" (5.1 cm by 129.5 cm).

4 striped outer-border strips: From Exotic Stripe in Purple, first cut seven strips from selvage to selvage, each 3 1/2" (8.9 cm) wide. (The stripes will then run perpendicular to the long sides of the strips.) Cut off the selvages at the ends of the strips, then sew the strips together end to end—pay attention to the stripe repeats so that the joins are nearly invisible. From this long pieced strip, cut two side borders 60 1/2" (153.7 cm) long and a top and bottom border each 57" (144.8 cm) long.

BLOCK PATCHES

The block patches are cut from two templates—Template Q and Template R.

240 striped Template-Q triangles: Cut all the stripe fabrics into strips each a scant 3 1/2" (8.9 cm) wide—cut them LENGTHWISE so that the stripes run parallel to the long sides of the strips. Then using Template Q, cut triangles from each of the strips. Cut 20–30 triangles from each of the nine stripe fabrics for a total of 240 triangles.

120 solid Template-R patches: Cut the seven solid fabrics (the *Shot Cottons*) into strips each 1 5/8" (4.1 cm) wide (the exact width of Template R). Cut a total of 120 Template-R patches from these strips—16 in Lilac, 20 in Lavender, 20 in Pink, 16 in Apricot, 16 in Honeydew, 16 in Pudding, and 16 in Watermelon.

MAKING BLOCKS

Make the blocks using a 1/4" (6-mm) seam allowance (the allowance marked on the templates).

The piecing is quite tricky, so be certain that the stripes are well starched and pressed. It is best to draw the seam lines on the back of the pieces. Pin carefully at the ends where the stripe and the solid seam lines match up.

Street markings become a dance of colorful lines that capture the spirit of X-Effect.

Assembly

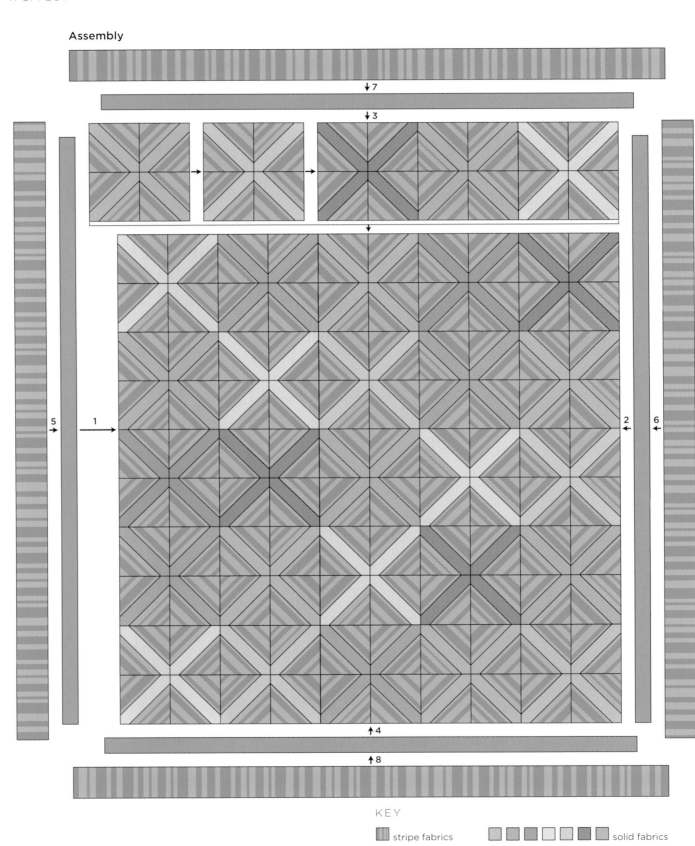

KEY

stripe fabrics solid fabrics

30 X-Effect Blocks: For each large X-Effect Block, choose eight different striped Template-Q triangles and four of the same solid-color Template-R patches. Following the diagram for the Small Blocks, sew a triangle to each side of each of the four solid patches. Then following the X-Effect Block diagram, sew the four Small Blocks together so that they form an X through the center of the large block. Make a total of 30 large blocks.

Small Block

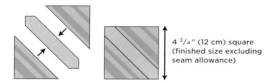

4 ³/₄" (12 cm) square
(finished size excluding
seam allowance)

X-Effect Block

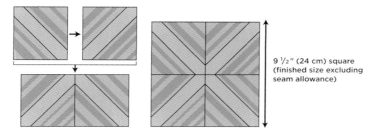

9 ¹/₂" (24 cm) square
(finished size excluding
seam allowance)

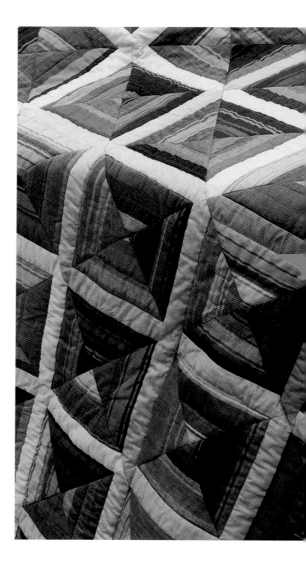

ASSEMBLING TOP

Arrange the blocks, either laying them out on the floor or sticking them to a cotton-flannel design wall. As shown on the assembly diagram, arrange six horizontal rows of five blocks each. Try to make sure that identical stripes do not meet at the seams.

Once you are satisfied with your arrangement, sew the blocks together in horizontal rows, using a 1/4" (6-mm) seam allowance throughout. Then sew the rows together.

Sew the longer solid inner borders to the sides of the quilt center, then sew on the top and bottom solid inner borders. Sew the longer striped outer borders to the sides of the quilt, then sew on the top and bottom striped outer borders.

FINISHING QUILT

Press the quilt top. Layer the quilt top, batting, and backing, then baste the layers together (see page 167).

Using a medium-dark taupe thread, machine quilt in-the-ditch around all the patches in the blocks, then quilt zigzags in the outer border. Using a lilac thread, quilt zigzags in the inner border.

Trim the edges of the backing and batting so that they align with the patchwork top. Then cut the binding on the bias and sew it on around the edge of the quilt (see page 167).

SQUARE IN SQUARE

This play on squares came to me from a tile wall in Baja California. Blue-and-white square patterned tiles were roughly painted by hand so each square was a different scale and intensity. The wall grabbed my eye and kept me looking at all the variations so I was sure it would be good as a subject for my next quilt. Looking at my range of shot cottons, I chose the dusty bluish ones first, then cool tones that would approximate my first blue impression of the tiles. Changing the bright cream of the tiles to ecru softened the contrast.

FINISHED SIZE

60" x 72" (155 cm x 186 cm)

MATERIALS

Use the specified 42–44"- (112–114-cm) wide fine-weight Kaffe Fassett *Shot Cottons* for the patchwork, and use an ordinary printed quilting-weight cotton fabric for the backing.

PATCHWORK FABRICS

Light fabrics: 1 1/4 yd (1.2 m) of *Shot Cotton* in Sandstone, and 1 yd (1 m) each of the following three colors—Tobacco, Lavender, and Lilac

Dark fabrics: 1 yd (1 m) of *Shot Cotton* in Bronze, and 1/2 yd (50 cm) each of the following six colors—Nut, Thunder, Steel, Eucalyptus, Bordeaux, and Moss

OTHER INGREDIENTS

Backing fabric: 4 yd (3.7 m) of desired printed quilting fabric

Binding fabric: 1/2 yd (50 cm) extra of *Shot Cotton* in Steel

Thin cotton batting: 67" x 79" (170 cm x 205 cm)

Quilting thread: Neutral medium-taupe thread

TIPS

Although this is a fairly easy quilt to make, the patches need to be cut and stitched precisely to form neat square blocks.

CUTTING PATCHES

Press and starch the patchwork fabrics before cutting. (Read page 163 for more information about preparing *Shot Cotton* for your patchwork project.)

The quilt is made up of three different blocks that are stitched together in the same way, but using different-size patches: Block A, Block B, and Block C. Each block is made with two colors, one light and one dark. There is no need to make this quilt exactly as the original; any combinations of lights and darks will work well.

When cutting the pieces for each individual block, pin them together in a stack.

BLOCK-A PATCHES

Cut the patches for each of the 40 Blocks A as follows:

1 center square: From the chosen light fabric, cut one center square 2" by 2" (5 cm by 5 cm).

4 inner-ring rectangles: From the chosen dark fabric, cut one rectangle (piece 1) measuring 1 1/4" by 2" (3.5 cm by 5 cm), two rectangles (pieces 2 and 3) measuring 1 1/4" by 2 3/4" (3.5 cm by 7 cm), and one rectangle (piece 4) measuring 1 1/4" by 3 1/2" (3.5 cm by 9 cm).

4 outer-ring rectangles: From the chosen light fabric, cut one rectangle (piece 5) measuring 2" by 3 1/2" (5.5 cm by 9 cm), two rectangles (pieces 6 and 7) measuring 2" by 5" (5.5 cm by 13 cm), and one rectangle (piece 8) measuring 2" by 6 1/2" (5.5 cm by 17 cm).

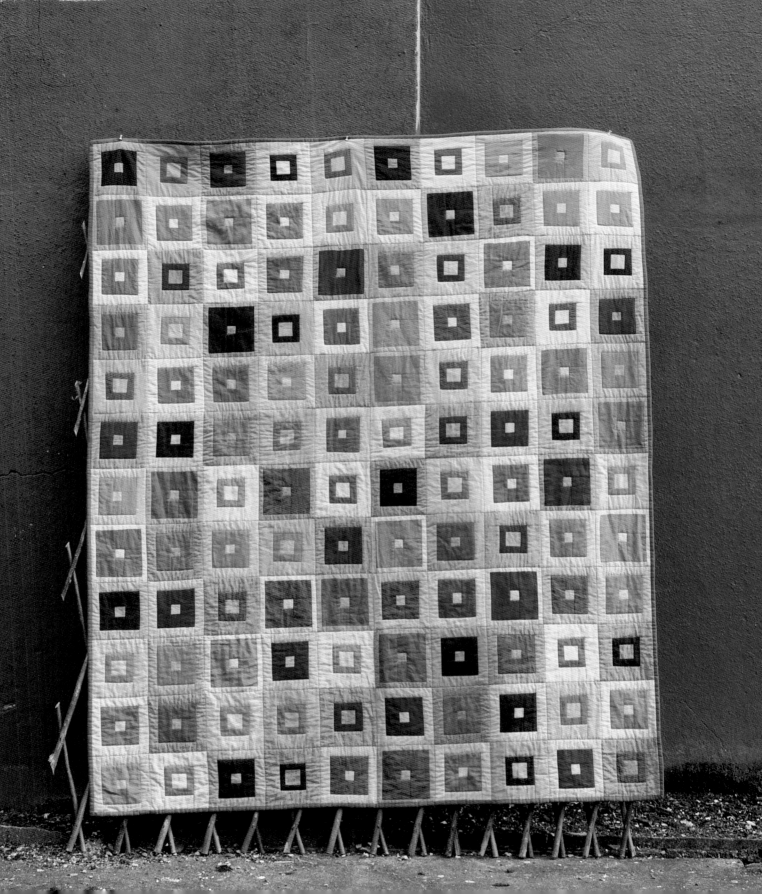

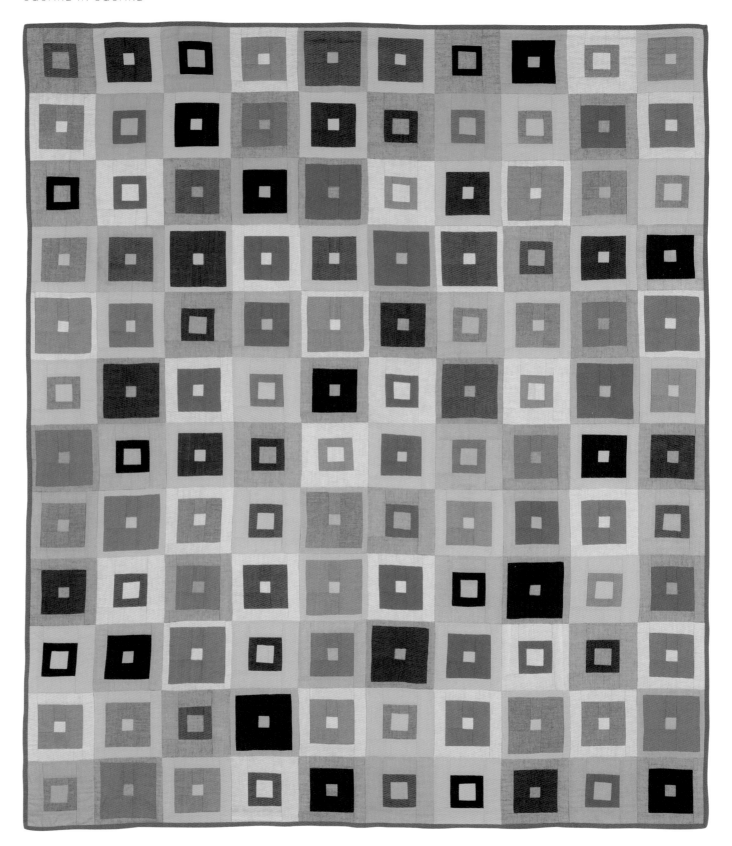

BLOCK-B PATCHES

Cut the patches for each of the 57 Blocks B as follows:

1 center square: From the chosen light fabric, cut one center square 1 1/2" by 1 1/2" (4 cm by 4 cm).

4 inner-ring rectangles: From the chosen dark fabric, cut one rectangle (piece 1) measuring 2" by 1 1/2" (5.5 cm by 4 cm), two rectangles (pieces 2 and 3) measuring 2" by 3" (5.5 cm by 8 cm), and one rectangle (piece 4) measuring 2" by 4 1/2" (5.5 cm by 12 cm).

4 outer-ring rectangles: From the chosen light fabric, cut one rectangle (piece 5) measuring 1 1/2" by 4 1/2" (4 cm by 12 cm), two rectangles (pieces 6 and 7) measuring 1 1/2" by 5 1/2" (4 cm by 14.5 cm), and one rectangle (piece 8) measuring 1 1/2" by 6 1/2" (4 cm by 17 cm).

BLOCK-C PATCHES

Cut the patches for each of the 23 Blocks C as follows:

1 center square: From the chosen light fabric, cut one center square 1 1/2" by 1 1/2" (4 cm by 4 cm).

4 inner-ring rectangles: From the chosen dark fabric, cut one rectangle (piece 1) measuring 2 1/2" by 1 1/2" (6.5 cm by 4 cm), two rectangles (pieces 2 and 3) measuring 2 1/2" by 3 1/2" (6.5 cm by 9 cm), and one rectangle (piece 4) measuring 2 1/2" by 5 1/2" (6.5 cm by 14 cm).

4 outer-ring rectangles: From the chosen light fabric, cut one rectangle (piece 5) measuring 1" by 5 1/2" (3 cm by 14 cm), two rectangles (pieces 6 and 7) measuring 1" by 6" (3 cm by 15.5 cm), and one rectangle (piece 8) measuring 1" by 6 1/2" (3 cm by 17 cm).

MAKING BLOCKS

Make the blocks using a 1/4" (7.5-mm) seam allowance.

40 Blocks A: Following the diagram for Block A, sew the pieces together in the order shown. First sew the shortest dark rectangle (piece 1) to the top of the center square. Then adding on the dark pieces in a counterclockwise direction around the center, sew on the two medium-length dark rectangles (pieces 2 and 3), and lastly the longest dark rectangle (piece 4). For the outer ring, first sew on the shortest light rectangle (piece 5) to the top of the block. Then sew on the two medium-length light rectangles (pieces 6 and 7), and lastly the longest light rectangle (piece 8). Make a total of 40 Blocks A.

Block A

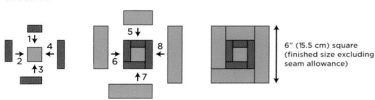

6" (15.5 cm) square (finished size excluding seam allowance)

The cool tones of an abstract of square shapes on a building site remind me of my Square in Square quilt.

Assembly

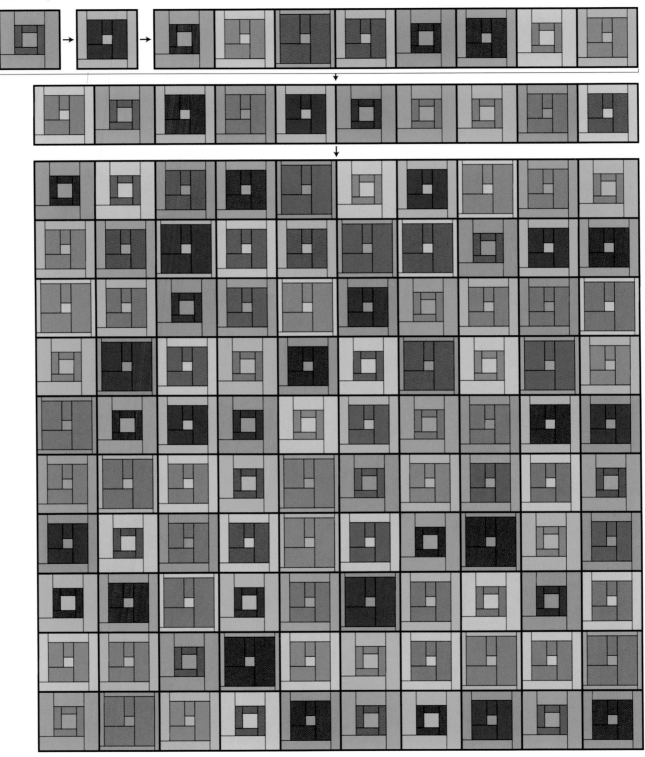

KEY

dark fabrics light fabrics

57 Blocks B: Following the diagram for Block B, sew on the dark rectangles (pieces 1–4) around the center square in a counterclockwise direction as for Block A. Then, for the outer ring, sew on pieces 5–8 as for Block A, again adding them on in a counterclockwise direction. Make a total of 57 Blocks B.

Block B

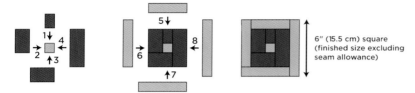

6″ (15.5 cm) square (finished size excluding seam allowance)

23 Blocks C: Following the diagram for Block C, sew on the dark rectangles (pieces 1–4) around the center square in a counterclockwise direction as for Block A. Then, for the outer ring, sew on pieces 5–8 as for Block A, again adding them on in a counterclockwise direction. Make a total of 23 Blocks C.

Block C

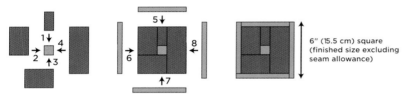

6″ (15.5 cm) square (finished size excluding seam allowance)

ASSEMBLING TOP

Arrange the blocks, either laying them out on the floor or sticking them to a cotton-flannel design wall. As shown on the assembly diagram, arrange 12 horizontal rows of ten blocks each. Aim for a pleasing random mix of colors and block types.

Once you are satisfied with your arrangement, sew the blocks together in horizontal rows, using a ¼″ (7.5-mm) seam allowance throughout. Then sew the rows together.

FINISHING QUILT

Press the quilt top. Layer the quilt top, batting, and backing, then baste the layers together (see page 167).

Using a neutral medium-taupe thread, machine stitch in-the-ditch around each block on the quilt. Then machine stitch in-the-ditch around the square formed by the first round of strips on all Blocks A and Blocks B; on Blocks C, machine stitch in-the-ditch around the center square.

Trim the edges of the backing and batting so that they align with the patchwork top. Then cut the binding on the bias and sew it on around the edge of the quilt (see page 167).

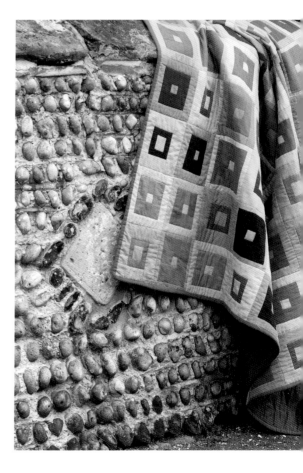

JAMBO THROW

This bold weave-pattern reflects the many hours I have spent pouring over books about African woven textiles. The African narrow-strip weavings are striped in mainly golds, rusts, and cobalt blue. The intense stripe repetitions in these cloths have always taken me on a trip. For my interpretation, I chose all the hot golds, rusts, and wine tones from my stripes, and threw in one cooler gray lavender stripe to add a ping of difference. The result is like all the leaves of autumn collaged into a quilt.

The stripes on the African cloths usually all run in one direction, but by placing my stripes in a weave-pattern—alternating vertically and horizontally—I created an exciting rhythm. The spatial variations within the stripe designs and the color tones give the quilt a richness. The border uses only one stripe fabric, though it looks like more because of the variations in it. I wasn't tempted to put any solid *Shot Cottons* in this throw as I wanted to capture the mesmeric quality of the obsessive pattern on the striped African cloths. I get deliriously lost in all those stripes. I didn't want any let-up! No restful spaces.

FINISHED SIZE

40" x 50" (104 cm x 130 cm)

MATERIALS

Use the specified 42–44"- (112–114-cm-) wide fine-weight Kaffe Fassett *Woven Stripes* for the patchwork, and use an ordinary printed quilting-weight cotton fabric for the backing.

PATCHWORK FABRICS

Border fabric: 1/2 yd (50 cm) of *Caterpillar Stripe* in Yellow

Stripe fabrics: 1/8–1/3 yd (15–35 cm) each of the following 13 stripes—*Caterpillar Stripe* in Tomato, Earth, and Dusk; *Exotic Stripe* in Midnight, Purple, Earth, and Dusk; *Broad Stripe* in Red and in Sunset; *Narrow Stripe* in Red; *Alternating Stripe* in Orange, Red, and Olive

OTHER INGREDIENTS

Backing fabric: 3 yd (2.8 m) of desired printed quilting fabric

Binding fabric: 1/2 yd (50 cm) extra of *Caterpillar Stripe* in Yellow

Thin cotton batting: 47" x 57" (120 cm x 145 cm)

Quilting thread: Ocher-colored thread

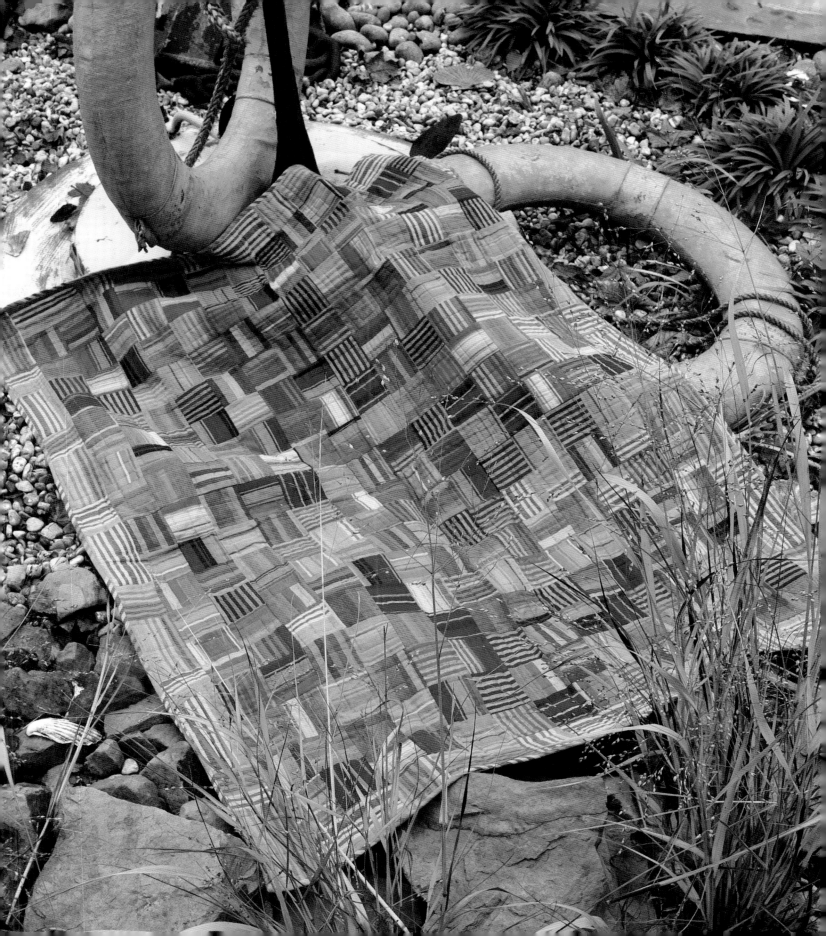

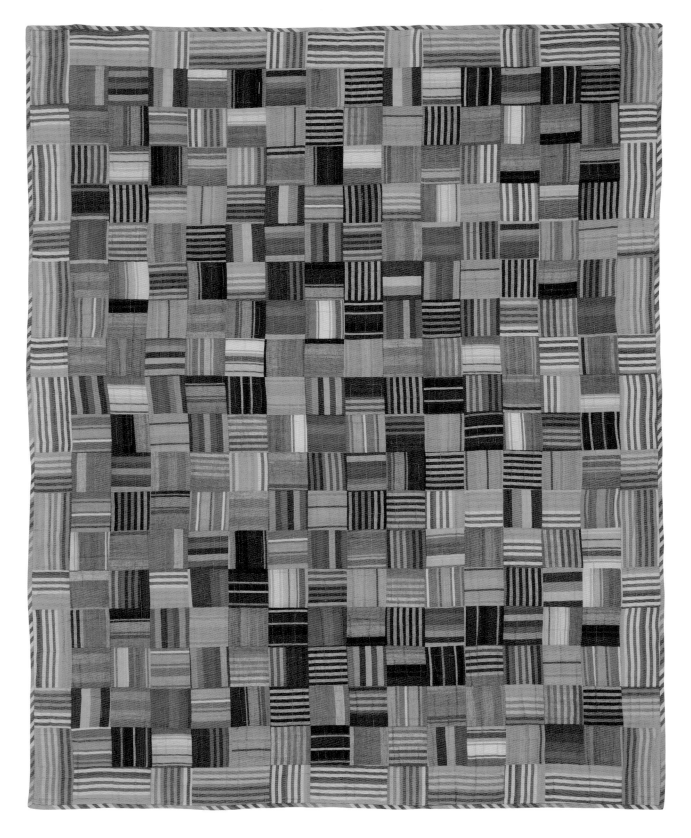

TIPS

Making this simple quilt is a great way to use up scraps of the Kaffe Fassett *Woven Stripes*. There is no need to stick to the original color palette to achieve a beautiful effect. The center of the quilt is made up of only one size square and the border from the same square size plus one size rectangle, so it is a good quilt for a beginner.

CUTTING PATCHES

Press and starch the patchwork fabrics before cutting. (Read page 163 for more information about preparing *Woven Stripes* for your patchwork project.)

Cut the border pieces first so you can use any left-over border fabric for the square patches at the center of the quilt.

20 border squares: From the border fabric, cut 20 squares 3″ by 3″ (8 cm by 8 cm).

24 border rectangles: From the border fabric, cut 24 rectangles 3″ by 5 1/2″ (8 cm by 14.5 cm), with the stripes running parallel to the long sides. Stack the border squares and rectangles together so they don't get mixed in with the other squares you are about to cut.

252 center-quilt squares: From the stripe fabrics, cut a total of 252 squares 3″ by 3″ (8 cm by 8 cm).

ASSEMBLING TOP

Arrange the 252 center-quilt squares, either laying them out on the floor or sticking them to a cotton-flannel design wall. Position them into 18 horizontal rows of 14 squares each and alternate the direction of the stripe so every other square has horizontal stripes and every other square has vertical stripes. Mix the colors randomly.

Using a 1/4″ (7.5-mm) seam allowance throughout, sew the squares together in horizontal rows as shown on the assembly diagram. Then sew the rows together.

Make the top and bottom borders by sewing together four border squares and five border rectangles, alternating the squares and rectangles and starting and ending with a rectangle.

Make two side borders in the same way, but using six border squares and seven border rectangles for each.

Sew the top and bottom borders to the quilt center, then sew on the side borders.

This woven African cloth boasts just the sort of playful stripe mood I was trying for in Jambo.

Assembly

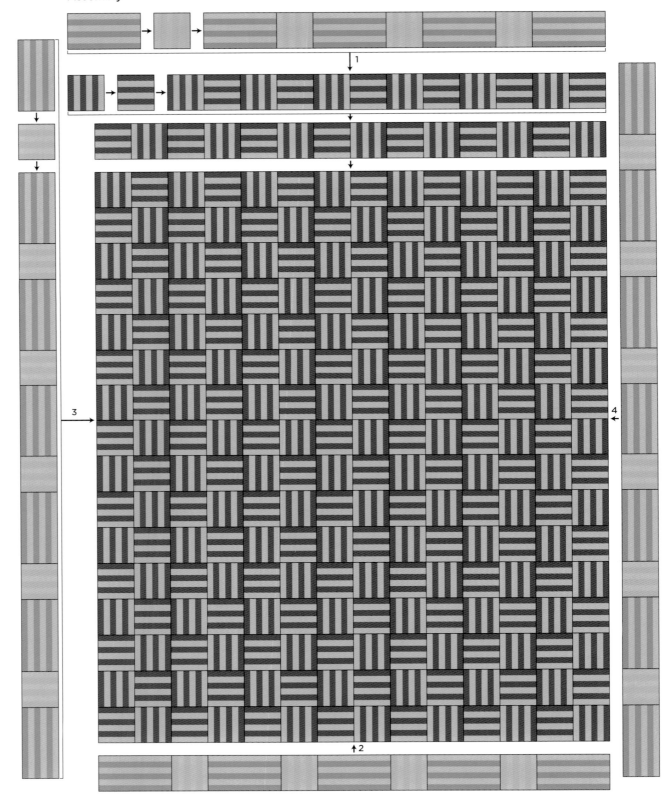

FINISHING QUILT

Press the quilt top. Layer the quilt top, batting, and backing, then baste the layers together (see page 167).

Using an ocher-colored thread, machine quilt little free-form square shapes inside each square and two free-form squares in each rectangle.

Trim the edges of the backing and batting so that they align with the patchwork top. Then cut the binding on the bias and sew it on around the edge of the quilt (see page 167).

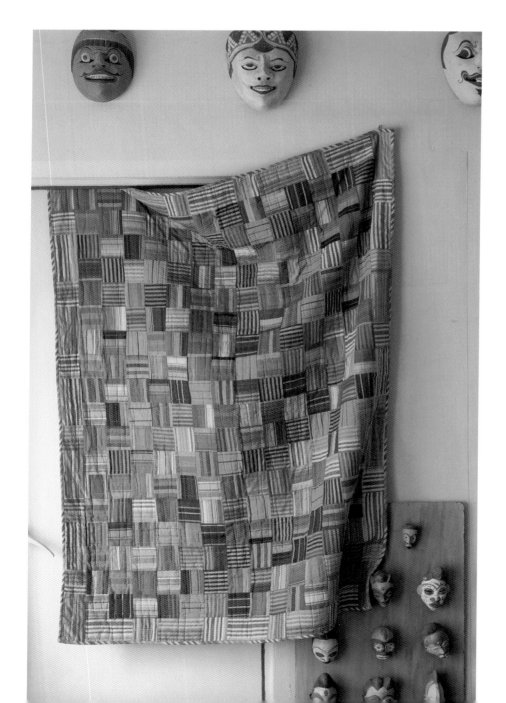

ROSITA ZIGZAG

The great Missoni family in Italy, who produce the world's most stunning machine-made knitwear, have taken a zigzag pattern like this as their signature motif. I worked with them in the 1970s when I had just started knitting. They saw my first published design in British *Vogue* and flew to London from Milan to sign me up. It was a thrill, indeed, to work for these switched-on, elegant Italians, Tai and Rosita Missoni, who understood my love of color perfectly. For our quilted homage to them, we chose a rather Byzantine palette.

FINISHED SIZE

82" x 85 1/4" (208.3 cm x 216.5 cm)

MATERIALS

Use the specified 42–44"- (112–114-cm-) wide fine-weight Kaffe Fassett *Shot Cottons* and *Woven Stripes* for the patchwork, and use an ordinary quilting-weight print for the backing.

PATCHWORK FABRICS

Stripe fabrics: 1 1/8 yd (1.1 m) each of the following 11 stripes—*Broad Stripe* (BS) in Red, Yellow, and Sunset; *Alternating Stripe* (AS) in Red, Olive, Orange, and Blue; *Narrow Stripe* (NS) in Yellow; *Caterpillar Stripe* (CS) in Earth and in Dark; and *Exotic Stripe* (ES) in Midnight

Solid fabrics: *Shot Cotton* (SC) of each of the following eight colors—1/2 yd (50 cm) of each of Thunder and Bronze; and 1/4 yd (30 cm) of each of Apricot, Tangerine, Ecru, Galvanized, Pudding, and Watermelon

OTHER INGREDIENTS

Backing fabric: 8 1/2 yd (7.6 m)

Binding fabric: 3/4 yd (70 cm) extra of *Shot Cotton* in Bronze

Thin cotton batting: 89" x 93" (225 cm x 235 cm)

Quilting thread: Ocher-colored thread

Templates: See page 173.

TIPS

For those who would like a patchwork challenge, this is a quilt that will test your patch-cutting and sewing skills. As there will be plenty of excess fabric left over, you can make the quilt larger if you like.

CUTTING PATCHES

Before cutting, press and starch the patchwork fabrics, straightening the stripes as much as possible. (Read page 163 for more information about preparing *Woven Stripes* for your patchwork project.)

There are 32 horizontal rows of zigzags across the quilt. Some of the zigzags are made up of striped fabrics and some of solids. The striped zigzag rows have 24 Template-K diamonds that form the zigzags, and start and end with a Template-L rectangle. (Note that because the *Shot Cottons* and *Woven Stripes* are reversible, the patches can be flopped to form the reversed shapes required, but if you were using printed solids or stripes, you would need to use reverse shape templates to cut the mirror-image patches.)

The solid zigzag rows have 24 Template-M parallelograms that form the zigzags, and start and end with a Template-N rectangle.

The edging pieces for the top and bottom of the quilt are Template-O triangles, and at the top two corners of the quilt Template-P rectangles.

STRIPED ZIGZAGS

Consult the Fabric and Template Chart on page 134 for which fabrics (and templates) to use for each zigzag row. DO NOT cut the stripes in layers.

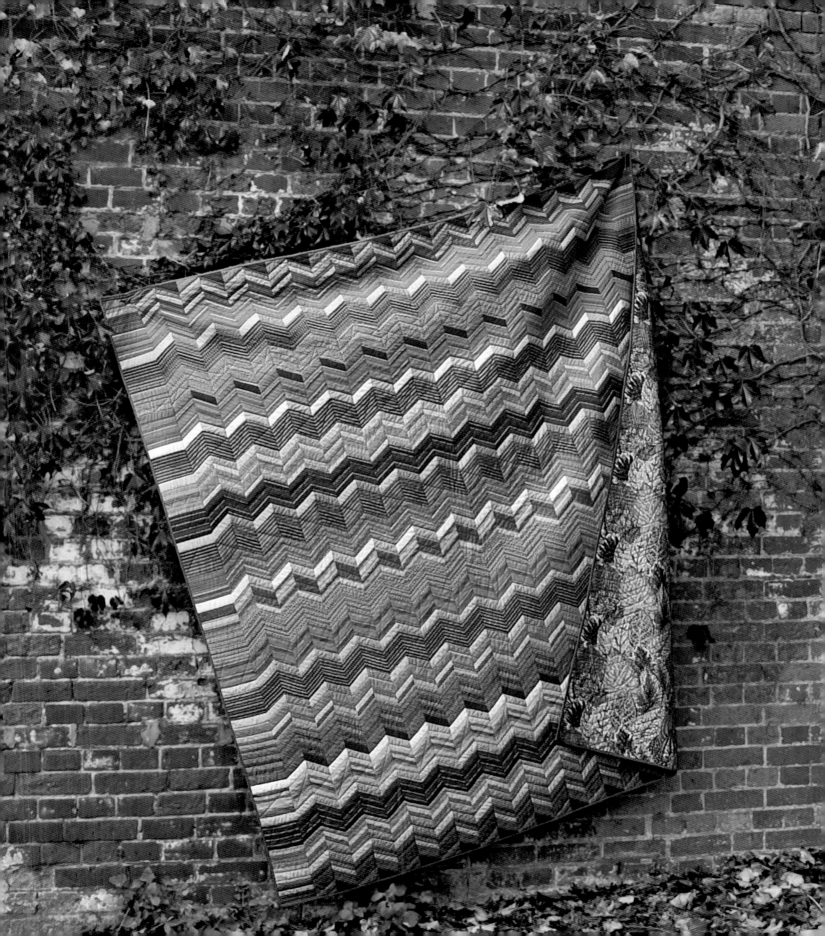

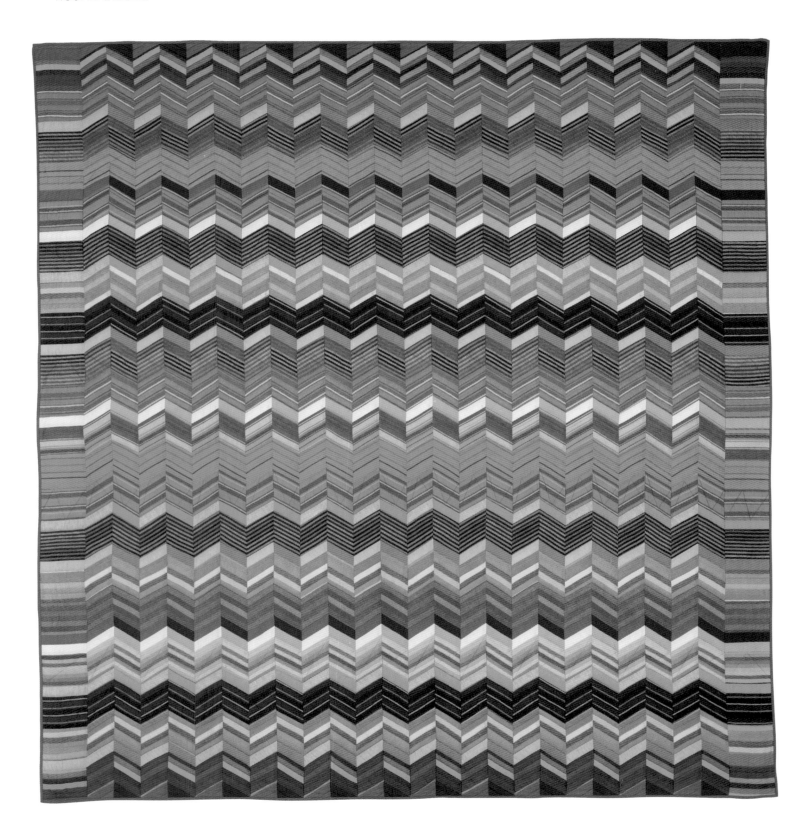

Zigzag 1: The first zigzag row at the top of the quilt is made from Broad Stripe in Red (see the chart). Each striped zigzag is made up of 24 diamonds—12 cut from one stripe sequence for the "uphill" segments (see Strip B), and 12 cut from the same fabric but from another stripe sequence for the "downhill" segments (see Strip C).

To cut the patches for this row of diamonds, first cut one 3 1/2" (8.9-cm) strip of fabric from the 1 1/8-yd (1.1-m) piece of the stripe fabric, cutting the strip parallel to the selvage so the stripes run lengthwise. (Cut the strip as straight as possible, as you must cut matching patches from it.) Now find a matching sequence of stripes on the fabric and cut an identical strip. From these two identical strips, cut a total of 12 matching Template-K diamonds from these two strips—eight from one strip and four from the other. (Reserve the rest of the second strip for more patches if you want to make the quilt wider.) Keep these 12 patches together.

Next, cut two more (different) matching strips from Broad Stripe in Red and cut 12 matching Template-K diamonds from these in the same way. Keep these 12 patches together.

For striped patches at the beginning and the end of Zigzag 1, cut two Template-L rectangles from Broad Stripe in Red, with the stripes running parallel to the longest edges. These do not need to match the same stripe sequence as the diamonds. Keep these patches with the other two piles of patches.

Cut patches for all the remaining striped horizontal zigzags in the same way as you cut the pieces for Zigzag 1. Label each of the groups of patches with their zigzag row number.

SOLID ZIGZAGS

Consult the Fabric and Template Chart for which fabrics (and templates) to use for each horizontal zigzag.

Zigzag 3: The third zigzag row on the quilt is the first solid zigzag. Each solid zigzag is made from one light and one dark solid. Use *Shot Cotton* in Pudding and in Watermelon for Zigzag 3 (see the chart). Each solid zigzag is made up of 24 parallelograms—12 cut from the lighter solid for the "uphill" segments (see Strip B), and 12 cut from the darker solid for the "downhill" segments (see Strip C).

For Zigzag 3, cut 12 Template-M parallelograms from Pudding and 12 from Watermelon. Keep these two sets of 12 patches together.

For solid patches at the beginning and the end of Zigzag 3, cut two Template-N rectangles—one from Pudding and one from Watermelon. Keep these patches with the other two piles of patches.

Cut patches for all the remaining solid horizontal zigzags in the same way as you cut the pieces for Zigzag 3. Label each of the groups of patches with their zigzag row number.

Fabric and Template Chart

HORIZONTAL ZIGZAG	VERTICAL STRIP A TEMPLATE/FABRIC	VERTICAL STRIP B TEMPLATE/FABRIC	VERTICAL STRIP C TEMPLATE/FABRIC	VERTICAL STRIP D TEMPLATE/FABRIC
Edging	P/SC in Bronze	O/SC in Bronze	O/SC in Thunder	P/SC in Thunder
Zigzag 1	L/BS in Red	K/BS in Red	K/BS in Red	L/BS in Red
Zigzag 2	L/AS in Olive	K/AS in Olive	K/AS in Olive	L/AS in Olive
Zigzag 3	N/SC in Pudding	M/SC in Pudding	M/SC in Watermelon	N/SC in Watermelon
Zigzag 4	L/CS in Dark	K/CS in Dark	K/CS in Dark	L/CS in Dark
Zigzag 5	L/AS in Orange	K/AS in Orange	K/AS in Orange	L/AS in Orange
Zigzag 6	N/SC in Bronze	M/SC in Bronze	M/SC in Thunder	N/SC in Thunder
Zigzag 7	L/AS in Blue	K/AS in Blue	K/AS in Blue	L/AS in Blue
Zigzag 8	N/SC in Ecru	M/SC in Ecru	M/SC in Galvanized	N/SC in Galvanized
Zigzag 9	L/CS in Earth	K/CS in Earth	K/CS in Earth	L/CS in Earth
Zigzag 10	N/SC in Apricot	M/SC in Apricot	M/SC in Tangerine	N/SC in Tangerine
Zigzag 11	L/BS in Yellow	K/BS in Yellow	K/BS in Yellow	L/BS in Yellow
Zigzag 12	L/AS in Red	K/AS in Red	K/AS in Red	L/AS in Red
Zigzag 13	N/SC in Pudding	M/SC in Pudding	M/SC in Watermelon	N/SC in Watermelon
Zigzag 14	L/CS in Dark	K/CS in Dark	K/CS in Dark	L/CS in Dark
Zigzag 15	L/AS in Olive	K/AS in Olive	K/AS in Olive	L/AS in Olive
Zigzag 16	N/SC in Ecru	M/SC in Ecru	M/SC in Galvanized	N/SC in Galvanized
Zigzag 17	L/ES in Midnight	K/ES in Midnight	K/ES in Midnight	L/ES in Midnight
Zigzag 18	L/AS in Orange	K/AS in Orange	K/AS in Orange	L/AS in Orange
Zigzag 19	L/AS in Blue	K/AS in Blue	K/AS in Blue	L/AS in Blue
Zigzag 20	N/SC in Apricot	M/SC in Apricot	M/SC in Tangerine	N/SC in Tangerine
Zigzag 21	L/CS in Earth	K/CS in Earth	K/CS in Earth	L/CS in Earth
Zigzag 22	N/SC in Pudding	M/SC in Pudding	M/SC in Watermelon	N/SC in Watermelon
Zigzag 23	L/BS in Yellow	K/BS in Yellow	K/BS in Yellow	L/BS in Yellow
Zigzag 24	L/BS in Sunset	K/BS in Sunset	K/BS in Sunset	L/BS in Sunset
Zigzag 25	N/SC in Bronze	M/SC in Bronze	M/SC in Thunder	N/SC in Thunder
Zigzag 26	N/SC in Ecru	M/SC in Ecru	M/SC in Galvanized	N/SC in Galvanized
Zigzag 27	L/NS in Yellow	K/NS in Yellow	K/NS in Yellow	L/NS in Yellow
Zigzag 28	N/SC in Apricot	M/SC in Apricot	M/SC in Tangerine	N/SC in Tangerine
Zigzag 29	L/AS in Red	K/AS in Red	K/AS in Red	L/AS in Red
Zigzag 30	L/BS in Yellow	K/BS in Yellow	K/BS in Yellow	L/BS in Yellow
Zigzag 31	N/SC in Pudding	M/SC in Pudding	M/SC in Watermelon	N/SC in Watermelon
Zigzag 32	L/BS in Red	K/BS in Red	K/BS in Red	L/BS in Red
Edging	(no patch)	O/SC in Bronze	O/SC in Thunder	(no patch)

Strip Assembly

Strip A

Edging

1

2

3

4

5
6
7
8
9
10
11
12
13
14
15
16
17
18
19
20
21
22
23
24
25
26
27
28
29
30
31
32

Strip B

Edging

1

2

3

4

5
6
7
8
9
10
11
12
13
14
15
16
17
18
19
20
21
22
23
24
25
26
27
28
29
30
31
32

↑
Edging

Strip C

Edging

1

2

3

4

5
6
7
8
9
10
11
12
13
14
15
16
17
18
19
20
21
22
23
24
25
26
27
28
29
30
31
32

↑
Edging

Strip D

Edging

1

2

3

4

5
6
7
8
9
10
11
12
13
14
15
16
17
18
19
20
21
22
23
24
25
26
27
28
29
30
31
32

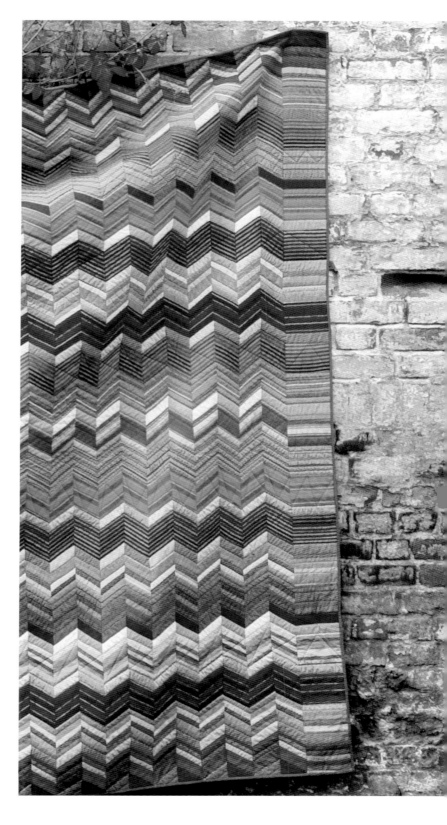

Assembly

Strip A

Strip B

Strip C

Strip D

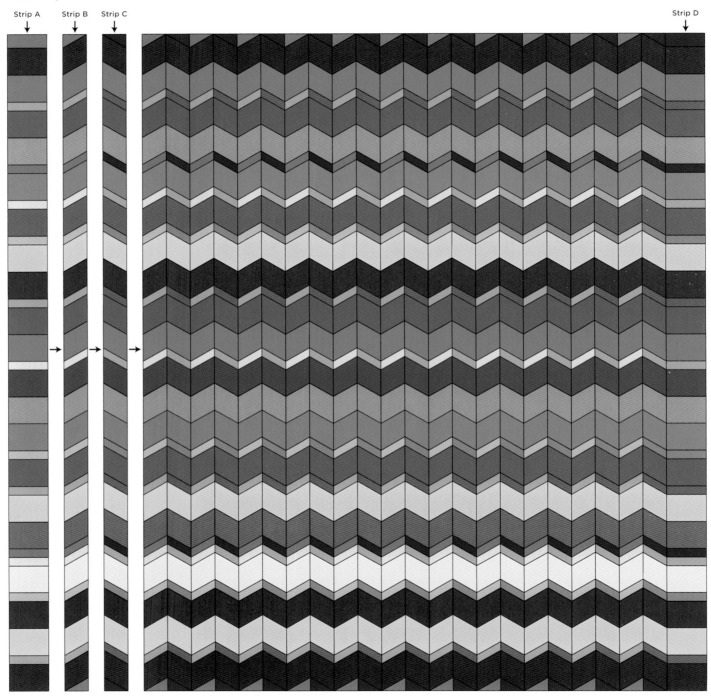

EDGING PATCHES

For the top and bottom solid edging patches on the quilt, cut 24 Template-O triangles from *Shot Cotton* in Thunder and 24 in Bronze. For the top corners, cut two Template-P rectangles—one from Thunder and one from Bronze.

ASSEMBLING TOP

Arrange the cut patches, either laying them out on the floor or sticking them to a cotton-flannel design wall. Start with horizontal Zigzag 1 at the top of the quilt. Look at the two sets of matching diamonds, and if one set looks slightly darker than the other, use the darker set for the "downhill" diamonds. Arrange the patches for Zigzag 1, positioning a rectangle at the beginning and end of the row. The stripes on all the "uphill" diamonds (Strip B) and the "downhill" diamonds (Strip C) meet to form zigzag stripes, but they do not match as they are cut from different stripe sequences.

Position striped Zigzag 2 in the same way. Then position Zigzag 3 (a solid zigzag), placing the lighter parallelograms in the "uphill" and the darker parallelograms in the "downhill" positions. Place the lighter rectangle at the beginning of the row and the darker one at the end.

Arrange all the zigzag rows in this way, following the Fabric and Template Chart.

Using a 1/4" (6-mm) seam allowance throughout (the seam allowance marked on the templates), sew the patches together in vertical rows. The strip assembly diagram shows how to assemble each of the four different types of vertical strips. Strip A is the first vertical row on the left of the quilt; the numbers on it are the zigzag row numbers. Strips B and C are the strips that are repeated across the quilt to form the zigzags. Strip D is the last vertical row on the left of the quilt. Sew pieces in each of the vertical rows together. Then sew the pieced vertical rows to one another as shown in the assembly diagram.

FINISHING QUILT

Press the quilt top. Layer the quilt top, batting, and backing, then baste the layers together (see page 167).

Using an ocher-colored thread, machine quilt in-the-ditch horizontally between the band of zigzags. Then quilt at intervals along the stripes in the striped zigzags to emphasize the stripes.

Trim the edges of the backing and batting so that they align with the patchwork top. Then cut the binding on the bias and sew it on around the edge of the quilt (see page 167).

GIRDER

I found a little thumbnail sketch of this layout in my diary, and it suddenly begged to be done. I can't even remember where I found the idea. I sketch many interesting structures as I travel and review them from time to time to see if they apply to what I'm designing at the moment. It's fascinating to watch something that was a little black-and-white pen drawing get blown up to a full-color reality. For this quilt I picked colors that I'd noticed on ancient Italian murals that had faded with time and grime. Restraining color is often as exciting as applying it in full-blooded gypsy style. Certain colors can come alive only when their surroundings are subdued. That mulberry tone in the back of the lattice would be gray in many contexts but is a glowing pink in this setting.

I love woven structures, from ribbons on old-fashioned letterboards to metal girders on Victorian ironwork. I've often knitted ribbonlike structures and have a formula that allows me to plow on without coming to grief with colors of ribbons melting into one another as they meet in the design. I make all the ribbon colors cool tones going in one direction and warm going in the other, so where they cross each other they stay distinct. I've applied that principle here.

The cool fresco tones of this structured design appeal to me. The neutral shades would work well in a soft gray room with bleached furniture. It could also be done in prints to look more like a weave of ribbons in a more jolly mood.

FINISHED SIZE

79" x 90 1/2" (200.7 cm x 229.9 cm)

MATERIALS

Use the specified 42–44"- (112–114-cm-) wide fine-weight Kaffe Fassett *Shot Cottons* for the patchwork, and use an ordinary printed quilting-weight cotton fabric for the backing.

PATCHWORK FABRICS

Border-triangle fabric: 1 1/4 yd (1.2 m) of *Shot Cotton* in Moor

Light-triangle fabric: 1 3/4 yd (1.6 m) of *Shot Cotton* in Granite

Dark-triangle fabrics: 3/4 yd (70 cm) of *Shot Cotton* in each of the following three colors—Thunder, Steel, and Bordeaux

Medium left-slanted rectangle fabrics: 3/4 yd (70 cm) of *Shot Cotton* in each of the following three colors—Nut, Bronze, and Pewter

Light-medium right-slanted rectangle fabrics: 3/4 yd (70 cm) of *Shot Cotton* in each of the following three colors—Blueberry, Galvanized, and Smoky

OTHER INGREDIENTS

Backing fabric: 7 1/2 yd (6.9 m) of desired printed quilting fabric

Binding fabric: 3/4 yd (70 cm) extra of *Shot Cotton* in Moor

Thin cotton batting: 86" x 97" (215 cm x 245 cm)

Quilting thread: Dark-taupe thread

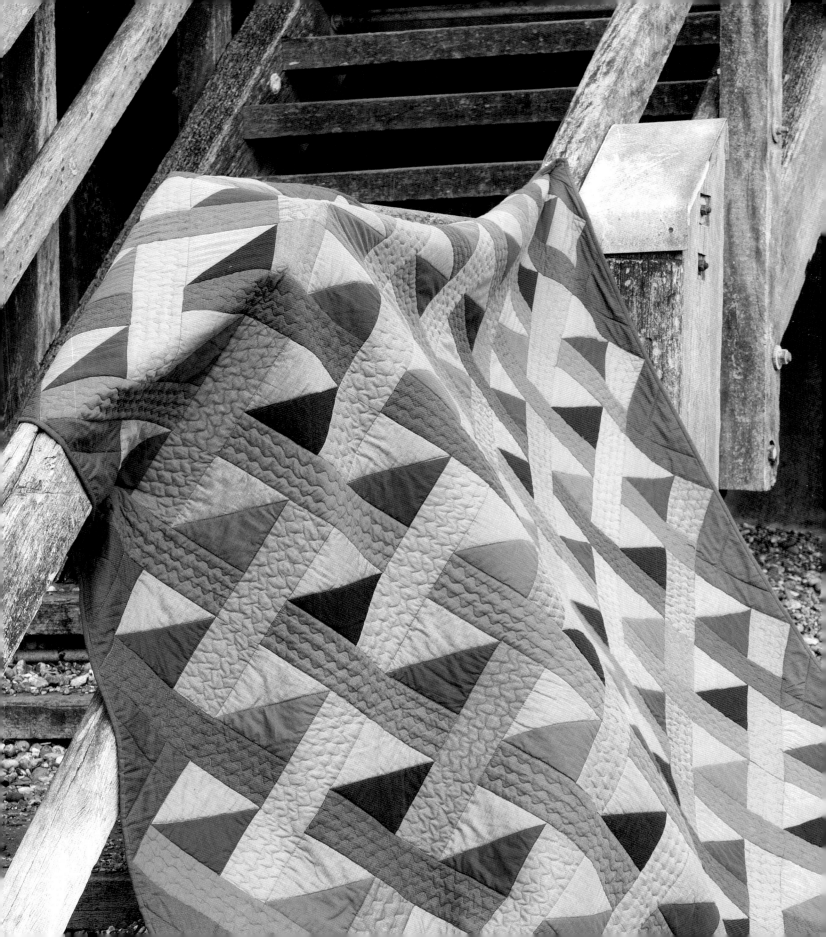

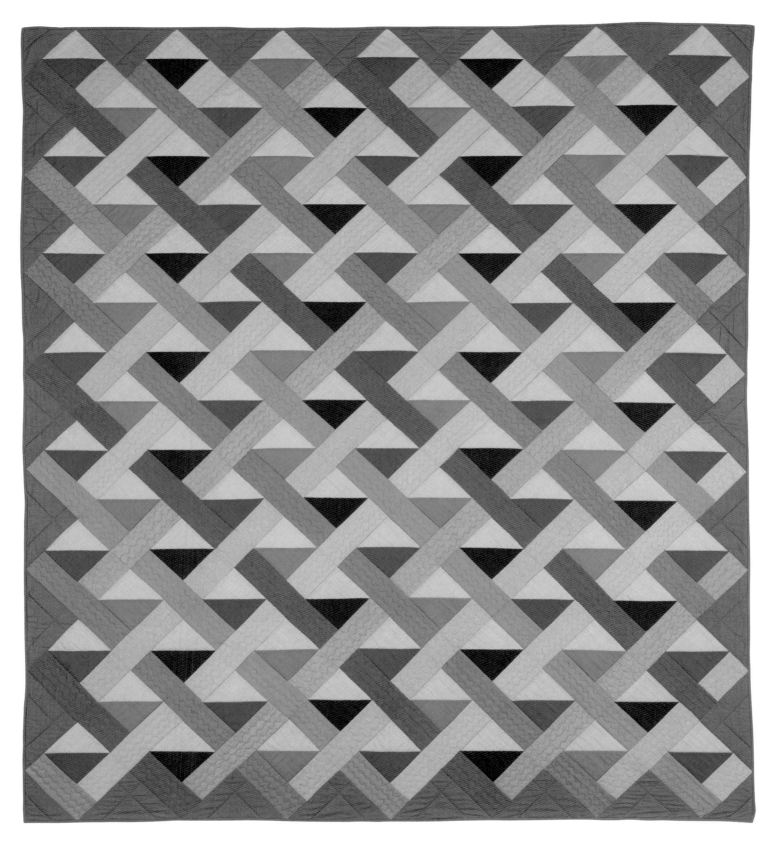

TIPS

Made entirely from Kaffe Fassett solid-colored *Shot Cottons*, the pieces for this quilt are easy to cut and the blocks easy to stitch. Some patience is required, however, making and arranging the blocks carefully row by row, to form the woven appearance of the format. All the colors are chosen for you. If you want to change the colors, pay careful attention to the positions of the light, dark, and medium tones.

CUTTING PATCHES

Press and starch the patchwork fabrics before cutting. (Read page 163 for more information about preparing *Shot Cotton* for your patchwork project.)

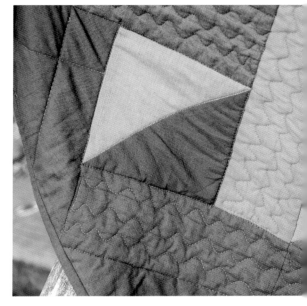

BORDER EDGING TRIANGLES

26 large edging triangles: From the border-triangle fabric (Moor), cut seven squares 12 5/8" by 12 5/8" (32.1 cm by 32.1 cm) and cut each of them diagonally from corner to corner in both directions to make four quarter-square triangles—for a total of 28 large triangles. You need only 26, so you can discard two.

4 small edging-corner triangles: From the border-triangle fabric (Moor), cut two squares 6 5/8" by 6 5/8" (16.8 cm by 16.8 cm) and cut each of them diagonally from corner to corner to make two half-square triangles—for a total of four small triangles.

TRIANGLE-SQUARES

98 light triangles: From the light-triangle fabric (Granite), cut 49 squares 5 7/8" by 5 7/8" (14.9 cm by 14.9 cm) and cut each of them diagonally from corner to corner to make two half-square triangles—for a total of 98 triangles.

98 dark triangles: From the dark-triangle fabrics, cut a total of 49 squares 5 7/8" by 5 7/8" (14.9 cm by 14.9 cm)—cutting 19 of these squares from Thunder, 15 from Steel, and 15 from Bordeaux. Then cut each square diagonally from corner to corner to make two half-square triangles—for a total of 38 Thunder triangles, 30 Steel triangles, and 30 Bordeaux triangles.

Lavender, green, and pink glass on a drain cover reflects the palette of Girder.

RECTANGLES

Nut and Bronze rectangles: From each of Nut and Bronze, cut 14 short rectangles 3 1/2" by 5 1/2" (8.9 cm by 14 cm) and 19 long rectangles 3 1/2" by 8 1/2" (8.9 cm by 21.6 cm).

Pewter rectangles: From Pewter, cut 14 short rectangles 3 1/2" by 5 1/2" (8.9 cm by 14 cm) and 18 long rectangles 3 1/2" by 8 1/2" (8.9 cm by 21.6 cm).

Blueberry and Galvanized rectangles: From each of Blueberry and Galvanized, cut 19 short rectangles 3 1/2" by 5 1/2" (8.9 cm by 14 cm) and 14 long rectangles 3 1/2" by 8 1/2" (8.9 cm by 21.6 cm).

Smoky rectangles: From Smoky, cut 18 short rectangles 3 1/2" by 5 1/2" (8.9 cm by 14 cm) and 14 long rectangles 3 1/2" by 8 1/2" (8.9 cm by 21.6 cm).

Assembly

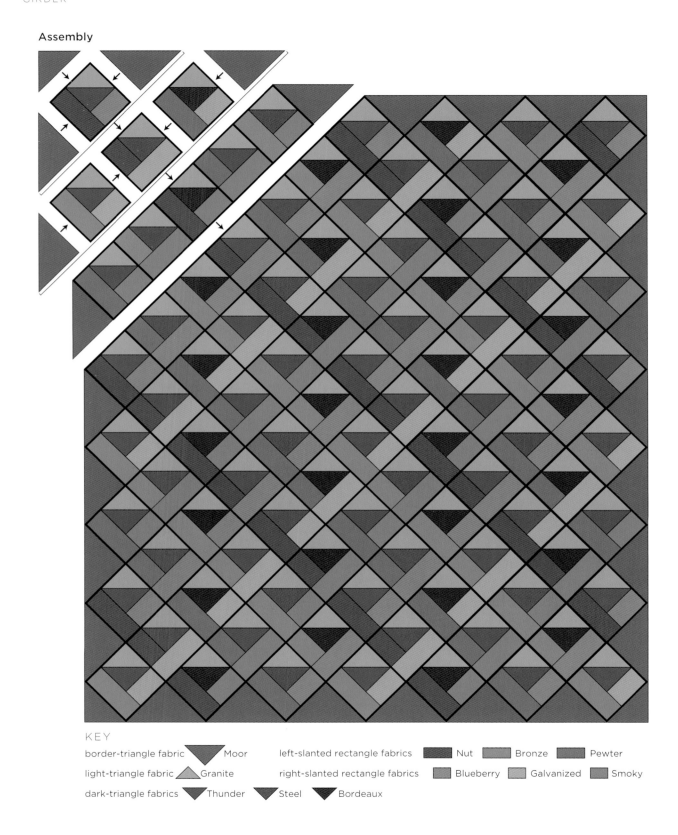

KEY

border-triangle fabric — Moor

light-triangle fabric — Granite

dark-triangle fabrics — Thunder — Steel — Bordeaux

left-slanted rectangle fabrics — Nut — Bronze — Pewter

right-slanted rectangle fabrics — Blueberry — Galvanized — Smoky

MAKING TRIANGLE-SQUARES

Make the triangle squares using a 1/4" (6-mm) seam allowance.

98 triangle-squares: For each triangle-square, use one light block triangle (Granite) and one dark block triangle (Thunder, Steel, or Bordeaux). Make the squares following the diagram. Make a total of 98 triangle squares, using up all the light and dark triangles you have cut. Keep the triangle-squares in stacks of 38 Granite/Thunder squares, 30 Granite/Steel squares, and 30 Granite/Bordeaux squares.

MAKING BLOCKS

Make the blocks using a 1/4" (6-mm) seam allowance.

Make each of the 98 blocks in the quilt following either the Block A diagram or the Block B diagram. Block A has a long left-slanted rectangle and a short right-slanted rectangle, and Block B has a short left-slanted rectangle and a long right-slanted rectangle. There are 56 Blocks A in the quilt and 42 Blocks B, and the block types are used in alternate rows.

It is easiest to arrange the "on-point" blocks on your design wall (or on the floor) in vertical rows, starting at the left side of the quilt. Make them in this order as well, so you can lay them in place as they are made.

Using the assembly diagram as a map, carefully select the long and short rectangles for each block. Note that each vertical row of blocks has the same color triangle-square running all the way down, and that the blocks in each vertical row are either all Block A or all Block B.

ASSEMBLING TOP

Check that your blocks have been arranged correctly, following the assembly diagram. Then arrange the large border triangles (the setting triangles) along all the edges of the quilt and position a small border triangle at each corner.

Using a 1/4" (6-mm) seam allowance, sew the blocks together in diagonal rows as shown on the assembly diagram, beginning and ending each row with a setting triangle. Finally, sew all the pieced diagonal rows together.

FINISHING QUILT

Press the quilt top. Layer the quilt top, batting, and backing, then baste the layers together (see page 167).

Using a dark-taupe thread, machine quilt in-the-ditch around all the patches. Then emphasize the woven appearance of the quilt format by quilting three long spaced-apart serpentine lines along the diagonal "sashing" grid. Echo-quilt triangles in the edging triangles.

Trim the edges of the backing and batting so that they align with the patchwork top. Then cut the binding on the bias and sew it on around the edge of the quilt (see page 167).

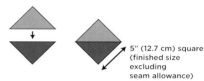

On-Point Triangle Squares

5" (12.7 cm) square (finished size excluding seam allowance)

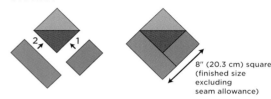

Block A

8" (20.3 cm) square (finished size excluding seam allowance)

Block B

8" (20.3 cm) square (finished size excluding seam allowance)

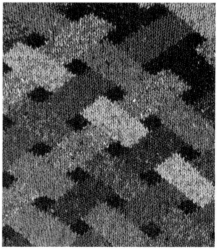

In one of my early knitwear designs I played with a lattice motif like the one on Girder.

OVERLAPPING TILES

I am drawn to old faded textiles where the contrast is low or nearly nonexistent so the muted range of my shot cotton colors suits me perfectly. I like the earthiness of them, and find I often need very little contrast to create separate areas of a design. In this quilt, inspired by tiles stacked at a garden center, the dark grounds make the chalky tones come alive. The fact that all the colors are medium to deepish shades makes this such a calm mood. The feeling of layers here is very effective. I can also imagine this quilt done in patterned fabrics, particularly stripes.

FINISHED SIZE

70" x 91" (177.8 cm x 231.1 cm)

MATERIALS

Use the specified 42–44"- (112–114-cm-) wide fine-weight Kaffe Fassett *Shot Cottons* for the patchwork, and use an ordinary printed quilting-weight cotton fabric for the backing.

PATCHWORK FABRICS

Background fabric: 2 3/4 yd (2.6 m) of *Shot Cotton* in Thunder

"Tiles" fabrics: 1/2 yd (50 cm) of *Shot Cotton* in each of the following 10 colors—Lipstick, Tobacco, Pea Soup, Pewter, Eucalyptus, Clementine, Granite, Curry, Bittersweet, and Galvanized

OTHER INGREDIENTS

Backing fabric: 5 1/2 yd (5.1 m) of desired printed quilting fabric

Binding fabric: Use left-over background fabric (Thunder)

Thin cotton batting: 77" x 98" (195 cm x 245 cm)

Quilting thread: Dark thread

TIPS

This is the perfect quilt for a beginner as almost the entire quilt is made up of one-size squares, and once the squares are arranged on your floor or your design wall, you simply sew them together in diagonal rows.

CUTTING PATCHES

Press and starch the patchwork fabrics before cutting. (Read page 163 for more information about preparing *Shot Cotton* for your patchwork project.)

BACKGROUND SQUARES AND TRIANGLES

133 background squares: From the background fabric (Thunder), cut 133 squares 3 1/2" by 3 1/2" (8.9 cm by 8.9 cm).

70 background triangles: From the background fabric (Thunder), cut 18 squares 5 1/2" by 5 1/2" (14 cm by 14 cm) and cut each of them diagonally from corner to corner in both directions to make four quarter-square triangles—for a total of 72 triangles. You need only 70, so you can discard two.

"TILES" SQUARES

Do not be concerned about the direction of the fabric grain in the "tiles" patches. They do not have to blend "seamlessly" together within the individual "tile" areas; changes in the grain make this quilt more interesting.

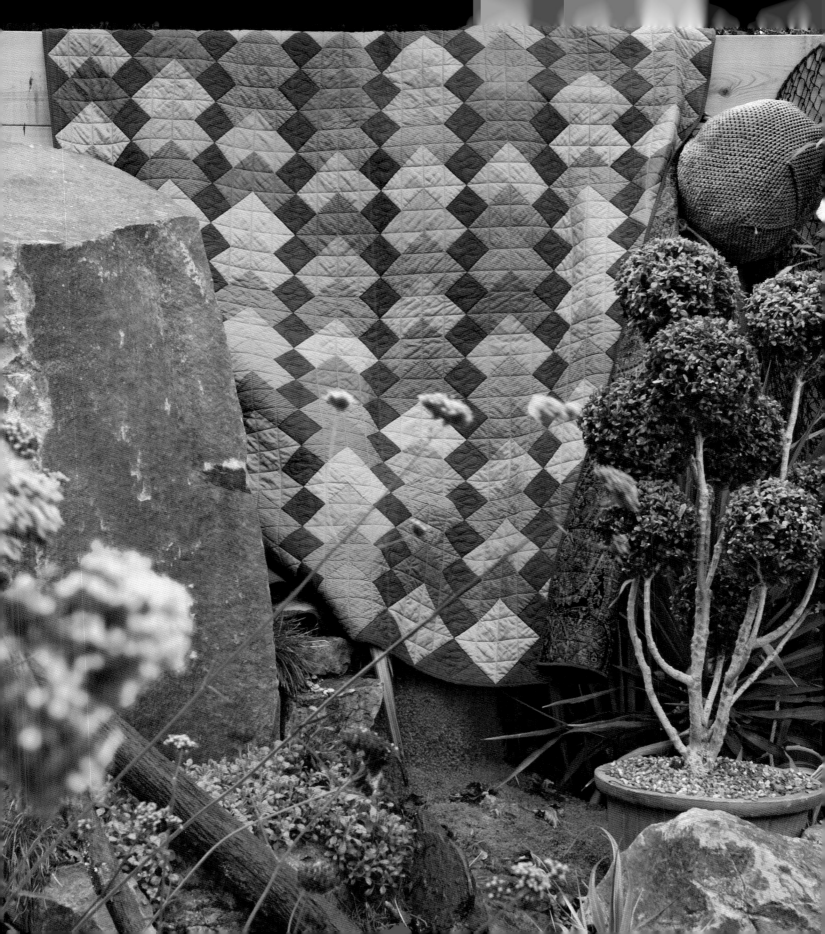

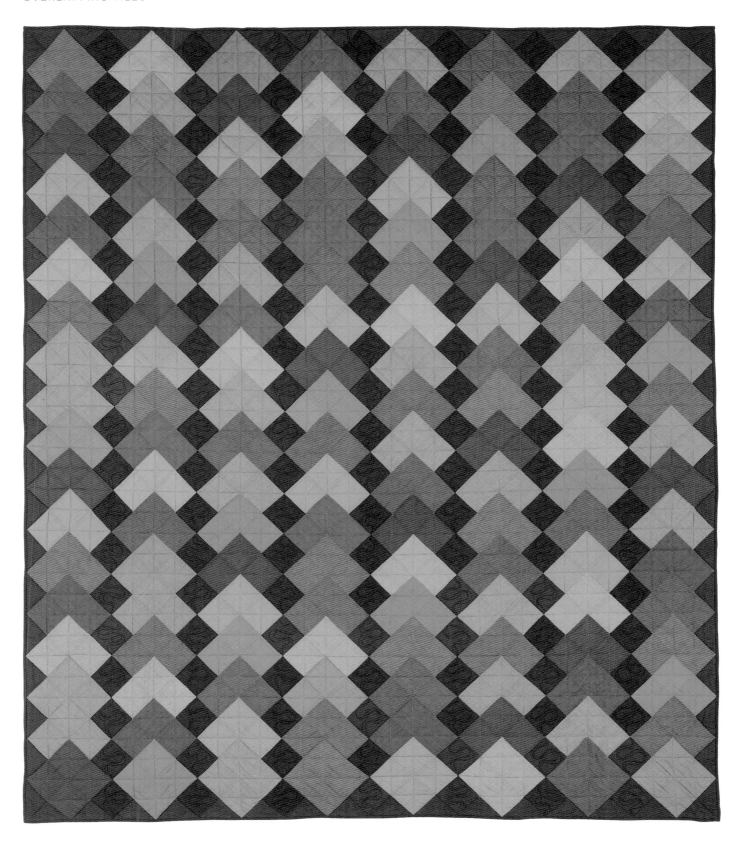

As you cut the squares, keep them in piles and label each pile with its shade name.

43 Lipstick squares: From the Lipstick, cut 43 squares 3 1/2" by 3 1/2" (8.9 cm by 8.9 cm).

46 Tobacco squares: From the Tobacco, cut 46 squares 3 1/2" by 3 1/2" (8.9 cm by 8.9 cm).

43 Pea Soup squares: From the Pea Soup, cut 43 squares 3 1/2" by 3 1/2" (8.9 cm by 8.9 cm).

45 Pewter squares: From the Pewter, cut 45 squares 3 1/2" by 3 1/2" (8.9 cm by 8.9 cm).

43 Eucalyptus squares: From the Eucalyptus, cut 43 squares 3 1/2" by 3 1/2" (8.9 cm by 8.9 cm).

45 Clementine squares: From the Clementine, cut 45 squares 3 1/2" by 3 1/2" (8.9 cm by 8.9 cm).

43 Granite squares: From the Granite, cut 43 squares 3 1/2" by 3 1/2" (8.9 cm by 8.9 cm).

43 Curry squares: From the Curry, cut 43 squares 3 1/2" by 3 1/2" (8.9 cm by 8.9 cm).

46 Bittersweet squares: From the Bittersweet, cut 46 squares 3 1/2" by 3 1/2" (8.9 cm by 8.9 cm).

43 Galvanized squares: From the Galvanized, cut 43 squares 3 1/2" by 3 1/2" (8.9 cm by 8.9 cm).

ARRANGING QUILT PIECES

Before you can assemble the quilt, you need to arrange the "tile" squares and background pieces, either laying them out on the floor or sticking them to a cotton-flannel design wall.

ARRANGING THE "TILES" SQUARES

Following the assembly diagram, arrange the "tile" squares "on point." Arrange these pieces in eight vertical rows of overlapping "tiles." Beginning at the top of the vertical row, each of the first 17 "tiles" is made up of three matching squares, and the 18th "tile" (the last "tile" at the bottom) is made up of four squares. Follow the Color Sequence Table for the "tiles" in each of the eight vertical rows; the first vertical row on the left of the quilt is "Row 1" and the colors go from top to bottom of the quilt.

ARRANGING THE BACKGROUND PIECES

Next, arrange the background squares between the "tiles." Lastly, fill in the edges with the background triangles.

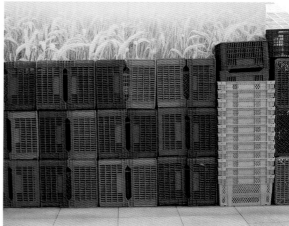

These crates in Istanbul strike the warm color palette that I was trying for in Overlapping Tiles.

Assembly

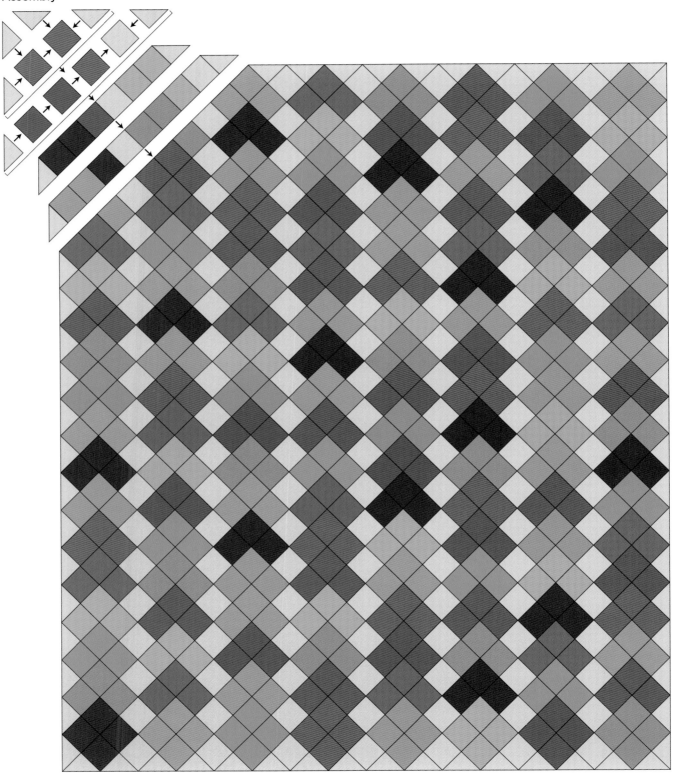

Color Sequence Table

ROW 1	ROW 2	ROW 3	ROW 4	ROW 5	ROW 6	ROW 7	ROW 8
A	B	C	D	E	F	G	C
H	E	I	B	H	A	H	B
I	F	J	G	I	C	D	G
J	D	A	H	J	F	I	A
D	G	F	D	C	D	E	H
B	C	E	F	A	I	B	J
F	I	D	J	B	J	A	D
E	J	B	I	E	H	G	C
G	A	G	C	F	A	J	F
C	D	H	F	G	I	B	E
I	B	E	J	H	E	C	I
J	H	C	D	I	A	F	G
A	G	I	A	B	H	J	D
D	E	J	F	C	G	B	H
B	F	C	B	A	F	I	A
G	B	H	E	H	E	D	C
E	D	J	F	D	I	G	F
I	C	G	A	J	B	H	E

KEY

- ▫ Thunder (background)
- ▪ Lipstick (A)
- ▫ Tobacco (B)
- ▫ Pea Soup (C)
- ▪ Pewter (D)
- ▫ Eucalyptus (E)
- ▪ Clementine (F)
- ▫ Granite (G)
- ▪ Curry (H)
- ▪ Bittersweet (I)
- ▫ Galvanized (J)

ASSEMBLING TOP

Using a 1/4″ (6-mm) seam allowance, sew the blocks together in diagonal rows as shown on the assembly diagram, beginning and ending each row with a setting triangle. Finally, sew all the pieced diagonal rows together.

FINISHING QUILT

Press the quilt top. Layer the quilt top, batting, and backing, then baste the layers together (see page 167).

Using a dark thread, machine quilt in-the-ditch around all the patches. Then quilt a meandering swirling ribbon shape in all the background squares and triangles. Quilt horizontal and vertical straight lines over the "tiles" to form an upright cross inside each of the "tiles" squares.

Trim the edges of the backing and batting so that they align with the patchwork top. Then cut the binding on the bias and sew it on around the edge of the quilt (see page 167).

RAIL FENCE

Here's another of Liza's stunning, simple quilts. I have spotted this design in many vintage books and even bought a velvet and cotton antique version for my collection. When you view this quilt up close it looks like a mass of disjoined rectangles, but stand back and the optical effect pops out. Although it is a classic old design, Liza's choice of colors makes it sharply contemporary. The contrasts are so powerful here with the soft teal grays, blacks, and graphite tones against hot pinky rusts and oranges.

FINISHED SIZE

67 1/2" x 76 1/2" (180 cm x 204 cm)

MATERIALS

Use the specified 42–44"- (112–114-cm-) wide fine-weight Kaffe Fassett *Shot Cottons* for the patchwork, and use an ordinary printed quilting-weight cotton fabric for the backing.

PATCHWORK FABRICS

Dark fabrics: 2 yd (1.9 m) of *Shot Cotton* in Steel, and 1/2 yd (50 cm) each of the following four colors—Coal, Moor, Thunder, and Prune

Medium fabrics: 2 1/8 yd (2 m) of *Shot Cotton* in Ginger, and 1/2 yd (50 cm) each of the following four colors—Clementine, Curry, Brick, and Terracotta

Light fabrics: 2 1/8 yd (2 m) of *Shot Cotton* in Galvanized, and 1/2 yd (50 cm) each of *Shot Cotton* in the following four colors—Aqua, Ecru, Honeydew, and Sandstone

OTHER INGREDIENTS

Backing fabric: 5 yd (4.6 m)

Binding fabric: 3/4 yd (70 cm) extra of *Shot Cotton* in Galvanized

Thin cotton batting: 74" x 83" (200 cm x 220 cm)

Quilting thread: Medium-toned neutral-colored thread

TIPS

If you are a beginner looking for an easy quilt with bold graphic appeal, this is the quilt for you. It can be made with just three *Shot Cotton* fabrics: a "light," a "medium," and a dark." To make things even easier, the simple blocks are made from a single rectangular patch shape. For a more lively combination, with more color interest, use all the suggested colors.

CUTTING PATCHES

Press and starch the patchwork fabrics before cutting. (Read page 163 for more information about preparing *Shot Cottons* for your patchwork project.)

Cut the border strips first so you can use the left-over border fabric for the blocks at the center of the quilt. Then cut the rectangles for the blocks. Each of the 195 blocks consists of one light rectangle, one medium rectangle, and one dark rectangle.

BORDER STRIPS

4 inner border strips: From Steel (the main dark fabric), cut two strips each 2" by 59" (5.5 cm by 157.5 cm) for the top and bottom borders, and two strips each 2" by 71" (5.5 cm by 189.5 cm) for the side borders.

4 center border strips: From Ginger (the main medium fabric), cut two strips each 2" by 62" (5.5 cm by 165.5 cm) for the top and bottom borders, and two strips each 2" by 74" (5.5 cm by 197.5 cm) for the side borders.

4 outer border strips: From Galvanized (the main light fabric), cut two strips each 2" by 65" (5.5 cm by 173.5 cm) for the top and bottom borders, and two strips each 2" by 77" (5.5 cm by 205.5 cm) for the side borders.

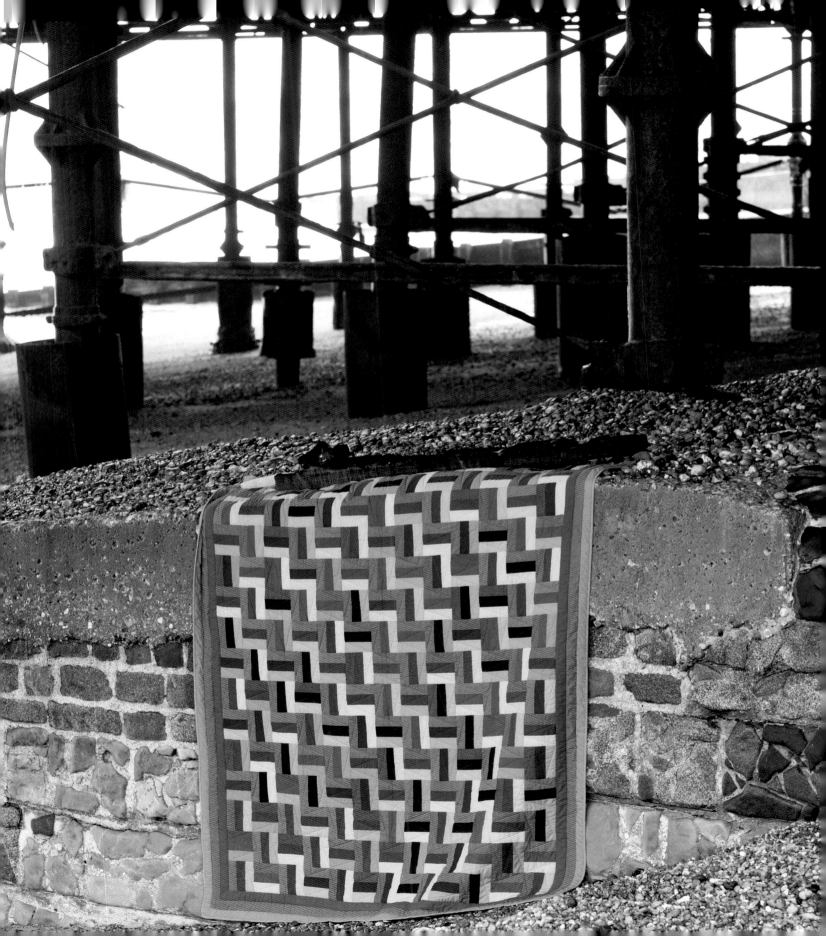

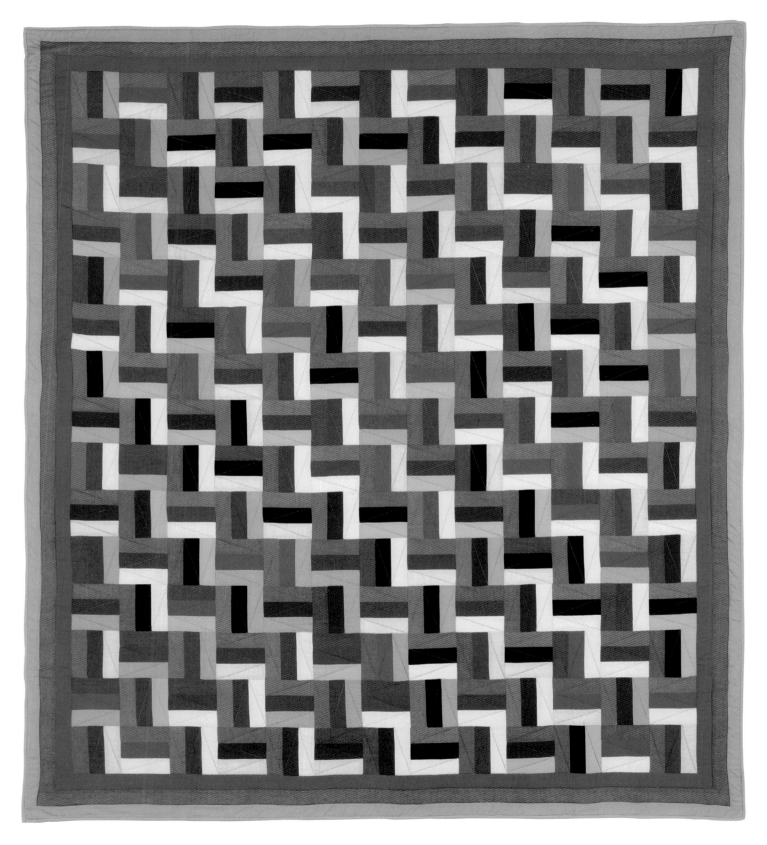

BLOCK RECTANGLES

195 light rectangles: From the light fabrics, cut a total of 195 rectangles 2″ by 5″ (5.5 cm by 13.5 cm).

195 medium rectangles: From the medium fabrics, cut a total of 195 rectangles 2″ by 5″ (5.5 cm by 13.5 cm).

195 dark rectangles: From the dark fabrics, cut a total of 195 rectangles 2″ by 5″ (5.5 cm by 13.5 cm).

MAKING BLOCKS

Make the blocks using a 1/4″ (7.5-mm) seam allowance.

195 blocks: For each block, select one light rectangle, one medium rectangle, and one dark rectangle. As shown in the diagram, sew the three rectangles together so that the dark rectangle is at the center. Make a total of 195 blocks.

Rail Fence Block

4 1/2″ (12 cm) square
(finished size excluding
seam allowance)

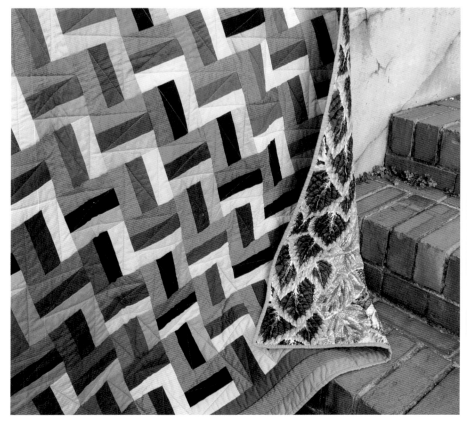

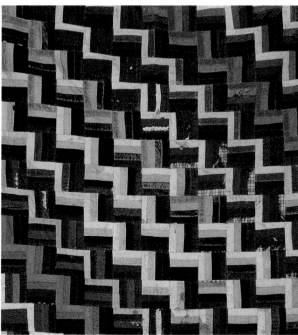

Above: A vintage Rail Fence quilt made mostly of velvets. Left: Liza's version of Rail Fence with my Begonia Columns print as a backing.

Assembly

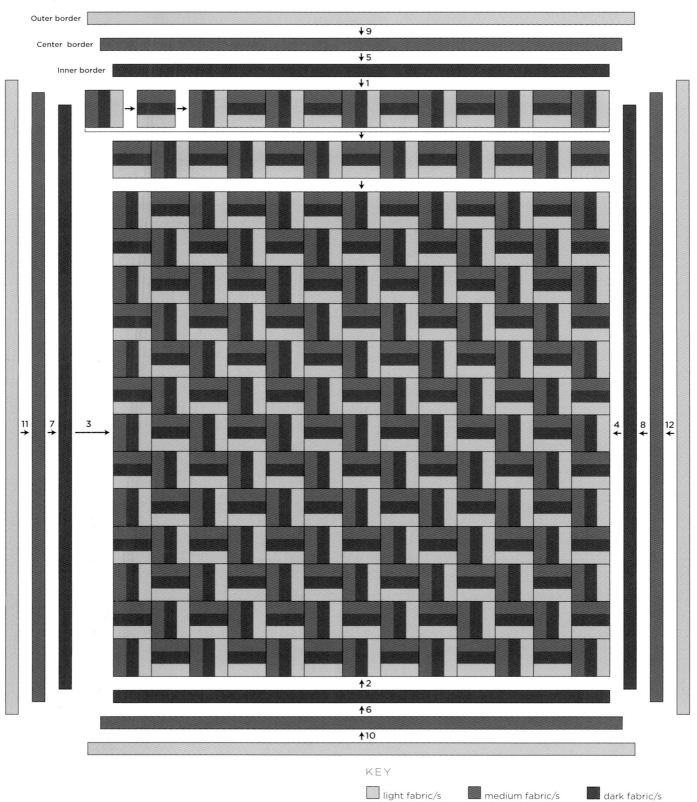

KEY

light fabric/s medium fabric/s dark fabric/s

ASSEMBLING TOP

Arrange the 195 blocks, either laying them out on the floor or sticking them to a cotton-flannel design wall. Position them into 15 horizontal rows of 13 blocks each. To achieve the optical effect, position the blocks with the "stripes" running alternately horizontally and vertically and so that the medium color is always either on the left of the block or on the top of the block. Mix the colors randomly.

Using a 1/4" (7.5-mm) seam allowance throughout, sew the blocks together in horizontal rows as shown on the assembly diagram. Then sew the rows together.

Sew the shorter inner-border strips (the Steel ones) to the top and bottom of the quilt, then sew the longer inner-border strips to the sides.

Sew the shorter center-border strips (the Ginger ones) to the top and bottom of the quilt, then sew the longer center-border strips to the sides.

Sew the shorter outer-border strips (the Galvanized ones) to the top and bottom of the quilt, then sew the longer outer-border strips to the sides.

FINISHING QUILT

Press the quilt top. Layer the quilt top, batting, and backing, then baste the layers together (see page 167).

Using a medium-toned neutral-colored thread, machine quilt each block by starting at one corner of the block and stitching diagonally across this rectangle to its opposite corner, then continue by stitching diagonally across the next rectangle to its opposite corner and then stitch diagonally across the last rectangle—this forms a simple zigzag across the block. Quilt each block in the same way. Stitch in-the-ditch in the borders.

Trim the edges of the backing and batting so that they align with the patchwork top. Then cut the binding on the bias and sew it on around the edge of the quilt (see page 167).

STRIPED SQUARES TOTE BAGS

After using my striped fabrics in straightforward ways in the quilts in this book, cutting them into triangles and creating these colorful boxes was a thrill. I had done similar boxes in my book *Simple Shapes Spectacular Quilts* in a mostly brown palette, so I know the idea expands easily into a larger project. The cool blues and grayish lavenders of the colorway shown at right make a deliciously cold mood, while the curry, lime, amber, and cinnamon tones of the yellow bag is spring and summer all at once! (We photographed this yellow bag on the lime-green floor of a funfair in our seaside location. However, it was so different from the rest of our book we dropped that shot. But if you have a lime coat or dress, this bag will be just the ticket!)

This idea would make a good table runner as well. Try it in all browns, reds, and rust-toned stripes. On the other hand, there are other patterns in this book that would make handsome bags—Samarkand (page 90) could be jolly, or those simple Zigzag Cushions (page 96) or Striped Rice Bowls (page 74).

FINISHED SIZE

Bag: 13" x 16 1/4" x 3 1/4" (33 cm x 41.3 cm x 8.3 cm)

Strap: 42 1/4" (107.3 cm) long

MATERIALS

Use the specified 42–44"- (112–114-cm-) wide fine-weight Kaffe Fassett *Woven Stripes* for the patchwork, and use an ordinary printed quilting-weight cotton fabric for the bag lining.

PATCHWORK FABRICS

Colorway 1: 1/2 yd (50 cm) of each of the following four stripes—*Alternating Stripe* in Orange and in Yellow; *Narrow Stripe* in Yellow; and *Broad Stripe* in Yellow

Colorway 2: 1/4 yd (30 cm) of *Caterpillar Stripe* in Blue, and 1/2 yd (50 cm) of each of the following four stripes—*Alternating Stripe* in Blue and in Teal; *Narrow Stripe* in Blue; and *Exotic Stripe* in Midnight

OTHER INGREDIENTS

Lining fabric: 3/4 yd (70 cm) of a printed quilting fabric

Thin cotton batting: 22" x 44" (56 cm x 112 cm)

Quilting thread: Medium-yellow thread for colorway 1 or dark-wine-red thread for colorway 2

Templates: Use templates V and W (see page 168)

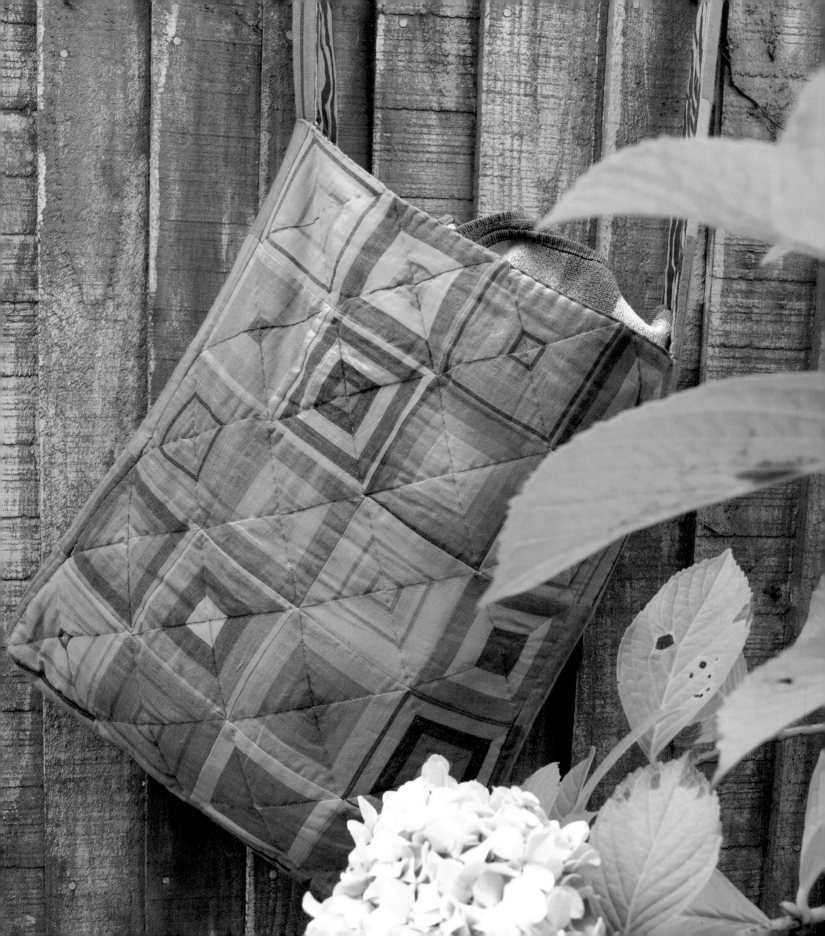

TIPS

This bag requires a little patience when you are cutting and piecing the triangles so that the stripes line up precisely to form neat concentric rings.

CUTTING PATCHES

Press and starch the patchwork fabrics before cutting. Be extra-generous with the starch. (Read page 163 for more information about preparing *Woven Stripes* for your patchwork project.)

40 sets of 4 matching triangles: For each of the 40 blocks, cut four identical Template-V triangles, with the stripes running parallel to the longest side of the triangle. Cut 4–12 different sets from each of the stripe fabrics in the chosen colorway. Pin the pieces for each set together.

27 squares: From the various stripes in the chosen colorway, cut a total of 27 Template-W squares.

MAKING BLOCKS

Make the blocks using a 1/4" (6-mm) seam allowance (the allowance marked on the templates).

40 blocks: Using a set of four identical triangles, make a block following the block diagram. Using the remaining matching sets, make a total of 40 blocks.

Striped Square Block

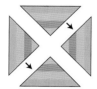 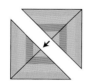 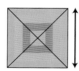

3 1/4" (8.3 cm) square
(finished size excluding
seam allowance)

ASSEMBLING BAG

Arrange the 40 blocks, either laying them out on the floor or sticking them to a cotton-flannel design wall. Use 20 blocks for the bag front and 20 blocks for the bag back, positioning them in five horizontal rows of four blocks each as shown on the assembly diagram. Then arrange the striped squares: a vertical row of five squares for each of the two side gussets (with the stripes running vertically) and a horizontal row of four for the base gusset (with the stripes running horizontally). Arrange a vertical row of 13 squares for the strap (with the stripes running vertically).

Using a 1/4" (6-mm) seam allowance throughout, sew the blocks for the front together in five horizontal rows of four, then sew the rows together. Sew the 20 back blocks together in the same way.

Assembly

Side Gusset
Top of Front
Side Gusset
Strap

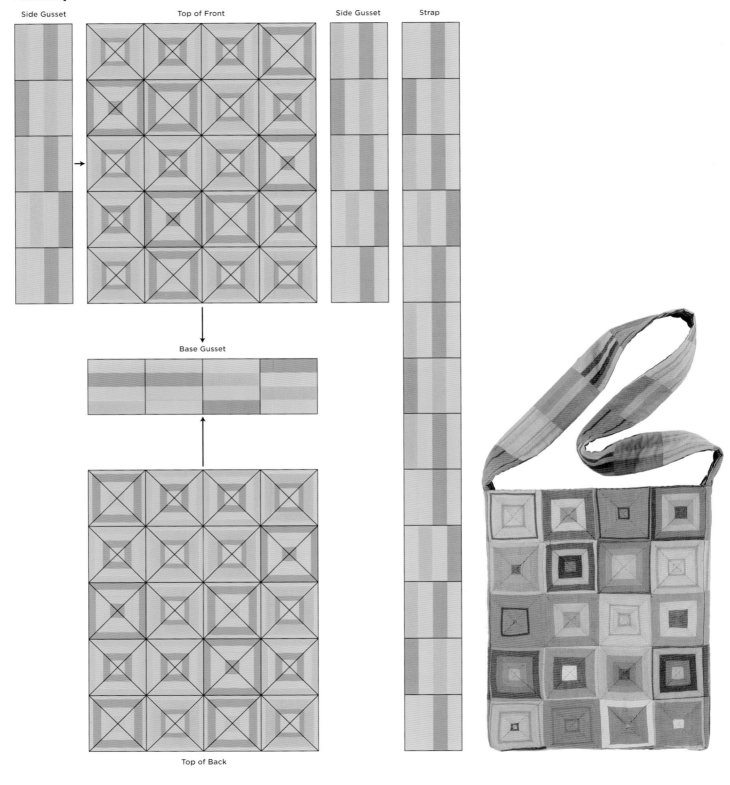

Base Gusset

Top of Back

Sew five squares together in a vertical row for each side gusset, then sew the four squares together for the base gusset. Sew the 13 squares for the strap together. (The strap is fairly long, so adjust the length now if desired.)

FINISHING BAG

Press the patchwork bag front, back, three gusset pieces, and strap. Using the patchwork pieces as your guide, cut a lining-fabric the same size as each of the six patchwork pieces. (You will probably have to sew two strips together to create a strip of fabric long enough for the strap.) Then cut a piece of batting the same size as each of the six patchwork pieces.

Baste the batting to the wrong side of the six patchwork pieces so it is firmly held in place, stitching through the center of each square or block horizontally, vertically, and diagonally.

With the right sides together and using a 1/4" (6-mm) seam allowance throughout, machine stitch a patchwork side gusset to each side of the patchwork bag front, starting the stitching 1/4" (6 mm) from the bottom edge of the bag. Stitch the base gusset to the bottom of the front, starting and ending the stitching 1/4" (6 mm) from the edge. Stitch the ends of the side gussets to the base gusset, again starting and ending the stitching 1/4" (6 mm) from the edge. Stitch the bag back to the other edges of the gusset pieces. Turn the bag right side out and press lightly.

Place the patchwork strap on top of the strap lining, with the right sides together. Sew the lining and patchwork strap together along both long side edges, leaving the ends unstitched. Turn the strap right side out and press lightly. Hand quilt the strap with two parallel lines of stitching about 1" (2.5 cm) apart along the center of the length of the strap.

With right sides together and raw edges aligned, machine stitch one end of the strap to the top of a side gusset. Stitch the other end of the strap to the other side gusset in the same way. Fold 1/4" (6 mm) to the wrong side along the top edge of the bag and baste in place. (The raw edges of the ends of the strap will now be inside the bag.)

Stitch together the bag-lining pieces in the same way as the patchwork bag, but do not turn right side out. Fold 3/8" (1 cm) to the wrong side along the top edge of the lining and baste in place.

With wrong sides together, slip the lining inside the bag, and baste the bag and lining together along the gusset seams. Slip stitch the folded edge of the lining in place. Then baste the front and the back to the lining along the same basting lines as the batting was basted in place. Hand quilt the gussets as for the strap. Quilt the blocks in-the-ditch along the block diagonals. Quilt a last line of stitching around the top of the bag, close to the edge. Remove the basting threads.

WORKING WITH HANDWOVEN SHOT COTTONS AND STRIPES

The *Shot Cottons* and *Woven Stripes* that I designed for production in India have unique qualities that make them a pleasure, and sometimes a challenge, to work with. Because they are handwoven they are beautifully "flawed." You may find there is a slight color variation within a length of fabric or perhaps a bump in the weave here and there. To my mind, these "flaws" add character to the fabrics—making them look like they are, indeed, made by humans. The handwoven quality also makes them seductively tactile. From time to time, it may be necessary to cut out a poorly woven spot, but this craft is called "patchwork" and these flaws can be overcome creatively and embraced!

My shots and stripes are also woven in relatively small amounts, compared to printed quilt fabrics. Because of this there are often subtle color "dye lot" changes from batch to batch. This doesn't worry me as I am fond of mismatching, but if a color change would bother you in the middle of a project, it is a good idea to buy all the yardage you need in each color from a single bolt.

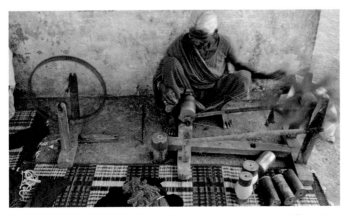

One of the village weavers in India showing us the many different stages of setting up the warps for my striped fabric.

UNIQUE QUALITIES OF THE *WOVEN STRIPES*

All my stripes are woven so that the stripes run parallel to the selvage. They come in a variety of types—some with regular (equal-size) stripes and others with stripes of varying widths. Each stripe type comes in a range of colorways. Each colorway, although it has a predominant color theme, contains several bands of a mix of colors. You can pick and choose which areas of the fabric to cut from, and thereby obtain a few different colors from a single length of fabric.

Another handy feature of the handwoven stripes is that there is no right side or wrong side of the fabric because the color is woven in, not printed on one side. This means that there is no need for "reverse" templates. To get the reverse (mirror-image) shape for triangles and other odd-shaped patches, all you need to do is flip over the shape. This makes patterns such as On-Point Handkerchief Corners (page 24) much simpler to make than it would be if you were using printed stripes.

CHARACTERISTICS OF *SHOT COTTONS*

Most of the *Shot Cottons* are woven with one color used for the warp (the threads running parallel to the selvage) and another color used for the weft (the threads running perpendicular to the selvage). This is how "shot" fabrics are created. It gives the fabric a kind of iridescent, shimmery quality. If you cut two patches from the same *Shot Cotton* and hold up one with the weft running up and down and the other with the warp running up and down, they may look very different. This is a wonderful feature if you love scrap quilts. Slight color variations make the quilts so much more interesting. One of the things Liza and I love about antique Amish quilts, which are made from all solid fabrics, is the mismatching of single colors. Many of the quilts, for example, have a lot of black in them, but the quilts look as though they were made from several black fabrics. The *Shot Cottons* can give a similar look just because of the illusion of the change of color from the varying directions of the warp and weft.

Most of the projects in the book featuring the *Shot Cottons* were made ignoring the direction of the warp or weft in each patch in order to make use of the richness that the color variation gives the design. There were times when that color variety, however, was not what was called for. In Two-Toned Boxes (page 106), we wanted to create the illusion of two L-shaped pieces enclosing a solid square in the center. To achieve this, the warps and wefts on the pieces in each block were placed in the exact same direction so that the seams would be less noticeable.

Like the *Woven Stripes*, the *Shot Cottons* look the same on both sides—there is no right side or wrong side. So, again, no need for reverse templates.

PREPARING THE SHOTS AND STRIPES

As with all quilting fabrics, you should prewash your hand-woven shots and stripes before cutting your patchwork pieces from them (page 165). This preshrinks the fabric just in case it might be suceptible to shrinking and it confirms that the fabric is colorfast. Wash the darks and lights separately. Take the fabrics still damp from the dryer and iron them until dry.

My *Shot Cottons* and *Woven Stripes* are more loosely woven than most quilting prints, so we strongly advise pressing well, and using sizing or starch before cutting. This will make the patch shapes more accurate. For all the projects, we used a product sold in the United States called Mary Ellen's Best Press. It is a clear starch that leaves no residue behind and doesn't stick to the iron. It is not an aerosol but comes in a spray bottle. Just barely dampen the fabric and press with an iron set for cotton. We use steam to press out all the stubborn wrinkles.

As you press the starched fabrics, try to straighten the warp and weft threads as much as possible. Pay particular attention to this when pressing the handwoven stripes as the stripes usually need to be lined up as well as possible with one or two of the straight edges of the patches. It is a good idea to be generous with the starch on the stripes, and this reminder is given in the instructions where straight stripes are especially important.

After pressing your fabrics and before cutting patches, you should remove the selvage with a rotary cutter. The selvage edges on handwoven fabrics are sometimes a little wavy, so you may need cut off a bit more along these edges than is necessary on standard quilting fabric. This has been taken into account when figuring out the yardage needed to complete a project. There is also a little extra calculated into the yardage for the stripes as you may spoil a few patches when trying to cut perfectly straight stripes.

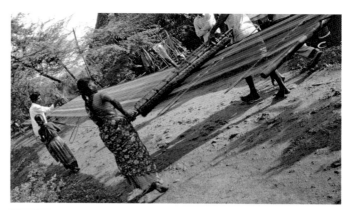

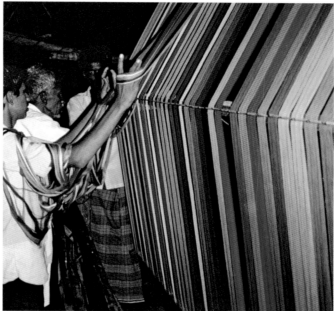

Two more stages in the preparation of the warp for my striped fabric. The streets of the village became rivers of color as the weavers worked.

Liza and I love the loose drape of the *Shot Cottons* and *Woven Stripes,* but we do like to stabilize them for machine quilting by using a printed quilting-weight fabric for the backing. If you choose to do hand quilting, however, a backing of one of the shots or stripes works very well because they "needle" beautifully. In all cases we have used a thin one-hundred-percent cotton batting, which gives the attractive, relatively flat appearance of an antique patchwork.

BASIC TECHNIQUES

Here are some useful tips to follow when making your quilts. If you are an absolute beginner at patchwork but are proficient at sewing on the sewing machine, you will have little trouble in tackling most of the quilts in the book, but it is always a good idea to take advice before beginning. Beginners may like to take a simple beginner's course or have an experienced patchworker guide them with their first project.

This chapter can't begin to cover all the many quilting short cuts, but the tips provided should make the patchwork process easier and more fun. Don't get too worried about technique when you begin. Some of the most wonderful museum quilts have imperfect stitching lines and these just add to the homemade charm. Concentrate instead on the beautiful colors you are using and on composing them into a spectacular quilt.

PATCHWORK FABRICS

The fabrics used in this book are the Kaffe Fassett ranges of *Shot Cottons* and *Woven Stripes* and the range of woven fabrics from Oakshott. They are a similar weight to other quilting fabrics, but for best results they need a little special preparation before being cut (see page 163).

CHOOSING FABRIC COLORS AND PRINTS

The instructions for each of the projects in this book provide a list of the fabrics you will need. If you are unable to obtain the exact shades recommended, don't let this deter you—just look for similar shades or select your own color palette, then follow the instructions for placement of lights and darks. The most fun part of patchwork, I believe, is playing with and mixing fabric colors and finding a palette that really sings!

When choosing your fabrics, you should pay particular attention to the lightness or darkness of the colors. My quilts usually have a fairly subtle contrast in the lights and darks used. So remember that if one group requires "light-toned" fabrics and the other "dark-toned" fabrics, you may be able to actually use medium tones instead of very light tones in the "lights" group; the patchwork geometry will work so long as the "darks" are slightly darker than the "lights." Closeness in tone, rather than sharp tonal contrast, creates a composition of great richness and hidden depths. If you study your favorite antique quilts you will see they often use very restrained lightness–darkness contrasts.

Always look carefully at the photograph of the quilt as you are choosing your fabric palette. If you decide to do any of the layouts in this book in prints instead of exclusively in solids and stripes, then choose these with care. Be aware that if you use printed fabrics, you may need to make "reverse" templates as you can not flip the fabric over to get a mirror image shape. Notice the scale of the prints. Very small-scale prints can look like solids at a distance, but provide more interest and visual "texture" than solids. Large-scale prints are particularly useful because you can cut completely different colors from different areas of the same fabric. Dots and stripes, even used in only a few areas of a quilt, add amazing movement to the composition.

When choosing multicolored prints, study them at a distance. Looking at them up close, you may think you are choosing a particular color, but at a distance they turn into something totally different. For example, you may think you are choosing a "red" because there are bright red small-scale motifs on a white ground, but at a distance it looks pink! Similarly, motifs in two different colors will blend together at a distance to make a totally new color, for example separate blues and yellows on the same print will make it look green.

If you are in doubt when using your own choices of fabrics instead of the recommended ones for the projects in this book, buy small amounts of fabrics and test them by cutting and arranging some patches and then standing back to see the effect at a distance.

DETERMINING FABRIC AMOUNTS

Figuring out how much fabric you need for my designs is not a very exact science because I use so many different fabrics. The quantities in the instructions for the patches are sometimes only an approximate guide, but tend to be generous. Of course, it is better to have too much fabric than too little, and you can use the leftovers for future projects.

If you do run out of fabric, it is not a tragedy. I think of it as a design opportunity! The replacement you find may make the quilt look even better. After all, quiltmaking was a craft designed to use up scraps, and chance combinations of fabrics sometimes resulted in antique masterpieces.

When calculating exact fabric amounts for borders, bindings, or backings on your own designs, remember that although specially made cotton patchwork fabrics are usually 44" to 45"

(about 112 cm to 114 cm) wide, the usable width is sometimes only about 40" to 42" (101.5 cm to 106.5 cm) due to slight shrinkage and the removal of selvages.

PREPARING FABRIC

Be sure to prewash your cotton fabrics before use (see page 163 for more detailed instructions for preparing Kaffe Fassett *Shot Cottons* and *Woven Stripes*). This will confirm colorfastness and preshrink the fabric just in case it may be prone to this. Wash the darks and lights separately and rinse them well. Then press the fabric with a hot iron while it is still damp. After pressing, cut off the selvages; you can do this quickest with a rotary cutter.

TOOLS AND EQUIPMENT

If you have a sewing machine, you probably already have most of the tools necessary for patchwork in your sewing box. Aside from the sewing machine, you'll need fabric scissors, pins, needles, a ruler, a tape measure, an ironing board, and an iron. Nothing more is needed for making a simple patchwork entirely in squares.

For other patch shapes, you will need templates. Nonstandard sizes and shapes can be made from cardboard or special template plastic.

The most useful patchwork tools are a rotary cutter, a rotary-cutter mat, and a rotary-cutting ruler. With these you can cut your patches quickly and in accurate straight lines.

DESIGN WALL AND REDUCING GLASS

The two items I strongly recommend for successful patchwork are a design wall and a reducing glass. A full-size quilt can be arranged on the floor, but it is much easier to view on a wall. Our design wall is large enough for a queen-size bed cover and is made with two sheets of insulation board each measuring 4 feet by 8 feet (about 122 cm by 244 cm). Insulation board is a very light board about 3/4" (2 cm) thick; it has a foam core that is covered on one side with paper and on the other with foil. Any sturdy, lightweight board like this would do, but insulation board is especially handy as it can be cut with a craft knife.

To make yourself a design wall, cover each of the two boards on one side with a good-quality cotton flannel in a neutral color such as dull light brown, taupe, or medium gray. Then join the boards with three "hinges" of strong adhesive tape, sticking the hinges to the back of the boards so that you can fold the flannel sides together. The tape hinges will also allow you to bend the design wall slightly so it will stand by itself. If you want to put the wall away with a design in progress on it, just place paper over the arranged patches, fold the boards together, and slide them under a bed.

A quilter's reducing glass looks like a magnifying glass, but instead of making things look larger it makes them look smaller. Looking at a fabric or a design in progress through a reducing glass helps you see how the fabric print or even a whole patchwork layout will look at a distance. Seeing your quilt layout reduced makes the errors in color or pattern in the design just pop out and become very obvious. Reducing glasses are usually available in shops that sell patchwork supplies. A camera isn't quite as good but it is an acceptable substitute.

PATCH PREPARATION

Once you have prepared all the fabrics for your patchwork, you are ready to start cutting patches. Square patches, rectangle patches, and simple half-square or quarter-square triangle patches can be cut quickly and accurately with a rotary cutter, but you will need to use scissors for more complicated shapes.

USING A ROTARY CUTTER

Rotary cutting is really useful for cutting accurate square patches and quilt border strips. Having a range of large and small cutting mats and rotary-cutting rulers is handy, but if you want to start out with just one mat and one ruler, buy an 18" by 24" (46 cm by 61 cm) mat and a 6" by 24" (15 cm by 61 cm) ruler. The ruler will have measurement markings on it as well as 90-, 60-, and 45-degree angles.

Get someone to demonstrate to you how to use a rotary cutter if you have never used one before, paying particular attention to safety advice. Always use the cutter in conjunction with a cutting mat and a rotary-cutting ruler. You press down on the ruler and the cutter and roll the cutter away from you along the edge of the ruler.

With a little practice, you will be able to cut patches very quickly with a rotary cutter. Long strips can be cut from folded fabric, squares from long strips, and half-square triangles from squares. Just remember to change the cutter blade as soon as it shows the slightest hint of dulling.

MAKING TEMPLATES

Templates are not always required for patchwork projects as simple squares, squares, rectangles, strips, and half-square or quarter-square triangles can be cut with a rotary cutter. But for some of the patchworks in this book you do need templates and these are provided on pages 168–173. Photocopy any templates you need and cut them out before you begin your quilt. If the shapes can be cut quickly with a rotary cutter, use the template as a guide to your rotary cutting. If not, you can make a cardboard or plastic template from them and use it to trace around.

Special clear template plastic makes the best templates. It is very durable and will retain its shape despite being repeatedly traced around. It is also handy because of its transparency—you can see through it to frame fabric motifs.

It is a good idea to punch a hole in each corner of your template at each pivot point on the seam line, using a 1/8" (3 mm) hole punch. This will increase the accuracy of your seam lines, especially on diamonds and triangles.

Before going on to cut all your patches, make a patchwork block with test pieces to check the accuracy of your templates.

CUTTING TEMPLATE PATCHES

To cut patches using a template, place the template face down on the wrong side of the fabric and align the fabric grain line arrow with the straight grain of the fabric (the crosswise or the lengthwise grain). Pressing the template down firmly with one hand, draw around it with a sharp pencil in the other hand. To save fabric, position the patches as close together as possible or even touching.

CUTTING REVERSE TEMPLATE PATCHES

A reverse template is the mirror image of the patch shape. A template that is marked as a template and a reverse template can be used for both shapes. For the reverse shape, lay the template face up (instead of face down) on the wrong side of the fabric, and draw around it in the usual way. None of the projects in this book require reverse templates as the fabrics used are reversible, but if you use nonreversible substitutes you may need them.

SEWING PATCHES TOGETHER

Quilt instructions give a layout diagram for how to arrange the various patch shapes to form the quilt design. Often several patches are joined together to form small blocks and then the finished blocks are sewn together to form the whole quilt. Whether you are arranging a block or a whole quilt, lay the patches out on the floor or stick them to a large board covered with cotton flannel (see Tools and Equipment). Then study the effect of your arrangement carefully, stepping back to look at it or looking at it through a reducing glass.

Only stitch pieces together once you are sure the color arrangement is just right. If you are unsure, leave it for a few days and come back to it and try another arrangement, or try replacing colors that do not seem to work together with new shades. Remember that an unpredictable arrangement will have more energy and life than one that follows a strict light/dark geometry.

MACHINE-STITCHING STRAIGHT SEAMS

Sew, or piece, patches together following the order specified in the quilt instructions. Use the same neutral-colored thread to piece the entire patchwork. I find that medium-taupe or medium-gray thread will work for most patchworks. But when the overall palette is very light use ecru thread.

Pin the patches together with right sides facing and match the seam lines and corner points carefully. (If you are proficient at the sewing machine, you will be able to stitch small squares together without pinning.) As you machine stitch the seam, remove each pin before the needle reaches it. Always stitch from raw edge to raw edge, except on inset seams. There is no need to work backstitches at the beginning and end of each patch seam because the stitches will be secured by crossing seam lines as the pieces are joined together.

To save time and thread, you can chain piece the patch. To do this, feed through the pinned together pieces one after another without lifting the presser foot; the machine stitch will stitch through nothing a few times before it reaches the next pair of patches. Simply clip the pairs of patches apart when you're finished.

PRESSING PATCH SEAMS

Press all seams flat to imbed the stitches. Then open out the patches and press the seam allowances to one side. As you continue stitching patches into blocks, then the blocks into rows as instructed, press the seam allowances in each row (of patches or blocks) in the same direction. Press the seam allowances in every alternate row in the opposite direction to avoid having to stitch through two layers of seam allowances at once when joining the rows together.

STITCHING INSET SEAMS

Most of the projects in this book are made with simple, easy-to-stitch straight seams. On-Point Handkerchief Corners (page 24) and African Collage (page 68) require inset seams—these are seams that turn a corner.

To sew an inset seam, first align the patches along one side of the angle and pin, matching the corner points of the patches exactly. Machine-stitch along the seam line of this edge up to the corner point and work a few backstitches to secure. Then pivot the set-in patch, align the next side with the edge of the adjacent patch and pin. Beginning exactly at the corner point, work a few backstitches to secure, then machine-stitch along the seam line.

Trim away excess fabric from the seam allowance at the corner of the inset patch as necessary. Then, easing the corner into the correct shape, press the new seams.

QUILTING AND FINISHING

After you have finished piecing your patchwork, press it carefully. It is now ready to be quilted. Quilting is the allover stitching that joins together the three layers of the quilt sandwich—patchwork top, batting, and backing.

I often use stitch-in-the-ditch machine quilting for my quilts. In this type of quilting the stitching lines are worked very close to the patch seams and are invisible on the right side of the quilt. Echo quilting is another simple quilting pattern that suits many patchwork designs; it is worked by stitching 1/4" (6 mm) inside the patch seam lines to echo the shape of the patch. A third option is outlining motifs on large-scale prints with quilting stitches.

More complicated quilting patterns can be marked on the quilt before you machine-stitch them. Quilting stores sell quilting stencils for these.

Test your chosen quilting on a spare pieced block, stitching through all three quilt layers. This is also be a good way to check whether the color of the quilting thread is suitable. The thread color should usually blend invisibly into the overall color of the patchwork quilt when it is viewed from a distance.

PREPARING THE QUILT BACKING AND BATTING

Before you quilt your patchwork, you need to prepare the two other layers. Choose a backing fabric that will not do a disservice to the quilt top. Liza likes using sale fabrics for backings, but they still have to have a certain charm of their own and go well with the patchwork top.

Cut the selvages off the backing fabric, then seam the pieces together to form a backing at least 3" (7.5 cm) bigger all around than the patchwork top. Join the pieces for the backing in the most economical way possible. Sometimes it is a more frugal use of fabric to sew horizontal seams across the backing.

Batting comes in various thicknesses. Pure cotton or mixed cotton and polyester batting that is fairly thin is a good choice for most quilts. Thicker batting is usually only suitable when the quilt layers are being tied together with little knots rather than quilting. I prefer thin one-hundred-percent cotton batting because it gives the attractive, relatively flat appearance of an antique quilt.

If the batting has been rolled, unroll it and let it rest before cutting it to about the same size as the backing.

BASTING TOGETHER THE QUILT LAYERS

To keep the three layers of the quilt firmly in place during the quilting process, baste them together. Lay the backing wrong side up and place the batting on top of it. Lay the finished, pressed patchwork right side up in the on top of the batting.

Beginning at the center for each stitching line, baste two diagonal lines from corner to corner through the layers of the quilt. Work stitches about 3" (7.5 cm) long and try not to lift the layers too much as you stitch. Always beginning at the center and working outward, baste horizontal and vertical lines about 4" (10 cm) apart across the layers.

MACHINE-QUILTING

For machine-quilting, use a walking foot for straight lines and a darning foot for curved lines. Choose a color that blends with the overall color of the patchwork for the top thread and one that matches the backing for the bobbin thread. Follow the sewing machine manual for tips on using the walking or darning feet.

BINDING QUILT EDGES

When the quilting is finished, remove the basting threads. Then baste around the quilt just under 1/4" (about 5 mm) from the edge of the patchwork top. Trim away the excess batting and backing right up to the edge of the patchwork, straightening the edge of the patchwork at the same time if necessary.

Cut 2" (5 cm) wide binding strips either on the bias or on the straight grain. To make a strip long enough to fit around the edge of the quilt, sew these strips end to end, joining bias strips with diagonal seams. Fold the strip in half lengthwise with the wrong sides together and press.

Place the doubled binding on the right side of the quilt, with the right sides facing and the raw edges of both layers of the binding aligned with the raw edges of the quilt. Machine-stitch 1/4" (6 mm) from the edge and stitch up to 1/4" (6 mm) from the first corner. Make a few backstitches and cut the thread ends. Then fold the binding upward so that it makes a 45-degree angle at the corner of the quilt. Keeping the diagonal fold just made in place, fold the binding back down and align the edges with the next side of the quilt. Beginning at the point where the last stitching ended, stitch down the next side to within 1/4" (6 mm) of the next corner, and so on. When you reach the beginning of the binding, turn under the edge of one end and tuck the other end inside it.

Turn the folded edge of the binding to the back of the quilt and hand stitch it in place, folding a miter at each corner.

TEMPLATES

The templates for the projects are included actual size. The solid lines on the templates represent the seam lines and the dotted lines the seam allowances. The arrows on the templates indicate the direction of the fabric grain.

TWINKLE, pages 40–45
The five templates for this quilt are A, B, C, D, and E.

W
STRIPED
SQUARES

A
TWINKLE

E
TWINKLE

D
TWINKLE

C
TWINKLE

V
STRIPED
SQUARES

**STRIPED SQUARES
TOTE BAGS**, pages 156–161
The two templates for this project are V and W.

B
TWINKLE

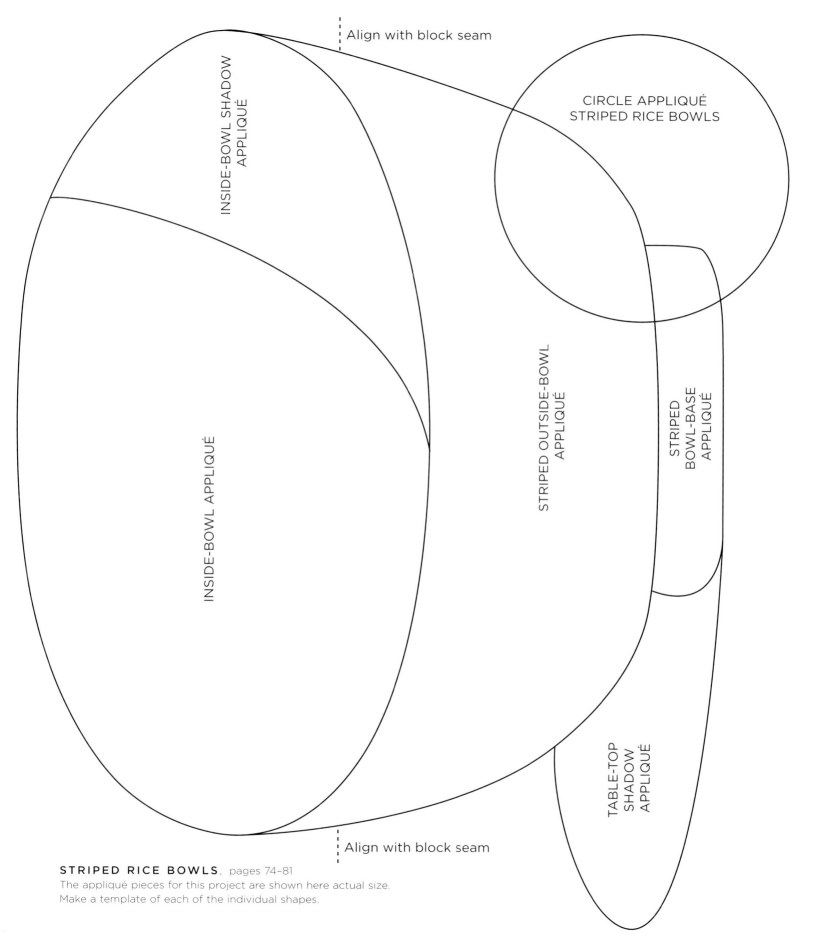

Align with block seam

INSIDE-BOWL SHADOW APPLIQUÉ

CIRCLE APPLIQUÉ
STRIPED RICE BOWLS

INSIDE-BOWL APPLIQUÉ

STRIPED OUTSIDE-BOWL APPLIQUÉ

STRIPED BOWL-BASE APPLIQUÉ

TABLE-TOP SHADOW APPLIQUÉ

Align with block seam

STRIPED RICE BOWLS, pages 74–81
The appliqué pieces for this project are shown here actual size.
Make a template of each of the individual shapes.

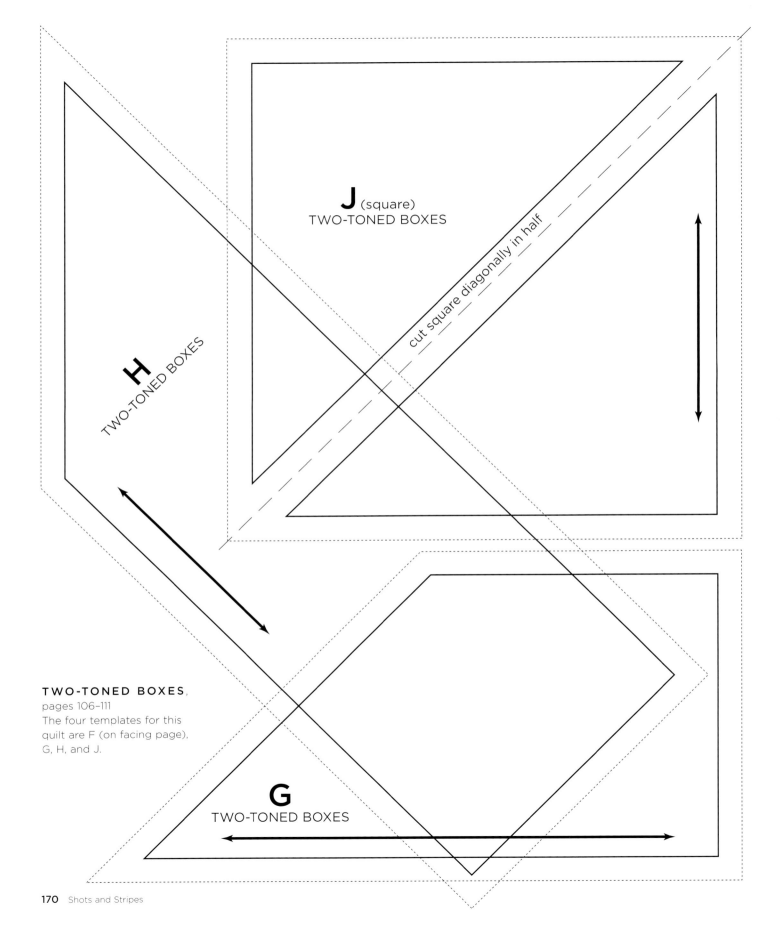

J (square)
TWO-TONED BOXES

cut square diagonally in half

H
TWO-TONED BOXES

TWO-TONED BOXES,
pages 106–111
The four templates for this
quilt are F (on facing page),
G, H, and J.

G
TWO-TONED BOXES

SAMARKAND, pages 90–95
The six templates for this project are
AA, BB, CC, DD, EE, and FF.

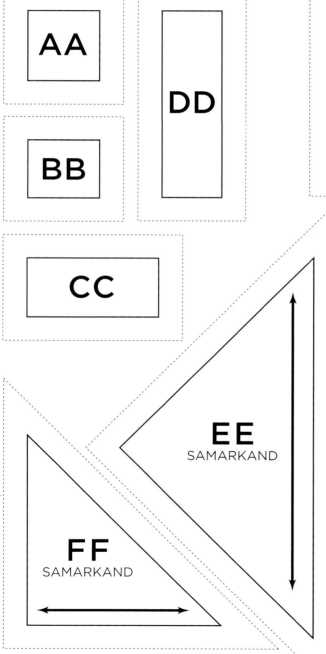

AA

BB

CC

DD

F (square)
TWO-TONED BOXES

cut square diagonally in half

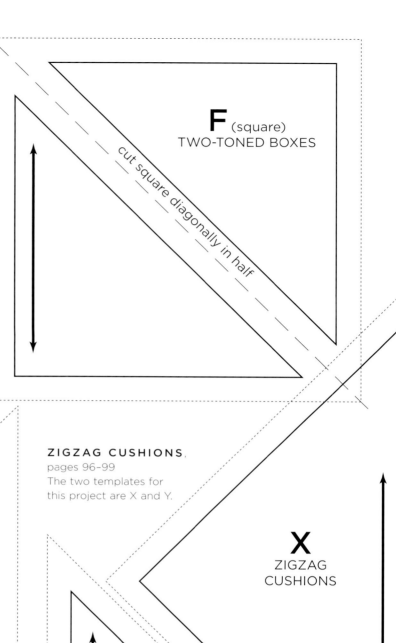

ZIGZAG CUSHIONS,
pages 96–99
The two templates for
this project are X and Y.

EE
SAMARKAND

FF
SAMARKAND

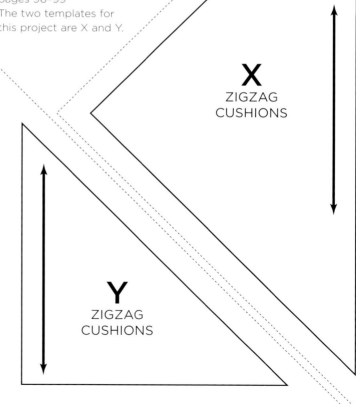

X
ZIGZAG
CUSHIONS

Y
ZIGZAG
CUSHIONS

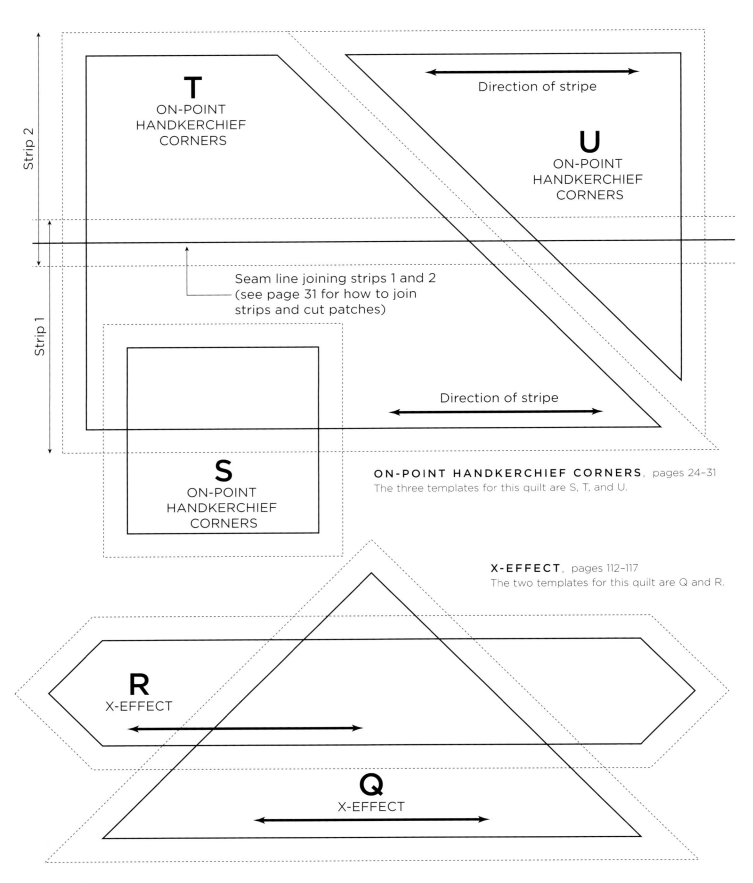

Strip 2

Strip 1

T
ON-POINT
HANDKERCHIEF
CORNERS

Direction of stripe

U
ON-POINT
HANDKERCHIEF
CORNERS

Seam line joining strips 1 and 2
(see page 31 for how to join
strips and cut patches)

Direction of stripe

S
ON-POINT
HANDKERCHIEF
CORNERS

ON-POINT HANDKERCHIEF CORNERS, pages 24–31
The three templates for this quilt are S, T, and U.

X-EFFECT, pages 112–117
The two templates for this quilt are Q and R.

R
X-EFFECT

Q
X-EFFECT

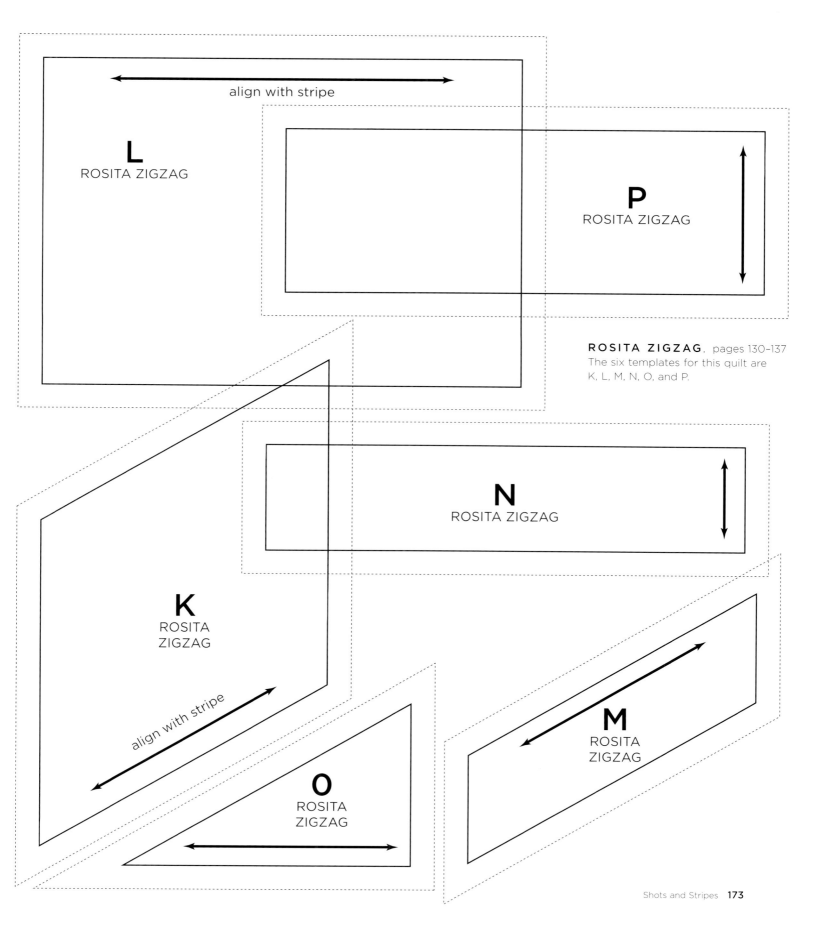

L

ROSITA ZIGZAG

align with stripe

P

ROSITA ZIGZAG

ROSITA ZIGZAG, pages 130–137
The six templates for this quilt are
K, L, M, N, O, and P.

N

ROSITA ZIGZAG

K

ROSITA
ZIGZAG

align with stripe

M

ROSITA
ZIGZAG

O

ROSITA
ZIGZAG

ACKNOWLEDGMENTS

First and foremost, I'd like to give a huge thank you to Liza Lucy for coming up with this concept and patiently keeping it on the boil till we could produce the book. Secondly, Brandon Mably for his constant support and collaboration on the quilts, styling, and location hunting. The long but joyous task of putting together a book like this is made considerably lighter with the help of many people, so thanks to Dora Debrova for sewing our cushions and bags, and to Pauline Smith, Rebekah Lynch, Corienne Kramer, Judy Baldwin, Sally Davis, Julie Stockler, and Claudia Chaback for sewing up our quilts. Thanks to Judy Irish, Donna Laing, and Bobbi Penniman for quilting in their sensitive style. Thanks to the good souls of Hastings, for maintaining the handsome setting for our book. Thanks to Yvonne and Belinda Mably for their cheerful help and hospitality. A huge thanks to creative Anna Christian for artful direction, and publisher Melanie Falick for recognizing this concept as a good one. Thanks to our wonderful photographer Debbie Patterson for her never-failing eye and to our loyal editor Sally Harding for keeping all our wild ducks in a row but mostly for her deep appreciation for what we do. Thanks to the Electric Quilt Company, Bernina, and Rowan Patchwork fabrics. Thanks to Michael Oakshott for his wonderful palette of Oakshott fabrics.

For support, encouragement, and holding down the fort, thank you Katy Kingston, Richard Womersley, Tanya Volochin, and Alex, Elizabeth, and Drew Lucy.

FABRIC SOURCES

Most of the patchworks in this book are made entirely of Kaffe Fassett handwoven *Shot Cottons* and *Woven Stripes*, and a few use Oakshott fabrics.

To find sources for Kaffe Fassett fabrics, do a search on the Internet or contact one of the following:

www.westminsterfibers.com

www.coatscraft.co.uk or www.knitrowan.com

For Oakshott fabrics, contact: www.oakshottfabrics.com

PHOTO CREDITS

All photographs copyright © Debbie Patterson unless listed below:

All photographs of flat quilts shown with instructions copyright © Jon Stewart.

Photos on pages 7, 15, 61 (bottom left and center), 71, 105, 115, 121, 127, 141 (bottom), 143, 147 (bottom), 153 (bottom right), 162, and 163 all courtesy of Kaffe Fassett Studio archive.

PROJECT INDEX

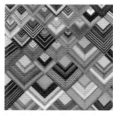
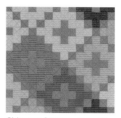
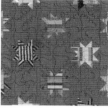
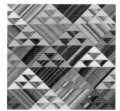
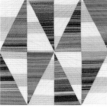
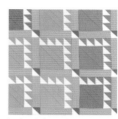
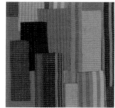

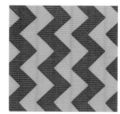
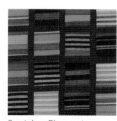
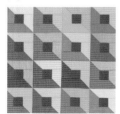
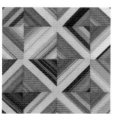
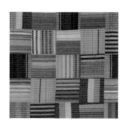
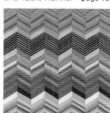
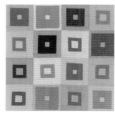
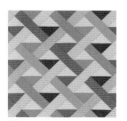

Published in 2013 by Stewart, Tabori & Chang
An imprint of ABRAMS.

Library of Congress Cataloging-in-Publication Data

Fassett, Kaffe.
 Kaffe Fassett quilts shots and stripes / by Kaffe Fassett and
Liza Prior Lucy.
 pages cm
 ISBN 978-1-61769-016-7
1. Quilting—Patterns. 2. Patchwork—Patterns.
3. Tablecloths. I. Lucy, Liza Prior. II. Title. III. Title: Quilts. IV.
Title: Shots and stripes.
 TT835.F36726 2013
 746.46'041—dc23

 2012028690

Editors: Sally Harding and Melanie Falick
Designer: Anna Christian
Production Manager: Tina Cameron

The text of this book was composed in Gotham.

Abrams books are available at special discounts when
purchased in quantity for premiums and promotions as
well as fundraising or educational use. Special editions
can also be created to specifications. For details, contact
specialmarkets@abramsbooks.com or the address below.

Printed and bound in China
10 9 8 7 6 5 4 3 2 1

115 West 18th Street
New York, NY 10011
www.abramsbooks.com